HOME
WITH HIP HOP FEMINISM

Intersections in Communications and Culture

Global Approaches and Transdisciplinary Perspectives

Cameron McCarthy and Angharad N. Valdivia
General Editors

Vol. 26

The Intersections in Communications and Culture series is part
of the Peter Lang Media and Communication list.
Every volume is peer reviewed and meets
the highest quality standards for content and production.

PETER LANG
New York • Bern • Frankfurt • Berlin
Brussels • Vienna • Oxford • Warsaw

Aisha S. Durham

HOME
WITH HIP HOP FEMINISM

Performances in Communication and Culture

PETER LANG
New York • Bern • Frankfurt • Berlin
Brussels • Vienna • Oxford • Warsaw

Library of Congress Cataloging-in-Publication Data
Durham, Aisha S.
Home with hip hop feminism: performances in communication and culture /
Aisha S. Durham.
pages cm. — (Intersections in communications and culture:
global approaches and transdisciplinary perspectives; v. 26)
Includes bibliographical references and index.
1. Feminism—United States—History. 2. African American feminists—
History. 3. Hip-hop—United States—History. I. Title.
HQ1410.D87 305.4209—dc23 2014016270
ISBN 978-1-4331-0708-5 (hardcover)
ISBN 978-1-4331-0709-2 paperback)
ISBN 978-1-4539-1382-6 (e-book)
ISSN 1528-610X

Bibliographic information published by **Die Deutsche Nationalbibliothek**.
Die Deutsche Nationalbibliothek lists this publication in the "Deutsche
Nationalbibliografie"; detailed bibliographic data are available
on the Internet at http://dnb.d-nb.de/.

Cover art by John Jennings
Interior book design by Kevin Dolan

The paper in this book meets the guidelines for permanence and durability
of the Committee on Production Guidelines for Book Longevity
of the Council of Library Resources.

Printed in the United States of America

To the Durham and McInnis Family
and my homegirls near and far.

Contents

Illustrations

Acknowledgments

THIS BOOK DOCUMENTS A JOURNEY—A MOVEMENT OF CULTURE AND BODIES FROM Diggs Park to the Ivory Tower and back again. I carry with me the stories of women who refused to be erased. Some present, some passed on. Tarsha, LaToya, Delneice, Tanesha, Artesia, Maria, Portia, and Keyisha—I see you. Latina, Taressa, Nicole, Renisha, and Donna, I rewrite your stories in spaces where we are unseen. Let this book be my community love letter to you all and all of the Diggs Park women who "make do" and "make time" to love, laugh, and live fearlessly.

Along this journey, I have been sustained by the unwavering support of my families at home and in the academy. To my parents Sharon and Jerome McInnis: This is the world in word that you dared me to be. To my brother, Sherwood "DJ Wood" Durham: I am the rhyme to your rhythm. Felicia Brown and Adrian Gale, you are soul-stirring life givers. To Celiany Rivera Velázquez, Jillian Báez, Himika Bhattacharya, Carolyn Randolph, and others in the ICR (Institute of Communication Research) Collective; to Brittney Cooper, Susana Morris, Rachel Raimist, Robin Boylorn, and others in the Crunk Feminist Collective; and to Ruth Nicole Brown, Claudine Taaffe, Chamara Kwakye, and others in SOLHOT (Saving Our Lives Hear Our Truths): Thank you. You provided the creative-intellectual space for me to cultivate my ideas, and your work has nourished me from Illinois to Texas to Florida. Claudio Moreira, Manoucheka Celeste, Neha Vora, and Vanita Reddy, you offered to read unready versions to help me over writing hurdles. Angie Cruz, you offered your home so I could

push through writer's block. I read your cheers in the blank space where/when there are no words. Know that I am because we are.

There are phenomenal people who laid the groundwork for this project. Mary Savigar, Cameron McCarthy and Norman Denzin, it has been your guidance and your vision early on that has helped me make concrete lofty ideas about a multivoiced, mixed method book on hip hop feminism. Joan Morgan, this book would not have been possible without you. It has taken the research help of David Reeves, Megan Farah, Joelle Cruz, and Heather Curry to archive it. It has taken "gender talks" with antisexist hip hop scholars John Jennings, Stephen Parris, Byron Hurt, Mark Anthony Neal, and Bakari Kitwana to smooth some of my ideas. Most important, it has taken the loving feedback and mentorship of Paula Treichler, Sarah Projansky, Gwendolyn Pough, Angharad Valdivia, Elaine Richardson, Cynthia Dillard, Mary Weems, Robin Means Coleman, Bernadette Calafell, Devika Chawla, Srividya Ramasubramanian, Carolyn Ellis, Susan Harewood, Shoshana Magnet, Desiree Yomtoob, Zenzele Isoke, and Tanya Saunders to see this process to the end. Among a constellation of stars, you all are my feminist universe. I look up to you.

Throughout this process, I have looked to one person: Kevin Dolan. Kevin, you've heard my stories as many times as I told them, you've massaged them, you've dressed them, and you've made them presentable to the world. Whatever beauty folks find in the pages that follow will be because your hands blessed them.

On Going Home

*Bullets fly, mothers cry and friends die in Oakleaf Forest, but April
Johnson has tuned her ear to sounds unlike those echoed throughout
her Norfolk neighborhood. Armed with a bow in one hand and a large
bass violin in the other, April, 17, plays melodies sweet enough to block
out the wailing cries of hopelessness coming from her housing project.*

— AISHA DURHAM (1994)

I BEGAN NARRATING THE EXPERIENCES OF WORKING-CLASS BLACK GIRLS LONG
before I birthed this book or conceived of the real prospect of two so-called
at-risk teens wielding pens and bows as instruments to get out of the ghetto
in the summer of 1994. Like a hip hop mixtape advertised from the trunks of
'hood hooalties, a tattered folder of rhymes was traded under desktops be-
tween classes in high school hallways from student to student until one day my
poetry caught the attention of a visiting journalist who rifled through my folder
as I professed—without a lick of professional experience but a lot of homegrown
confidence—that I was a writer too. That day, the journalist offered me an in-
ternship at a local daily newspaper where I learned the image-making craft of a
wordsmith. I had one summer, one story. At 17, I penned the tale of a longtime
friend April Johnson, whose life script could have been summed up in a stereo-
type of black[1] urban girlhood. But this writer knew better. I knew April better
than any would-be narrator in that Norfolk newsroom. I had within me an inti-
mate knowledge of the private lives of poor black women and girls from public
housing. I knew April's life story. It echoed mine.

The next summer after our story was published, a news photographer
scanned my dim-lit living room and recommended an outside headshot against
the quintessential red brick wall for a better picture to frame a new feature article
about my ghetto-turned-good-girl success story. I was told to lean against the
newly renovated white porch column. Look away from the camera, the photog-
rapher told me. I looked down at my hands and interrupted the shoot. I ran in

the house to dump my boyfriend-collected rings and copper bangles made cour-tesy of a bag of pennies welded by my older brother at vocational school. There could be no visually communicable accoutrements of welfare queendom. Fol-lowing me outside, my mother hand-pressed my wrinkled white church blouse and my untamed ponytail. I resumed my pitiful pose against the white porch column, looking away from the photographer as my mother offered one more stage(d) direction: Look like you need some money.

These two performative moments serve as epistemological watermarks throughout each chapter of this book. For one, they pinpoint what bell hooks describes as a homeplace[2]—the physical, cultural, and intellectual spaces where I make sense of my being in the world as an outsider-within.[3] An articulation of embodiment is paramount to how I theorize my lived experience[4] and identify my distinct interpretive and narrative departures from canonized approaches that are legitimated in newsrooms and university classrooms where concomi-tant professional codes of writer/researcher objectivity deny the very sensuality that is needed to understand and represent it. In both spaces and throughout this collection of stories interrogating the representational politics of black women from the hip hop or post–civil rights generation (born between 1965 and 1984), I insist on life-affirming poetics that emerge from a doing, knowing body whose historical, conjunctural speech-bodily-written acts are sometimes irreconcilable and deliberate but never detached. The power to frame, reposition, and define one's place in the world is deeply personal. I am wedded to the idea that human actors create the conditions from which we live; given that presumption, there can be no meaningful theorization of power that is not felt first. In *Home with Hip Hop Feminism*, I draw from the personal to make sense of my felt researcher/ed self in relation to virtual bodies and other flesh-bone black women grappling with being in the contemporary. More pointedly, I ask: How do we experience our bodies in relation to media and popular culture representations or what I de-scribe later as living memories? How do we describe the epiphanic moments—moments of heightened awareness of the situated self—when the real and imag-ined body converge or collide?

Second, the two performative moments from high school underscore the awareness of the imagined black female body in media and popular culture pro-duction by black girls and women who negotiate identity and representation in meaningful and purposeful ways that are sometimes unintelligible to those who cannot recognize our "tactical subjectivity"[5] as part of the subjugated knowl-edge we use to navigate the matrix of domination or intersecting domains of power.[6] Although my position as a news writer and writing subject has shifted,

my ability to intervene in mass media representational systems that redefine me has not, particularly in the cases when I craft a specific life story or stylized body to perform doublespeak. April and I fulfilled the trope of the redeemable project girl—the poor female who confesses her underclass sins to affirm white-washed middle-class beliefs, such as meritocracy. At the same time we resumed the white-column poses that frame our public identity, we were aware they were "fronts"—strategic performances employed for the immediate purpose to collect cash for college. We worked the (representational) system within the symbolic-material conditions of our existence—if only for two moments.

These moments foreground concurrent conversations in feminist studies, hip hop studies, and media and cultural studies about media power, representations, and agency as they are worked out and through flesh-bone black female bodies. In the introduction, I map the emergent but not fully codified interdisciplinary field of hip hop feminism. Hip hop feminism can be defined as a sociocultural, intellectual, and political movement grounded in the situated knowledge of women of color from the broader hip hop or the U.S. post–civil rights generation who recognize culture as a pivotal site for political intervention to challenge, resist, and mobilize collectives to dismantle systems of exploitation.[7] This book provides a relevant cultural criticism about, by, and for women of color. I imagine it as a cross between *Black Feminist Cultural Criticism, Check It While I Wreck It, Invisibility Blues, Home Girls: A Black Feminist Anthology, This Bridge Called My Back,* and *Home Girls Make Some Noise: A Hip Hop Feminism Anthology.*[8] Each chapter interrogates representations while working through them to reimagine positionality within my homeplaces using language and writing that affirms our everyday experiences.

Hip hop feminism has come of age during the emergence of new racism. New racism relies on the old logic of color-conscious racism. It is characterized by state divestment in public institutions and social welfare programs along with corporate discriminatory practices such as redlining and the resegregation of schools and neighborhoods in the 1980s. The powerful myth of colorblindness cloaked in American multiculturalism makes new racism invisible. As such, the failures of "assimilation" by African Americans and other working-class communities of color are attributed to individual and/or cultural deviance, weakness, or immorality.[9] Hip hoppers have come of age in these disenfranchised communities while dominant white society and the upwardly mobile African American middle class have blamed societal ills on the culture we have created. Under new racism there is little acknowledgment of state, political, and economic formations that actively police, contain, and marginalize these communities. Jimmie

Reeves and Richard Campbell argue the 1965 state document *The Negro Family: The Case for National Action* (commonly known as the Moynihan report)[10] has "provided the New Right with seemingly 'objective' research that justifies eliminating affirmative action programs, cutting welfare funding—and prosecuting a brutal war on black youth under the guise of the war on drugs."[11] State power coalesced with what they call "cultural Moynihanism"[12] during the Reagan era in which antiblack scientific racism legitimated exclusionary practices.

The media have been integral to the maintenance of new racism or the colorblindness of postrace by facilitating the guise of inclusion through representational politics. New racism and similar terms such as modern racism, enlightened racism, and postrace all suggest segregation and discrimination no longer exist. Proponents of postrace would claim that difference is celebrated. Colorblindness does not erase race; it does whitewash racial hierarchy.[13] Colorblindness is rooted in a superficiality that promotes the harmony of difference where Melissa Etheridge, James Taylor, and Three 6 Mafia (rapping about a pimp's hardship) can equally participate in a kind of sonic democracy during the 78th Academy Awards show. Nearly a decade later, it also happens when the fully clothed feminist pop singer Lily (white) Allen can riff off Three 6 Mafia in her tune "Hard Out Here" and unapologetically proclaim that the use of twerking black dancers in her music video was satirical and light-hearted.[14] Challenging colorblindness as a part of new racism in media and contemporary popular culture would bring black and other women of color from the background and help to galvanize hip hop feminism as a sociopolitical, intellectual movement.

I use hip hop feminism within the historical context of the hip hop generation, which is a response to new racism.[15] Bakari Kitwana reads Generation X as a label that does not capture the specific experiences of communities of color. He also suggests the increased visibility or the proliferation of hip hop in popular culture does not correspond to the containment and exclusionary practices slated in public policies, such as the elimination of cross-town busing and mandatory sentencing that have further marginalized these communities. I connect hip hop visibility with "high visibility" conceptualized by the black feminist scholar Michele Wallace to describe the problem of in/visibility confronting black female bodies under new racism.[16] The hypervisibility of the imagined black female body in hip hop popular culture can translate to the collective muted voice of real young black women. At the same time, however, I describe hip hop as a homeplace where many homegirls come to a feminist voice through it.[17] Applying Jürgen Habermas to hip hop, hip hop feminist scholar Gwendolyn Pough adds: One has to be seen before one can be heard.[18] Both Pough and Kitwana ac-

knowledge the unevenness of power under a new racism that seeks to erase difference by showcasing it. This is the representational strategy of postrace. Pough extends Kitwana's critique of new racism, adding that it must include an analysis of gender within hip hop popular culture if the hip hop generation is going to be successful in reimagining alternative modes of relations that do not depend on the exploitation or invisibility of black women.

The "post" factor is particularly important for Kitwana in *The Hip Hop Generation: Young Blacks and the Crisis of African American Life.* To really understand hip hop and the people who comprise the hip hop generation, Kitwana suggests we have to examine the political, social, and economic conditions of people of color growing up after the Civil Rights Act of 1964, which set the legal parameters for enfranchisement as well as the subsequent "post" imaginary of the American Dream that remains·elusive for many members of the hip hop generation. For example, hip hoppers coming of age in the mid-1970s in the South Bronx endured an average per capita income of $2,430, and youth unemployment ranged between 60 percent and 80 percent.[19] Kitwana contends the hip hop generation is informed by the deferment of the American Dream, class warfare, police brutality, the explosion of gangs and drugs, racial animosity, and a misunderstanding of complex race relations between the civil rights generation and the "post" generation.[20] These masculine frames of reference do apply to black women, but in ways that sometimes differ from some of Kitwana's discussion. I follow Pough's lead and take up the task that Kitwana outlines by using the axis of gender to describe my lived experience as a black feminist from the hip hop generation during the formation of new racism.

To provide additional context for understanding how this book's separate, self-enclosed chapters fold onto one another as a coherent remix of experience about the situated researcher/ed self, I describe how hip hop feminist studies is in conversation with feminist studies, hip hop studies, and media and cultural studies. It is not a genealogy.[21] It is not about the "new new." I do identify important conversations in the emergent field and use the chapters to illustrate the range of hip hop feminist studies in terms of theory, method, and writing practice. I attempt to distinguish hip hop feminist scholarship even as I simultaneously write it back onto earlier women of color and self-identified third world and multiculturalist feminism from which it is also birthed. As such, *Home with Hip Hop Feminism* not only represents an internal conversation among chapters about bodies and texts, it highlights my specific engagement across the intellectual and cultural sites where I am situated. In describing my particular experience in relation to real and textual black bodies, I return to theories in the flesh to

(re)interpret methods that center the shifting body to produce embodied narratives that (re)member homeplace(s) to engender a hip hop feminist becoming.

THE REPRESENTATIONAL POLITICS OF LOCATION:
MEDIA / CULTURAL STUDIES / FEMINISM / ME

I'm often asked when I lecture if my intention was to launch a hip-hop feminist movement. Truth is, [her book] "Chickenheads" was born of far less lofty, more selfish ambitions. Sometimes we write just to see ourselves. When it came to the discourse of the late '80s to early '90s I was feeling a bit invisible. . . . Ultimately, I wrote "Chickenheads" because I knew, lacking my kind of empirical evidence, that I was not alone in this. . . . I wrote "Chickenheads" in short, because I knew as hip-hop feminists we had shit to say and a lot to offer, but nobody was asking us to join the conversation. . . . So no, I didn't write "Chickenheads" with a movement in mind, but I think we might of gotten one anyway.

— JOAN MORGAN (2007)

I still ponder the book I wrote, Black Macho and the Myth of the Superwoman, *and the disturbance it caused: how Black women are not allowed to establish their own intellectual terrain, to make their own mistakes, to invent their own birthplace of writing. . . . Part of the politics of a Black woman writer . . . is that there is no pre-ordained location, because there is no power. So a "politics of location" is entirely process for me, unlocated and perhaps schizophrenic. By schizophrenic, I mean that it is more than one process, more than one location, perhaps three or four, none of which necessarily connect in a self-evident manner. Or perhaps it is because I haven't found the connections yet. Perhaps this is the level at which my work can be in dialogue with itself without superimposing a premature closure or a false unity.*

— MICHELE WALLACE (1989)

The autoethnographic books *When Chickenheads Come Home to Roost: My Life as a Hip Hop Feminist* by Joan Morgan and *Black Macho and the Myth of the Superwom-*

an by Michele Wallace were written twenty years apart, yet the books and the authors' subsequent reflections about them resonate with me as I also chart my lived experience of navigating representations of black womanhood, such as the unruly chickenhead and the invulnerable superwoman.[22] The former journalists use popular culture to extend black feminist thought. They also use popular culture to recall the simultaneous in/visibility of a particular black female body and/or thought within and across their self-described homeplaces (hip hop, black nationalism, and feminism). Each describes the maddening process of speaking in/to multiple locations at once. Most important, Morgan and Wallace address the uneven power in the production of knowledge in the academy where the black female body is taken up as an object of study but real black women are either "locked out"[23] or not asked "to join the conversation"[24] to speak about the conditions/traditions of our existence on our terms.

In popular culture, black women often exist as visible nonspeakers who garner attention as sexual spectacles in the public imagination.[25] The rap music video also may be illustrative of the in/visibility that black women confront in the intellectual terrains of feminist studies, hip hop studies, and media and cultural studies. Some black feminist scholars who are admittedly removed from hip hop culture speak us into existence—as real and imaginary audiences—by assuming what we think and who we are in relation to an unabashedly misogynist culture.[26] In the process of speaking for us, young black women are constructed with little agency to decode or develop the critical tools necessary to navigate our world. Take Tricia Rose's response to a once locked-out Michele Wallace (now positioned within the canon of black feminist theory). She challenges Wallace's construction of male rappers as unequivocally sexist and female rappers as defiantly feminist or womanist.[27] Rose suggests black women rappers affirm pleasure and privilege black girls and women in the public sphere through expressions, style choices, and subject matter, but they are not consistently feminist.[28] Rose and Morgan talk about hip hop yet draw from the black feminist thought that Wallace noted earlier as a young writer. The two make distinctions from black feminism even as they attempt to connect women in hip hop to a larger black feminist discourse.[29]

Hip hop feminism extends black feminist thought by looking at hip hop self-representations—representations created and reproduced within hip hop culture—to talk about everyday experience and the operation of power. The unruly chickenhead is one example of a self-representation specific to hip hop culture. In *Black Feminist Thought*, Patricia Hill Collins uses representations to theorize power as dynamic, structured in systems of domination, and inextricably

linked to social constructions of race, class, gender, and sexuality.[30] Black feminist thought, Collins contends, was never meant to be a prescription for black women's marginality; rather it should serve as a tool to understand the shared experience of black women and their relationship to various spheres of power. As social conditions change, so must social theory.[31] Collins notes: "Although reclaiming and celebrating the past remains useful, current challenges lie in developing critical social theory responsive to the current conditions."[32]

In *Home Girls, Make Some Noise: A Hip-Hop Feminism Anthology*, I said hip hop feminist studies can fill some gaps in understanding black women's social reality today. I cited Carolyn Randolph, who describes the impact of HIV/AIDS among black women and our continued silence around issues addressing black female sexuality.[33] She and others such as Alisha Menzies argue all black women are framed as always already diseased.[34] Their work, which is located within hip hop feminism, grapples with a black female respectability gone awry when our visibility within black feminism and grassroots activities is conditioned on distancing ourselves from actual sex workers and women who perform in hip hop music video productions. In "The Stage Hip-Hop Feminism Built: A New Directions Essay," bloggers from the Crunk Feminist Collective suggest respectability remains one of the key issues black feminists continue to confront.[35] We need only read popular commentary about icons such as Beyoncé to grasp how we wrestle with the representation and self-reclamation of a sexuality that has been scripted for us throughout history.[36] Tia Smith Cooper,[37] Randolph, and Brittney Cooper and the Crunk Feminist Collective bloggers echo the concerns of feminists within the hip hop generation, a generation that has weathered punitive welfare-to-work policies, HIV/AIDS, the backlash against minorities' legal enfranchisement, underemployment in urban centers, trickle-down economics from Reagan to Obama, and the proliferation of the military- and prison-industrial complexes. *Home with Hip Hop Feminism* adds to contemporary black feminist thought by addressing issues of race, class, gender, and sexuality relevant to black girls living in and living with hip hop hypervisibility.

The third wave[38] is another space where hip hop feminism is located. The third wave operates as a white-centered second-wave feminist corrective that is anchored by a mother-daughter metaphor.[39] It privileges the indigenous intellectual work by feminists of color who acknowledge multiple, constantly shifting bases of oppression in relation to interpenetrating axes of identities.[40] There is an emphasis on paradox, conflict, multiplicity, and messiness informed by poststructuralism and postmodernism.[41] Despite the early contributions of the Third Wave Foundation black feminist Rebecca Walker and the important hip hop fem-

Introduction | 9

inist scholarship by Gwendolyn Pough, shani jamila, and others from *Colonize This!*,[42] white-centered third-wave feminism still struggles with an intersectional approach that can account for the complex sexual politics entrenched in race relations.[43] In the third wave, whiteness seems to be raced only through the adoption of some other form of otherness (e.g., gender, class, or sexuality). The otherness that some white-centered third-wave feminists adopt is inscribed onto the black female body. Their mobility depends upon the stability of the black female body in popular culture and feminist theory. Put plainly, the white third-wave feminist can move (or be heard) if her black peers stay still (or at least stay silent while t/werking in the background). Here, I bring us back to the pimp-performing Lily Allen, who offers her feminist critique about misogyny in (black-produced hip hop) popular culture by uncritically using the stereotype of gyrating black music video vixens. That Allen and supporters choose to tell rather than listen to how we might see like-me black bodies bespeaks third-wave race myopia.

The white-centered perspective is heard and given legitimacy, considering it is recognized as the sole, rightful heir to the second wave in popular culture and the academy. Adapting Ann duCille's mammy-child metaphor to discuss the third wave, Astrid Henry describes the role of black women in white-centered feminism. She contends:

> Within this new feminism, we can see a kind of triangular relationship between child (third-wave feminists), mother (white second-wave feminists), and surrogate mother or "mammy" (black second-wave feminists). Black feminism nurtures, inspires, and bequeaths wisdom to the third wave's infant feminism, yet black feminism cannot take white feminism's place as mother feminism—the Feminism that gets to wear a capital "F."[44]

This mother-daughter wave model has significant implications for hip hop feminism. First, the black other-mother provides the labor, but neither she nor her children recoup rewards in an academy that privileges and transfers educational capital through whiteness. The black other-mother serves as the intellectual mammy. It is because of whiteness that the third-wave feminist can lay claim to the black woman's body of knowledge. They claim to know it intimately and perceive it (and our otherness) to be theirs—their property. In this model, hip hop feminism becomes the neglected child that has raised itself, which is a sentiment implied in much of the early critiques from white-centered third-wave feminism that suggested the personal, creative-based scholarship by young feminists of color was theoretically underdeveloped.[45] Mapped against the third wave, then, hip hop feminism is a bastardized, unrooted form of feminism that is

unable to speak itself into existence except when white-centered feminists want to play with difference. This is how the pop artist and academics alike can invoke black feminism (in) theory but simultaneously exclude actual black women from talking about gender and its intersections with class, sexuality, and race.

It is important to note that Pough positions her work within the third wave. Still, the location of Pough in the third wave must be read in terms of race and the uneven production of knowledge in feminist studies that remains invested in this racist model. Hip hop feminism has been developed within, against, and alongside the third wave. My idea of the waves comes from seeing my local Hampton Roads homegirl, Missy Elliot, rock them in rap videos and from Chicana feminist Chela Sandoval, who rearticulates the concept of the "third" to address the in-between space that U.S. third world women occupy to describe our differential mode of consciousness-in-resistance.[46] Even so, Kimberly Springer reclaims the third wave for women of color even as she deconstructs it.[47] Editors of *Home Girls: A Black Feminist Anthology* planned to publish a book titled *The Third Wave: Feminist Perspectives on Race*.[48] Pough follows suit, providing a critique of (third-wave) feminism and phallocentric hip hop even as she becomes visible through these cultural-intellectual spaces. Pough and others describe hip hop feminism according to our movement within specific spaces where our visibility sometimes has been predicated on a particular form of difference, such as gender in hip hop, the post-generation within black feminism, and race within third-wave feminism. These differences might characterize the distinct voice of hip hop feminism. I suggest this outsider-within position within both feminist and hip hop studies has deepened our understanding of the continued race and sexual politics at play.

Interrogating difference within media and culture is important to hip hop and black feminist political projects because the circulation of controlling images[49] or power-laden stereotypes contributes to the ongoing objectification of black women.[50] I return to Morgan and Wallace briefly to note their book titles: *When Chickenheads Come Home to Roost* and *Black Macho and the Myth of the Superwoman*. It is not surprising that their book titles mention controlling images too. Much of hip hop and black feminist studies tackle representations because media reinforce racism and justify gender exploitation. Media and popular culture are also important spaces where black girls and women are most visible, and hip hop has become the specific cultural space that black and Latina girls and women navigate. Like Morgan, I examine controlling images to discuss the lived experiences of black women that extend beyond the music video and beyond hip hop popular culture.

The ho—and its hoodrat and hoochie iterations—is the formidable hip hop controlling image that is a part of the dominant vernacular today. Here, I am reminded of a critical flashpoint in hip hop feminism that demonstrated how hip hop representations of black women proliferated mainstream society. In 2007 when MSNBC radio host Don Imus described a predominantly African American Rutgers University women's basketball team as "nappy headed hos," he used language from popular hip hop culture. His diatribe attached the ethnic signifier of hair to hypersexuality to convey black un/desirability.[51] While the ho gains meaning within a specific hip hop cultural context, his comment underscored how representations of racialized gender and sexuality moved outside of hip hop to support dominant white supremacist portrayals of black women, and he demonstrated how these representations can be deployed to dehumanize any woman. And it is because of the latter that antisexist artists, academics, and activists alike should be invested in challenging controlling images.

Challenging representations of racialized gender in hip hop is not new despite the seeming new arrival of hip hop feminism in college courses and conferences. Hip hop studies emerged as a serious site of academic inquiry in cultural studies more than two decades ago. Research continues to be devoted to black boys and men who use cultural tools honed in hip hop to make sense of our postmodern world in the face of deindustrialization, police brutality, underemployment, and gang violence.[52] That said, it has been the gender analysis in hip hop feminism that has pushed our understanding of masculinity and its intersection with sexuality, class, and race in the field. Early hip hop studies in the United States did not explicitly reference the British tradition of cultural studies (Tricia Rose excluded), but it was informed by the Centre for Contemporary Cultural Studies (Birmingham). The British cultural studies approach placed the lived experiences of the working class within a structural framework to centralize questions of knowledge, power, meaning, subjectivity, identity, and agency.[53] Early hip hop studies integrated Afrocentrism with Gramscian Marxism to discuss rappers as organic intellectuals and employed concepts of hegemony and oppositional consciousness to describe disaffected urban black male youth. The reinterpretation of culture and resistance developed at the Centre has had a transatlantic reach in hip hop studies.[54] The British tradition also calls attention to the interrelated spheres of the state, economy, and civil society as they pertain to working-class youth. Its emphasis on the public sphere—the masculine spaces of the street, the pub, and the pool hall—in earlier work did erase working-class female experiences despite female participation in those spaces. I point to the British tradition of cultural studies because hip hop studies has followed a similar

male-centered trajectory where we see black women in dance halls, strip clubs, and street corners but rarely do we hear the voices of black women.

Other than defining the "where" and "who" of hip hop, early hip hop studies defined what counted for hip hop culture. Until recently, hip hop could be narrowly summed up by the signifying practices of break dancing, deejaying, emceeing, and graffiti writing. Rap music continues to be privileged. Girls and women only enter this already masculine-identified world as rappers or rap video vixens. I suggest this hegemonic framing of hip hop is due in large part to men who identified with those aspects of the culture in their personal lives, endorsed the discourse of the endangered black male, or participated in venues that privileged black men where they could produce and disseminate their work. Women provide complementary and often contested narratives about hip hop. One example is the construction of rap as the musical form endemic of hip hop. Some forms of R&B are also acknowledged as a part of hip hop culture. First, interviews and biographies suggest poetry and spoken word were important to develop a woman-centered hip hop voice.[55] Second, the blending of rap with R&B has been the hallmark of influential female rappers, such as Missy Elliott (formerly of an all-girl R&B group) and Lauryn Hill and Queen Latifah, who have both integrated singing and rhyming. Singers such as Mary J. Blige, Erykah Badu, and Beyoncé also resonate with women from the hip hop generation because they talk about the experiences of black women and girlhood and they project a hip hop aesthetic through their self-positioning, comportment, and style.

Let homegirls in Diggs Town[56] public housing tell it:

> Hip hop could be rap, Kurtis Blow, Lauryn Hill, Erykah Badu, India Aire, Missy. Hip hop could be reggae, dancehall. Dancing. Breaking—the electric boogaloo back in the day. It's just dance. It's dress. Poetry. Clothing. Your whip. Everything. Your ice. It's a feeling, [an] attitude. It's just life. Everything is hip hop.[57]

The hip hop definition the women offer is expansive. It is one that cannot be condensed by the so-called four elements. Focus group participants and Diggs Town public housing residents Latina, Renisha, Donna, Taressa, and Nicole identify hip hop as life. They recognize that everyday life includes the practices, spaces, and worldviews in which they participate. Hip hop, then, becomes a part of embodied experience. The women recall the sentiments of veteran hip hop performers Mos Def (now Yasiin Bey) and KRS-One, who claim we are hip hop. Both the performers and the black women "body"[58] hip hop culture, which is often read as the end product of corporate popular culture. Hip hop feminism has been

formidable in rethinking hip hop and expanding how we imagine the culture. By privileging poetics and the spectacular and ordinary performances by black women, I work to body hip hop too. It is my attempt to present a range of stories that make up the ways I recall, (re)member, and represent hip hop feminism as it is in conversation with feminist studies, hip hop studies, and media and cultural studies.

<div style="text-align:center">

INTERPRETIVE INTERACTIONISM AS METHOD, MODEL,
AND WRITING PRACTICE: AUTOETHNOGRAPHY, TEXTUAL EXPERIENCE,
AND REFLEXIVE INTERVIEWS

</div>

In *Home with Hip Hop Feminism*, what is said about black women's lived experience is just as important as how researchers choose to represent it. Theory, method, and writing are inextricably embodied processes of knowledge production.[59] As such, a discussion of methodology necessitates one about writing because it is the write-up, or the final presentation, of experience condensed to a digestible, referential text that ultimately legitimates research and authorizes the researcher/ed experience. This book hinges on interpretive interactionism, which is itself a methodological toolkit and narrative approach to understand lived experience as it is enacted and performed.[60] It describes when bodies and texts meet, which is evidenced by writing and methodological approaches such as autoethnography, creative interviewing, semiotics, poetry, participant observation, life story, performance texts, and self-story construction.[61] Interpretive interactionism aims to illuminate the crisis of representation between the so-called real and the symbolic world. It explores lived experience and assumes that epiphanic moments—those moments of heightened awareness of the situated self—emerge from interactions that render crises of identity and/or representation.[62] Each chapter describes epiphanic moments by black women from the hip hop generation as we engage with representations that shape how we navigate everyday life. The following section outlines how interpretive interactionism organizes the book by bringing together autoethnography, textual analysis or textual experience, and reflexive interviews, as well as by privileging performance writing as a research practice to represent the lived experiences of black women from the hip hop generation.

The organization of the book reflects the methodological approach of interpretive interactionism. In his rearticulation of the method under performance ethnography, Norman K. Denzin contends "performance and their lived representations reside in the center of lived experience. We cannot study experience

directly. We study it through and in its performative representations."[63] The book stages researcher/ed engagement with real and textual bodies. These staged encounters are divided into three parts: autoethnography, textual experience, and ethnographic interviews. The three parts provide an overarching illustration of the way texts stand in between what we know about ourselves and about others (body ↔ text ↔ body).

The organization also punctuates the interpretive process that begins and ends with the researcher/ed body.[64] I use interpretive interaction as a model to divide the book into three parts: recall, (re)member, and represent. They describe how I engage with memory, media, and other women in Diggs Town. In part I, for example, I open with a set of autoethnographies that situate my researcher/ed body in scholarly, cultural, and lived communities. These three autoethnographic chapters provide a kind of entrée for the reader into my homeplace(s) and a contextualization for the textual analyses and ethnographic interviews that are reinterpreted as reflexive, dialogical performance ethnographies that speak back to my researcher/ed self and the popular representations of black women from the hip hop generation. In all, the organization of the book is modeled after interpretive interactionism to present a reflexive, dialogical conversation about identity and representation among black women.

Interpretive interactionism recognizes writing as a research practice.[65] In "Writing: A Method of Inquiry," Laurel Richardson and Elizabeth Adams St. Pierre emphasize writing as a creative process that is a "tangled method of discovery"[66] collected in dreams, conversations, and observations and through other senses to provide a crystallization of experience.[67] Bringing black feminism to bear on this research practice, Audre Lorde also identifies the process of writing poetry as a "revelatory distillation of experience." She adds: "Poetry is the way we help give name to the nameless so it can be thought. The farthest horizons of our hopes and fears are cobbled by our poems, carved from the rock experiences of our daily lives."[68] Along with Richardson and St. Pierre, Lorde theorizes embodiment through writing to make sense of lived experience.[69]

Interpretive interactionism also adopts literary techniques honed in feminist writing by women of color. Earlier, I placed the work of Michelle Wallace and Joan Morgan together to address how hip hop feminism extends black feminist thought through reflexive and/or autoethnographic writing. This writing centers the situated body as the interpreter of knowledge, privileges the emotive, and employs poetics that move from the "I" outward.[70] By poetics I mean narrative devices such as flashbacks and foreshadows and the manipulation of language to create rhythm and imagery.[71] These literary devices and strategies are

not confined to poetry. In part 1, for example, I use flashbacks to stage a "struggle of memory" or a "politicization of memory"[72] that is part of the performance of showing my lived experience as a Diggs Town homegirl. My integration of poetics in poetry and prose throughout this book engages another kind of representational politics in which "literature" (as art) is often housed outside ethnographic "research" (as science). Black feminist anthropologist Zora Neale Hurston recognized her ethnographies as stories and wrote them in novels such as *Their Eyes Were Watching God*.[73] Hurston, Lorde, and others push the boundaries of ethnographic textuality and ethnography[74] and force us to reconsider the ways that theory and method are embodied processes. *Home with Hip Hop Feminism* extends this tradition in both interpretive interactionism and black feminism by "fleshing" the interrelationships between the home/body ↔ text ↔ body/body that inform, mediate, and create the psychic and material conditions of black women's lived experience. As Diggs Town resident Taressa said:

> If they just picked up the book and read the things I speak, and the way that my mindset is, they would look at me in a totally different essence. It's like you can say, oh, I read this thing, Taressa wrote this thing. When you read about what I said, you know, you say, she's positive, she's got her head on strong—this, that and the third—but when you come to The Park, you like, this girl with all this knowledge coming from The Park? [S]ome of the best, the most knowledgeable, the most positive people that can probably create a change in the world live in The Park.

Recalling the Homegirl

Autoethnography

The longing to tell one's story and the process of telling is symbolically a gesture of longing to recover the past in such a way that one experiences both a sense of reunion and a sense of release. It was the longing for release that compelled the writing but concurrently it was the joy of reunion that enabled me to see that the act of writing one's autobiography is a way to find again that aspect of self and experience that may no longer be an actual part of one's life but is a living memory shaping and informing the present.

— BELL HOOKS (1998)

I think both feminist and indigenous scholars who are interested in documenting and salvaging—that is, rescuing from waste, destruction, and invisibility—the richness of the past and the nuances of the present, have efficaciously used narrative in their diverse configurations of life histories, testimonies, autoethnographies, memories, and memoirs as a precise and rigorous methodological tool.

— IRMA MCCLAURIN (2008)

As Black girls and women, we are experts of our lives. Period. SOLHOT is a space where our expertise collides with those narratives written about us. We are finding a language to be known for who we really are and have that be all right.

— RUTH NICOLE BROWN (2010)

AUTOETHNOGRAPHY UNEARTHS. IT IS THE MIND-MINING EXCAVATION OF EXPERIence exhumed from buried field notes and dormant memories recovered to reconstruct one's self within a particular historical or cultural context. As an embodied method and writing genre, it encompasses the personal narrative, which can be extended to interpretive biography, performance auto/ethnography, ethnographic biography, reflexive ethnography, auto-anthropology, and autobiographic ethnography.[1] Each name marks a turning point within disciplines

and/or paradigms that interrogate researcher/ed subjectivity and the representation of experience. Irma McClaurin challenges the "newness" of these turns narrated primarily by white male ethnographers who have always had the luxury of defining the self and how "the other" is represented in research.[2] The fragmented self celebrated in postmodernism is the unfinished project of modernity experienced by people of color.[3]

Analyses of subjectivity and the self are central to the "direction, content, analysis, praxis, and materiality" of black feminist scholarship.[4] There is an explicit integration of the researcher/ed self *throughout the book* because it serves as my political stance against the systematic objectification of the black female body.[5] I use the autobiographical to reject research/er objectivity—those newsroom and university classroom professional codes—that seeks to write-white out my black body by forcing me to detach my sensed self from the textual and real black female bodies I encounter.

In part 1, autoethnography enacts a conversation between the researcher/ed body and memory. It closely resembles what Audre Lorde defines as biomythography, or a life narrative that weaves myth and biography to rescript reality.[6] Entertainment and news media representations recalling black urban girlhood activate memories of home as the physical and psychic space where I entered hip hop feminism. Experience concretizes my theoretical engagement with hip hop feminism, and it situates the multiple, multilayered stories of a lone homebound blackgirl alongside "official" ones to offer complementary and competing coming-of-age narratives about inner city life in the Norfolk, Virginia, Diggs Park public housing complex.

Diggs Park becomes the backdrop and the bookend for an intimate conversation about the black body from the hip hop generation. Diggs Park can be characterized as a ghetto, but that term is so saturated with lifeless stories of failure— failed femininity, middle-class acculturation, and American ethnic assimilation in academic, popular media, and public policy talk—that it fails to fully account for the richness of human experience for folks who have lived there. For some, the ghetto remains a vacuous space filled with a population without people. It is imagined as a statistical reality of risks, life chances, and unlikelihoods that become meaningful only in debates using rates (drop out, pregnancy, recidivism) and rolls (child welfare, unemployment) to recount the so-called underclass or black pathology. Part 1 retells a different story, a story that is neither resistant nor celebratory but one that recasts the ghetto by (re)visiting Diggs Park and the intraracial conversations about class and culture from interconnected stories of history makers and cultural actors narrating lived experience.

The recurrent theme of home echoes through the examination of self and subjectivity in autoethnographic or autobiographical writing by black women and other women of color. In the first line to the introduction from the canonical black feminist anthology *Home Girls*, Barbara Smith said, "There is nothing more important to me than home."[7] Smith describes home as a psychic and physical space where she understood her black self in segregated Georgia, an intellectual-cultural place where she developed the techniques to theorize and express black feminist thought by the black women who surrounded her, and a political site of renewal and resistance where dealing with home truths is vital for communities of color to survive.[8] bell hooks reiterates this as a homeplace— or a space of renewal and recovery for black women.[9] Diggs Town, hip hop culture, and hip hop and black feminism serve as the physical, psychic, cultural, and intellectual homeplaces that I travel to in both memory and/or presence to recall, (re)member, and represent the lived experiences of homegirls from the hip hop generation.

In chapter 1, I use the popular hip hop documentary *Beyond Beats & Rhymes* (2006) to recall home. The documentary captures ongoing conversations among scholars, cultural critics, and hip hop insiders about the state of African Americans by interrogating distinct expressive forms associated with hip hop culture. I draw from two scenes to describe memories as the researched underclass and as the graduate researcher returning to Diggs Park to explore the shifting discursive terrain of hip hop as a struggle over meaning waged through class performances. Class is articulated through taste values and notions of respectability. I connect the hip hop mantra emphasizing lived, embodied culture with bell hooks' description of a homeplace to discuss my researcher/ed self during the 1989 Virginia Beach Greekfest race riots. Chapter 1 sets the stage for a second homecoming where I interview a group of African American women from Diggs Park and represent an interpretation of their lived experience through poetic transcription in part 3. By recalling autoethnographic encounters of hip hop at home, chapter 1 calls attention to the racial and gender politics of class that echoes behind beats and rhymes.

Similar to chapter 1, chapter 2 also draws from news media reports about Diggs Park to provide an intimate account of black urban girlhood. The impetus for chapter 2 comes from conversations about the believability of the gritty Baltimore inner-city cable crime series *The Wire* (2002–2008). I wanted to shift the conversation about entertainment media and the construction of the real to fact-based media where authenticity (representation) is assumed. Chapter 2 blends local news stories with memory work to create a performance that is

experimental and experiential. I reconstruct life events by rearranging news stories covering my high school years. As a performance, the arrangement distills broad national initiatives such as urban renewal, welfare reform, and community policing to a neighborhood level. While newsmakers routinely rely on hand-picked opinion leaders and experts to bolster a representation of the real, I extract voices of Diggs Park residents to offer a grounded, community-centered one that highlights experience rather than the event. Emphasizing the interpretative, chapter 2 models the performance ethnographies of Andrea Deveare Smith and Norman K. Denzin.[10] Smith conducts interviews of Los Angeles residents and interprets them as performances to recount the 1992 riots while Denzin resurrects forgotten Native American history and historical figures such as Lewis and Clark in personal vignettes to reimagine Montana as a child and an adult vacationer. Both perform unsettling character-driven home stories about spectacular events that transformed the writers and the national character as well. Chapters 1 and 2 bring national discussions about the inner city home.

Part 1 closes with a choreopoem about home. The five self-enclosed autoethnographic performance narratives engender a particular knowing by shifting between bystander and actor in separate yet interconnected gendered worlds where a black girl bears witness to the psychic economy of poverty. Chapter 1 emphasizes emotional residues of everyday institutional, bodily, and epistemic violence. Hip hop feminism emerges in part as a reaction to these forms of violence. There are no news media stories to extract, no film scenes to jar recollection about punitive welfare policies, no demonstrations against sexual violence, or no corrections to a white-centered third-wave feminism that legitimated itself by severing hip hop feminism from its women of color tradition.[11] Here, the affective is amplified. The poetic and personal connect the reader to hip hop feminism through a story. The interconnected stories of reclamation—of body, of spirit, of homegrown truths—initiate the reunion in autoethnography that bell hooks, Irma McClaurin and Ruth Nicole Brown describe in the epigraphs to this section.[12]

Part 1 situates a discussion about hip hop that is local and lived out through the body. To recall means more than to retell; it implies reclaiming and calling up again lost memories and overlooked stories. Reality is rescripted through what Carolyn Ellis calls the ethnographic "I" or the vulnerable researcher who is able to see her body as more than an instrument to record and report information but as instrumental to sensing the gaps, holes, fissures, and fixtures of culture and identity.[13]

Behind Beats and Rhymes

Working Class from a Hampton Roads
Hip Hop Homeplace

OLD SKOOL. IT IS THE CORPORATE MUSIC CATEGORY FOR OLD RAP THAT ALSO OPER-
ates as a collective disclaimer for some 30-year-old-plus purists who herald the
late '80s as the hip hop heyday when "the message" carried as much weight in
the community as the bling now overshadowing the culture's transformative,
democratic power epitomized earlier by artists such as Public Enemy. Old skool-
ers offer youth a revisionist hip hop history that is greed free, gender inclusive,
and community-driven only. It is a seductive story I also recalled at recreational
centers, conferences, coffee shops, and kitchens until I watched the 2006 docu-
mentary *Beyond Beats & Rhymes*, which brought my particular hip hop story of
class performativity, intersectionality, and hybridity home again.

 Beyond Beats & Rhymes interrogates hegemonic black masculinity and its
impact on gender and sexual minorities participating in the culture. The film
echoes well-documented hip hop scholarship addressing women[1] and calls atten-
tion to the ways hip hop continues to be deployed to talk about race, gender, and
class.[2] The politics of class—articulated through taste values and notions of re-
spectability—is not explicitly addressed yet it undergirds the discussion between
the old skool and a new generation of hip hop culture. Rather than debate the
legitimacy of hip hop as an expressive form assessed by outsiders, filmmaker
Byron Hurt interviews notable industry insiders and activist-scholars along with
unnamed people "on the street" to critique its recent incarnation in popular cul-
ture. Hurt sets up the ordinary person against what could be characterized as
the old skool hip hop vanguard. What emerges from this positioning is the shift-
ing discursive terrain of "hip hop" and the struggle over meaning where class

distinctions attempt to stabilize hip hop—a cultural movement that has been fluid and mobile even as many of its participants have been contained and concentrated in working-class urban centers. For various interest groups, the stakes—political, cultural, and economic—are high. Not only is hip hop a leading U.S. cultural export and a profitable site where advertisers can pitch lifestyles of excess in a consumer-based economy, it also defines a generation and new modalities of social justice in the U.S. post–civil rights era.[3] For African Americans across socioeconomic classes, hip hop serves as a formidable way to gain visibility in the public sphere. For these reasons, *Beyond Beats & Rhymes* has gained traction in the "street" and the academy because it captures ongoing conversations about the state of African Americans and hip hop as the most visible Black American expressive culture that constitutes the national identity of an entire group today.

This chapter extends conversations captured in the documentary by examining class as it is articulated in and through the lived and commodified realities of African Americans engaging with hip hop culture. More than a decade after Stuart Hall pointedly questioned the significance of "black" in black popular culture,[4] there continues to be an overemphasis on the authentic-resistant working-class black male vernaculars to myopically theorize the black experience.[5] Hall asserts that "black" is an overdetermined and insufficient signifier. Class is overdetermined as well. Class appears in black cultural studies scholarship only to buttress race and provide a reference point to explain that experience. It is one reason why hip hop, only interpreted as black male underclass, can be disavowed today because its earlier registers have become too slippery to sustain a cohesive class critique. In my narrative, class uncertainty unsettles my assumptions about race and gender and hip hop culture. Each time that I believe I have a firm footing, the rug is ripped from under me and I am abruptly reminded that any clear-cut account of real-representational experiences that elide the slips in between ultimately will fall short. Class, for me, is that slippery in-between space of possibility because at any given moment it can convey economic status, legitimate racial authenticity, mark spatial identity, and dictate gendered modes of being in the world. Therefore my contribution to the conversation about hip hop seeks to trouble its totalizing narrative by illuminating points of intersectionality, hybridity, and performativity when class is at play.

Class becomes the catalyst for me to visit my childhood home as the hybrid researcher/ed with ghetto roots and middle-class academic credentials and to revisit hip hop as a cultural and intellectual homeplace. The first half of this chapter reviews the literature and popular discourse about hip hop culture and the hip hop generation through a discussion of the black underclass. The second

half recounts distinct moments where my lived experience stands alongside and against the literature and popular discourse defining me in hip hop homeplaces. I situate living memories in relation to media representations to describe lived and commodified realities, to address class intersections with racialized gender for a group of African American women whose performances are regulated and policed by the hip hop and larger African American community, and to place class in dialogue with postcolonial themes of home and hybridity to discuss hip hop as an in-between space of simultaneous belonging and unbelonging for African American women.

Hip Hop as a Homeplace

Central to my discussion of class is the notion of hip hop as a homeplace. bell hooks describes a homeplace as a physical, cultural, and intellectual space where she makes sense of being in the world as an outsider-within.[6] Connecting hip hop as lived, embodied culture (the "I am hip hop" mantra) with hooks' description of a homeplace, I recall my experience as a youth residing in public housing when the media representation of an explicit class consciousness of hip hop culture (via music lyrics, racialized space, and style) was redefined in the summer of 1989 when racial tensions between the majority black college students and white local shopkeepers and Virginia Beach police officers resulted in a race riot. I offer a layered account that envelops my memory with official accounts preserved in local newspaper reports and national documents for state workers. For example, the Federal Emergency Management Agency (FEMA) under the newly organized Department of Homeland Security references the Virginia Beach Greekfest riot as a model to show local officials how to police civil disobedience in a small city.[7] Hurt's documentary and my reflections about Diggs Park[8] create "new" memories from old events. These "new" memories not only reframe the race riots but reauthor the masculine-centered hip hop story from the perspective of an African American woman.

This hip hop home story I opt to retell necessitates space-time travel. The movement reflects unsettled memories—those I recollect from Diggs Park and the stories I collect from the local newspaper while in graduate school at a predominately white Midwest university; the movement also reflects the psychic and physical condition of U.S. postcolonial subjects whose living memory of home is constantly animated when experiences of dislocation and displacement are amplified. Describing the shifts in perception about home for the expatriate, Sujata Moorti suggests media allow us to develop a "diasporic optic" where we

are able to move through multiple worlds and identities.⁹

Watching Hurt's documentary and reading local newspaper reports about Diggs Park and the Greekfest race riots, I am the *researcher* examining representations of my life and like-bodies in a graduate program away from home as well as the *researched* at home remembering my life in the Norfolk public housing project. Both perspectives are mediated by representations, and they provide different vantage points to talk about experience as class intersects race, space, and gender. Class serves a dual function. It anchors a fleeting working-class and/or underclass authentic black identity that I want to reject yet claim as I wrestle with newfound middle-class mobility from a postsecondary education. Class also frames respectable femininities that I try to perform but do not possess in Diggs Park as the researched or the within-group researcher. The move from my Diggs Park past and present is a necessary one in the narrative because it shows that my story—like the multiple narratives of class and hip hop—is an unsettled, unfinished one.

My story of class in hip hop is sparked by two scenes from Hurt's documentary. The first scene cuts from rapper Chuck D commenting on hedonistic "happy niggers" in rap music videos to a close up of the Virginia-based rap duo the Clipse. The rappers relocated from the Bronx to Virginia Beach¹⁰ in the '80s, when Chuck D and Public Enemy left their mark on my childhood and the racially divided Hampton Roads after the race riots. The second scene splices college spring break images of men accosting women on a Southern boardwalk similar to the one along the Virginia Beach strip. A young black man, J-Hood, classifies female passersby as sisters or bitches—the latter group he suggests is always subject to sexual harassment because of taste choices, such as wearing shorts.

The wifey-ho rap remix of the Madonna-whore binary defining womanhood is also taken up by a group of African American women living in the Diggs Town public housing community. Social science researchers would lump this group into one category: the underclass. In the second half of this chapter, I recall how the Diggs Town women redefine their class position through performances of respectability (professional jobs, sexual restraint, and polite femininity) within the rap binary rather than the racialized space of the Diggs Town public housing community. While they disrupt the gendered construction of the underclass, some deploy the very binary that J-Hood imposes to describe other women—irrespective of income or profession—as without class. Both scenes in the documentary recall the racial and gendered politics of class to frame how we might talk about hip hop today.¹¹

(Re) Working Class at Home:
The Construction of Hip Hop and the Underclass

> *Intense poverty, economic collapse, and the erosion of viable public space were part and parcel of the new urban terrain that African-Americans confronted. Culled from the discourse of the postindustrial city, hip-hop reflected the growing visibility of a young, urban, and often angry so-called "underclass."*
>
> — MARK ANTHONY NEAL (1999)

> *Most interpreters of the "underclass" treat behavior as not only a synonym for culture but also as the determinant for class. In simple terms, what makes the "underclass" a class is members' common behavior—not their income, their poverty level, or the kind of work they do. It is a definition of class driven more by moral panic than by systematic analysis.*
>
> — ROBIN D.G. KELLEY (2004)

> *We have developed a subculture that's not acceptable. These people are the most underemployed, the most undereducated, the most underchurched; they are the most underdisciplined people in our society.*
>
> — NORFOLK CITY COUNCILMAN HERB COLLINS (1994)

Culture, behavior, and mobility (spatial, professional, and economic) mark class belonging. Canonical cultural studies scholarship outlining the development of hip hop culture notes that hip hop vocalizes the frustrations, fantasies, and fears of the so-called underclass.[12] When Herb Collins stressed the need to create a public housing czar to "uplift the mentality" of a debased subculture he witnessed while walking along a Diggs Town street, the black councilman had referenced its residents;[13] yet, his comments could have been applied to expressive forms, such as rap music, linked to the underclass as well. Collins depicted the Diggs Town underclass as isolated from mainstream society or normative cultural values. He connected the concept of (sub)culture to behavior to describe the

underclass, recuperating social science research about black urban poverty and black middle-class sentiments of racial uplift. In academic research, public policy, and popular media, discourses about class and culture intersect and overlap to produce hip hop and the underclass, both of which are defined less by economic structures than by the performances of racialized space, sexuality, and consumption practices. I argue it is the performative aspect of class, which Robin D.G. Kelley identifies as behavior, that allows insiders (other Black Americans or hip hop practitioners and cultural critics) to set the political agenda for "the race" by launching class-based attacks to police the black underclass.[14]

Defining the so-called underclass is no less problematic than defining class itself. The working poor and/or the underemployed underclass used to be distinguished from the middle class by labor; the middle class performed intellectual (white-collar) labor and the working class performed manual (blue-collar) labor.[15] White- and blue-collar occupations corresponded to income and education levels. These distinctions have been disrupted by shifts toward information technologies and consumer-based economies in the United States. Moreover, blue-collar workers with terminal high school degrees might earn more than $75,000 a year,[16] and black workers might shift between blue- and white-collar work, making it increasingly difficult to define class in relation to occupation.[17] While education may not be the sole determinant for class belonging for Black Americans, in informal interviews researcher Shawn Ginwright notes that Black Americans use education to claim a middle-class status.[18]

For Black Americans, education provides mobility—professional, economic, and spatial—in relation to the black working class and/or urban poor. For members of the black middle class who live in racially distinct or racially integrated neighborhoods, engagement with black working-class communities through religious and civic organizations offers the black middle class refuge from racial discrimination in the white residential and work world as well as racial solidarity with other blacks.[19] Yet their mobility—preferably upward—remains a marker of the kind of "differentness" the black middle class claim in relation to the black urban poor.[20]

If mobility is what marks the black middle class, it is containment and isolation that produce the underclass. Building on urban ethnographies of ethnic communities by Chicago School researchers, sociologist William Julius Wilson suggests the black underclass could be characterized by concentrated poverty.[21] As a result of expanding civil rights legislation, he added, the underclass emerged from the out-migration of working-class and middle-class blacks as well as a decline in manufacturing, the suburbanization of employment, and the rise of

low-wage service work—leaving black men unable to support families.[22] Rather than out-migration, Douglas Massey and Nancy Denton contend the specific hypersegregation of black communities intensified economic dislocation in major cities in the 1970s.[23] The out-migration of economically mobile workers in black neighborhoods resulted in a ghetto, which is seen as a "reservoir of pathology and bad cultural values"[24] because those who assimilated into the dominant society supposedly took their good work ethic and culture with them.

Kelley argues that the assumption of the underclass as unskilled, out of control, and culturally void in the absence of black middle-class leadership not only ignores hybridity within black neighborhoods but also fails to account for the heterogeneity in black neighborhoods where one could find a range of professions as well as attitudes and behaviors on a single block.[25] In one court in Diggs Town, for example, the African American women I interviewed had professions that ranged from the self-identified stay-at-home mother and dry cleaner attendant to a nurse practitioner, and they vocalized disparate opinions about black female sexuality and sexual expression. Kelley similarly argues for a broader understanding of the black working class and/or underclass that does not hinge on isolation but one that highlights hybridity and heterogeneity. Because of this hybridity and heterogeneity, Kelley contends the underclass cannot be codified as a distinct economic class.[26] Class has to mean more than Marxian relations to production, and black expressive culture has to do more than reflect a cohesive underclass. In pointing to the ways the black middle class deploy mobility to differentiate themselves and use behavior to define the underclass, Kelley and others acknowledge the ways that class, like culture, is performed.

To suggest class is performed does not discount the way materiality structures how we experience our bodies within specific racialized and classed spaces, such as the black ghetto. A meaningful experience is constitutive of discursive relations.[27] Murray Forman provides a compelling analysis of distinct rap music produced in urban centers, such as Seattle and Miami.[28] While he argues that space matters, it is the *discourse* of the ghetto, the hood, or the street that allows rappers to claim authenticity via racialized class to perform place, to perform home. How else could we make sense of rappers such as Snoop Lion (formerly known as Snoop Dogg) and the Clipse performing the hypermasculine black underclass? Snoop Lion, for example, manages to retain his "hood" status on a celebrity reality show where he raps in the series opening that his family ain't the Huxtables. The cable audience is inclined to interpret his class (re)positioning in terms of the hip hop underclass rather than his real economic wealth, which exceeds Bill Cosby's fictitious black middle-class family.

When the Bronx-born college students Gene (No Malice) and Terrence (Pusha T) Thornton of the Clipse made their major rap debut, I was in graduate school writing about the cultural significance of another hip hop duo, Dead Prez, who claimed they were a mix between Chuck D's Public Enemy and the infamous West Coast gangsta rap group NWA. In separate interviews, the Thornton brothers, who rap about "grinding" (working hard or selling drugs), admit their impetus to sell drugs was to perform a street hustler lifestyle rather than to make money to survive. "We wanted to be the flyest and freshest," Malice said.[29] The two recuperate stereotypes of excess (ghetto-fabulous) where unemployed men and women siphon taxpayer dollars from the state to maintain lavish lifestyles in the ghetto. Paradoxically, this stereotype works against the very construction of the ghetto that is defined by lack. Performing hustlers in the "hood" in one music video, the Clipse sit in a recognizable Norfolk public housing kitchen and stand in front of a nearby strip mall where my family members style hair. It is familiar to me. The camera pans black girls stepping and jumping double dutch in a Norfolk ghetto street where the brothers perfect their cool pose with their Hampton Roads posse wearing airbrushed T-shirts picturing a murdered classmate. At once, my youth experience of hip hop in Diggs Park activates my own performance of home. I throw my hands up at a Midwest club to sign the letters V and A—identifying with a place where I no longer live but am able to reclaim through a display of the insider through the masculine performance of local hip hop street culture. Our mediated performances highlight the ways the discourse of the underclass works to produce hip hop.

Class performances of hip hop are gendered feminine as well. While women and men occupy the street and the club where hip hop aesthetics are honed, the women who enter these masculine-defined spaces risk losing respectability (read: class). Here, I recall the gender category of sistahs versus bitches defined in the documentary by the young black man J-Hood. In her canonical work "Policing the Black Woman's Body in an Urban Context," Hazel Carby examines the way black middle-class respectability is tied to sexual piety and restraint.[30] For black middle-class women invested in the "positive" representation of black women within larger white society, working-class black women gyrating to 1920s jazz in nightclubs reified the racist stereotype that all black women were hypersexual. While the nightclub can be described as a complex, contested space where black women assert individual desire, from the perspective of the black middle class, the self-gratification of working-class women thwarts collective racial progress. Carby contends that one of the projects for black middle-class women working with religious and civic organizations (and, I will add, the academy), then, be-

comes cultivating a discourse of respectability that ultimately operates as containment through surveillance of "loose" working-class black women.

That racial progress hinges on the *representation* of the urban black female body is a recurrent conversation in hip hop culture and hip hop feminism.[31] Carby contends the black middle class is preoccupied with the working-class black female body not only because it impedes collective racial progress but that class-specific body threatens black and white middle-class relations as well as masculinity under black patriarchy.[32] As mentioned in the introduction, the "video-ho" stereotype jumped from the rap music video onto the virtual white space of syndicated radio and cable television programs when Don Imus called college women hos. As students, some black women gain middle-class cultural capital, thereby securing the gender-class status as a lady who is worthy of black male protection under the conditions of black female respectability.[33] It is important to note one of the rhetorical strategies during the Duke lacrosse rape scandal was to recast Crystal Mangum as a student rather than a stripper to gain support from the local black community. Black America's outrage about Duke and Don Imus's remarks was about misrepresentations of black women in white spaces *and* about avenging the honor of black ladies. In any event, black cultural criticism about the media spectacles emphasized the impact of racial stereotypes in white spaces instead of addressing the ways controlling images help justify the continued marginalization of black women and poor communities of color.

Examining intraracial politics in urban communities, Shawn Ginwright contends that the black middle class frames social problems and sets abstract, culturalist agendas (e.g., moral panic about saggy pants) that may not address the immediate, materialist concerns of the very community it seeks to help.[34] Positing class-based issues in terms of race only, the black working class can be doubly silenced despite its hypervisibility in popular media and academic scholarship. The narrow emphasis on the representation of black women is one example. Today, hip hop—albeit a commercially viable street hip hop—is fully integrated into the dominant or white middle-class culture. The struggle by the black middle class to redefine hip hop is central to addressing the collective self-determination of "the race." Hip hop is repositioned as an evolution of the underclass that now must be policed as it moves out of the isolated space of the ghetto to white spaces where the black middle class interacts. Hip hop is policed through class—articulated through taste values and notions of respectability. Because the black underclass is supposed to embody bad taste, the political project for black people is worked out and through the marked underclass black body. This project is demonstrated in the documentary *Beyond Beats & Rhymes*, recounted in the

comments from Norfolk City Councilman Herb Collins, and echoed in academic literature explaining hip hop through the construction of the underclass. Hip hop is the discursive space where new formations of racial uplift are constructed. In the following story, I grapple with the multiple articulations of class. The two sections comprise authoethnographic excerpts from two summers in Diggs Park public housing where I take up class as the at-risk researched in 1989 and the within-group researcher returning "home" nearly 20 years later to explore race, class, and gender politics in hip hop culture.

MY HIP HOP HOME STORY: GOING HOME AND HOMECOMING

Students who strolled the resort strip over the weekend wore black pride T-shirts, chanted the popular rap song "Fight the Power" and wore colorful leather medallions in the shape of Africa.

THE VIRGINIAN-PILOT (1989)

Earlier, in front of the Kona Kai [motel] at 16th Street, about 100 people sat down on the west side of the street when a Jeep Cherokee, rap music thumping from its speakers, pulled to a halt. The youths broke into the now familiar chant: "Too black too strong." Suddenly, a contingent of about 20 state troopers in riot gear rushed the students, running down one young man and clubbing him to his knees before handcuffing him.

THE VIRGINIAN-PILOT (1989)

They [police officers] placed me inside a handball court that held about 50 other males. None of the detainees was given food or water. One corner of the concrete wall and fence was initiated as the restroom. I felt like an animal inside a pet shelter especially made for police officers. They would look you over and then decide that if you were "the one" they arrested. To be detained without explanation made me feel inhuman.

CHRIS REDDICK, AS QUOTED IN THE VIRGINIAN-PILOT (1989)

Go(ing) Home: Greekfest Race Riots and the Erasure of Class

A well-orchestrated Spike Lee joint could not have concocted a more volatile racial climate than what erupted on the Saturday of Labor Day weekend in 1989.[35] The well-off white folk who fled Norfolk's black urban encroachment after school desegregation and mandatory cross-town busing now faced an influx of black youth parading en masse along the supposedly white-only Virginia Beach streets. Manicured lawns leading to the beach strip posted signs saying "Go Home." For the thousands of college-goers who came from across the country to celebrate black fraternity-sorority "Greek" week, merchants refused to accept "black money" and placarded "No Greekfest Here" in their storefront windows. Police, poised on horseback and outfitted in riot gear, anticipated disorder.[36] After all, white America still reeled from the black rage fictionalized in the 1989 film *Do the Right Thing*. They feared the real thing.

Across the waters amid shouts of "Shoot them dead," reports of thousands of black South Africans wading in Addington Beach waters to defy apartheid headlined the world news that Saturday.[37] National news reported white hecklers jeering "Go home, you blackies" to other Brooklynites demonstrating in the predominantly Italian American Bensonhurst neighborhood. It had been the third time the parents of Yusef Hawkins protested the killing of their 16-year-old son by a white gang.[38] And while I could discern Brooklyn was no Norfolk and the Virginia Beach in the U.S. American South was not the apartheid of South Africa, the visceral hatred hurled at folk who looked like me on television was plain to see. In all these designated white spaces, we were not welcome.

By Sunday there was a citywide curfew in Virginia Beach. Hundreds of National Guardsmen and police scooped young black passersby into paddy wagons to a makeshift jail that the mayor said she did not authorize but approved.[39] Other city officials requested the ban of all alcohol—a request that could not be legally enforced but merchants who did not want blacks there in the first place acquiesced to. Already, members of the black and white communities blamed the escalating racial violence on the locals—or the looters and drunken revelers who were not "students." Other than locals and "trained agitators"[40] from the North, popular culture served as a convenient culprit. Lines from the recently released film *Do the Right Thing* echoed in the street and irreverent rap lyrics, such as NWA's *Fuck tha Police* and Public Enemy's *Fight the Power,* thumped from booming sound systems. No one locked arms to sing we shall overcome; young folk foisted clinched fists in the tense Sunday heat refusing to move. Public Enemy's *Fight the Power* became the Sunday soundtrack. Their subsequent song, *Welcome*

to the Terrordrome, referenced the Greekfest riot, and these songs would usher emerging voices from the hip hop generation in Hampton Roads.

The Greekfest riot was aptly characterized as a race riot, but until Sunday, when the papers and television news showed young black people being penned and pummeled by police with batons, few in Diggs Park showed concern. These were the Cosby kids who not only thought cash could trump color but believed their university Greek-letter T-shirts could shield them from the brute racism of a still-segregated South. These were the same Cosby kids I followed with adoration and disdain during summer camps at Norfolk State University, located three minutes across a bridge from Diggs Park. I admired that they made it—in some cases, made it out of the ghetto—and yet I loathed their look of pity because I had not. Years later, the Cosby kids and my high school mentor said they had to expose me to culture, as if I had none. I had been seen without class; I was under class. I had been forever lumped in with the local "looters" who ruined their celebration (of coming up and getting over). What the 1989 Greekfest riots revealed was the racial politics of the New South and the tensions between and about class—both of which I would have to navigate at college and as one of those collegegoers going home.

My first two-hour trip as a collegegoer coming home was not necessarily my homecoming. I had made a permanent detour from Diggs Park to a newly purchased gray ranch house directly across from the projects. My mother stood with arms akimbo in the screen door directing me to the driveway with her typical nod. I grabbed my bag from a friend's car, peered over my right shoulder to freeze-frame a fading picture of the redbrick enclave of Diggs Park, and proceeded, pressing my lips together—holding the weight of my anticipation—as I tiptoed across this new threshold. My eyes traced an imaginary rainbow colored by the one-class-shy-of-graduation Norfolk State University student paintings my father stroked in the corner stairwell between my bedroom and the bathroom. I had never seen his artwork arranged in one place—on massive, smooth, plaster white walls. I had never seen the I-told-you-so look on his face. This house-talk he dangled during my childhood had not been a part of a daddy's Diggs Park drunken dream. He delivered. He had made a death-defying deal with Uncle Sam to offer his life with a tour in Vietnam in exchange for a low-interest homeowner's loan that he would make good on the summer my family moved out of the ghetto.

Everything that looked different from Diggs Park seemed similar. The same alarm clock from Diggs Park woke my mother who, half-asleep, slipped into her black-and-white uniform and walked in the wee hours to await the same No.13

bus that dropped her off at the backdoors of a hotel where she worked since the day she wrote her caseworker to say thanks-but-no-thanks for the $13 book of monthly food stamps for a reported family of two. My dad dipped into his thermals and tattered overalls to do a full-day stint in a freezer at a nearby meatpacking plant where he was the union organizer. Our phone number—a number I've known since I scribbled alphabets—came with us, along with the sultry vocals of Frankie Beverly and the crackle of chicken frying in my mother's favorite cast-iron pot. When my mother turned the brass knob to my new bedroom to say welcome home, she had a crackle in her voice that seemed to take twenty years to formulate. And still, I felt like a visitor.

For most of my life, my identity had been tied to a physical place: the Diggs Park ghetto. The same evening I left the ghetto to live in a college dormitory, I overheard another first-year student say jokingly, "That's ghetto." Indeed, I had entered another space. The term *ghetto* had entered the linguistic terrain to refer to people without class. Norfolk State University summer camp counselors and my high school mentor tried to cultivate an uncouth, at-risk teen. They reminded me exactly to whom "without class" referred. Friends—even those who still lived in Diggs Park—said the word *ghetto*. I didn't get it. I asked my best-friend-since-kindergarten if she knew when the Cosby kids deployed the term, they meant us. She, and a host of others I probed over the years, emphasized the term *ghetto* did not necessarily mean black women from the so-called underclass; it could refer to any body that exuded uncouth behavior. But, a *body* had to be (mis)behaving. *Somebody* defined uncouth. Who were these people? What was ghetto? Who was ghetto? These were questions that I would have to confront when I returned home to talk about hip hop and the politics of class for African American women.

Homecoming: Diggs Town and the Staging of Respectability

> Racially subordinate women are "sexual primitives" and racially privileged women are "sexually civilized" in a society where race, class, and sexual orientation—and secondarily individual behavior—still largely determine whether a woman (who so desires) can pass as a "lady." Lesbians, prostitutes, "nonwhites," prisoners, and poor women are categorically excluded from the caste of civilized sexual beings and chimerical rewards of being ladylike—protection from social ridicule and sexual abuse.
>
> — JOY JAMES (1999)

*You got the sisters, then the bitches. Them bitches [pointing to women
walking in bikini tops and shorts at the beach] because you see how
they dressed. Look how they dressed. Sisters don't dress like that. Look
at that [ass]. I might go over there and smack it.*

— J-HOOD (2006)

*Just because you see me with these doorknocker earrings on, I might
have locks, or I might have on the tightest dress you ever seen in
America, that does not make me out to be no ho or no hoochie.*

— TARESSA, DIGGS TOWN RESIDENT

We some classy ladies.

— WOMAN IN BEYOND BEATS & RHYMES (2006)

Away, I experienced one form of class through a masculine performance of the
street by signing the letters V and A in nightclubs and spending days watching
representations of Norfolk's public housing on cable television music stations.
Music sustained a sense of place; it did not replace my yearning to be called
home. For days, I awaited the call from my best-friend-since-kindergarten to
come to her old court in Diggs Park to talk to a group of African American
women about hip hop. The day I received the call I was decked out. Outfitted in
a crisp white-tee tucked inside faded low-rise jeans draping flip flops that curled
like the bangle-sized gold hoops circling the sides of my face, I wore the futile
role of a hip hop insider who looked the part and had been part of the commu-
nity but still needed a voucher to cross the street. No performance or costume
could mask the fact that I was a researcher—a data miner no different from a
cop or a caseworker who was authorized by the state to pry into poor black folks
privates to survey and collect—and ultimately leave. Data miners carried their
outsiderness like the notepads, briefcases, and manila file folders they fumbled
trying to find a doorbell on a redbrick wall that never existed. I remembered. No
one could be trusted with home truths, not even Aisha. The truth was, I took my
higher ed "ticket" and left Diggs Park, and I would have to be remembered or
rejoined into this community by invitation only.

After the call, I ran out the ranch house. I passed by my old home and the one-story church house where at least one day a week I practiced what I thought was a classy kind of ladyhood by wearing plastic pearls, pressed hair, and Payless pumps. I approached a row of renovated apartments with weathered white columns and fenced-in porches, which was renamed Diggs Town under a local urban renewal project as if to whitewash fifty years of abject poverty in the all-black public housing complex. The screen door flung open. Children ran out the house giggling, and I could hear the thump of double-dutch ropes, the rusty growl of a lopsided merry-go-round, and the smack of my first kiss. It was the Clipse video relived. A young woman named Nicole lodged her right arm and leg in the door to prevent it from swinging shut, cutting off my daydreams. She greeted me, the welcomed visitor.

At Nicole's home I crossed a familiar threshold of my past. Peeling decades of cinderblock paint, I followed a sandy woman wearing a pair of nude pantyhose, a prewig stocking cap, and a filled-out lace-lined black slip. I faded through the wall next door where I watched my girlfriend and my younger self huddled under an upstairs bedroom window fanning fresh coats of red painted nails, pretending to be that sandy woman. When the sandy woman looked back at me, I looked over to the new residents sitting on two facing sofas in her old home, and I confronted past memories when both women from the adjoining apartments were marked as "those women" in the Diggs Park court because of the independent black womanhood they opted to represent: one hyperfemme and the other butch—and both defiantly visible. I was drawn to them then and remembered them now in Nicole's living room where living memories sat next to the women rapping about new representations of black womanhood in popular culture.

The living room was barren—deliberately emptied of furniture except for an aluminum folding chair and the facing sofas. Nicole and Renisha fumbled with throw pillows, Taressa recrossed her legs, my best-friend-since-kindergarten steadied her daughter on one boney knee, and Donna slicked her ponytail as her daughter, Latina, raked her wrap with her manicured nails. I plopped on the cool linoleum floor tugging at my belt-free loops so my junk would not spill out the same way my notepad and recorders had from my bag minutes earlier. We all sat beneath the radio, which seemed to be aware of its importance in the room. It sat elevated in the corner, blaring corporate jingles, community announcements, and male rapper rants. We attempted to talk over it; when it was powered off, its presence was still pronounced because we turned to it, talked to it, pointed to it as if this black box had recorded something about our black selves that we womenfolk could not flesh out in front of one another. After all, it was black

radio's cultural representations of the sexually promiscuous hip hop hoodrat, chickenhead, ho, and hoochie rather than my insider-status with Diggs Park that brought me back there in the first place. Despite the physical emptiness, the radio consumed the sonic and symbolic space in Nicole's living room.

The hip hop representations the radio repeated had character(s). The black female ensemble collectively redefined gendered stereotypes of the so-called black underclass and recast themselves as the protected class of respectable women through education, work, motherhood, and romantic relationships. For example, the group defined a hoodrat as:

> Dirty. In the hood. Don't care what they put on, what they do. They go get their hair braided just to take it all out looking like Buckwheat.[41] [They] don't want a job, just sit around, ride the bike asking for dollars and a cigarette, or they might want a burger. [They] just chill in the hood.

The hoodrat was a classed and space-specific gendered body that differed from the chickenhead, video model, and hoochie stereotypes by style and sexual impropriety only. The latter characters bartered sex for money and had sex for pleasure and male attention. From the vantage point of Nicole and the group, "those women" were not confined to hip hop media representations but were real female bodies inside and outside the ghetto who were responsible for their individual experiences of harassment and discrimination at school, work, and their occasional visit to a nightclub. And as they talked about taboo sex acts, distasteful personal style ("Buckwheat" hair and low rise jeans), and labor, the term *wifey* emerged as a gender-specific hip hop identity that each member claimed. I detested the term and the conditions of polite femininity it implied. The women assured me that *wifey* was a "positive term for somebody that stays at home and takes care of the kids as a parent and mother. No ho'ing. Don't club too much. Goes to respectable clubs with gentleman." While they marked distinctions between the hoodrat and the hoochie and clearly defined the behaviors that characterized the wifey, I could not distinguish their words from Norfolk City Councilman Herb Collins or J-Hood, who talked about the sisters and the bitches in Hurt's documentary. On the linoleum floor I shrank with my dreadlocks, tugging my newly detestable low-rise jeans with a closed notepad beneath the black women and the black box feeling like an expatriate excommunicated from their sacred hoop for the same reason I was brought to summer camp years ago: I was without class.

CONCLUSION

I (re)visited home to recover my hip hop past housed in the Diggs Park projects of my youth. I (re)visited home to uncover new yet familiar stories that would allow me to talk about hip hop outside its overemphasized aesthetics and its overdetermined social science construction of the underclass. *Beyond Beats & Rhymes* and local news reports about local black youth attempt to explain culture through class. Hurt's work invited me to explore my lived experience in Hampton Roads as a member of the hip hop generation. From Hurt, I was able to recall how the politics of class guided the way I navigated "homeplaces" as the researcher/ed. By returning to the physical place of home through memory, group interviews, and media representations, I penned a parallel narrative of my cultural and intellectual homeplace of hip hop that was as nuanced and contradictory as my life story.

Class centered both narratives about hip hop. The so-called underclass construction that sutured my identity and "real" hip hop in its heyday had come undone by the new millennium when elements of hip hop became subsumed by corporations, when "youth" aged and later sought to sanitize and legitimate hip hop in hegemonic sites of power such as political and educational systems, and when hip hop's early registers (the ghetto) no longer resonated with practitioners and audiences as *the* moniker of (racial) belonging. I was left, and hip hoppers were left, with the task of redefining hip hop, which was in part the task of redefining the social identity of a racialized class in the post–civil rights era when class distinctions worked to undercut the unified, collective voice of "the race."

To implode the seductive master narrative of "the race," I highlighted hybridity, performativity, and intersectionality as a within-group researcher and a hip hop insider. I experienced class hybridity as the researcher/ed who was once at-risk in the projects and who was now an upwardly mobile class climber in the ranch house and ivory tower. I could be part of an underground hip hop community by performing the street-bound black masculinity away from "home" while being excommunicated at "home" in Diggs Town by a group of African American women who collectively rendered me without class (ghetto) because I rejected the term *wifey* and the conditions of black female respectability that accompanied it. Returning across the street to the ranch house to complete my ethnographic write-up, I looked left to the black church, then right to my childhood Diggs Park apartment to revisit that moment on the linoleum floor in Nicole's living room. That day I thought I lost hold of my past because of my

present dislocation in a place that still defines me. As the rug was ripped from under me and all my assumptions about race, class, and gender spilled out on the floor like my notepad and recorder, I was forced to rewrite my life story from a vantage point other than the old skool hip hop vanguard—from the ground up, as it were. On the floor, I found a many-sided lens of class, my diasporic optic, which has helped me see that the homeplaces I longed to revisit have been a part of the culture's living memory that we are now beginning to tell ourselves whenever we recall the dynamic ways we live out and live through our multiple identities and worlds as members of the hip hop generation.

CHAPTER TWO

The [News] Wire:
My Life Script[ed]

BACKSTORY: I DELIVERED A WEEKLY RECORDING OF SIX FEET UNDER TO A FRIEND who inquired whether I happened to dub the Sunday debut of *The Wire* too. I said no. I had no interest in watching drug wars for entertainment. In 2002, HBO sandwiched black criminality from *The Wire* between the white ones in *Six Feet Under* and *The Sopranos*. Early buzz about the Baltimore drama seemed to satisfy a kind of "anthropological fascination"[1] for a middle-class cable consuming audience. Ghetto realism, manufactured by the appearance of actual residents and public figures, made watching the fictional lives of poor people another form of surveillance similar to the kind performed by police in the series.[2] *The Wire* felt too close to home. In my college storage chest, I managed to neatly pack memories when I peeped out my parents' bedroom window to watch SWAT team spidermen scale our redbrick wall under floodlights where they met cops with a battery ram amped up to break down a door and break up a family during a midnight drug bust. To get by, I had to create some emotional distance by putting away some stories and folding friends' obits in a file folder. If I watched *The Wire*, I could unravel.

News about the prime-time series set in a mid-Atlantic housing project made me search for news stories about Diggs Park during my high school years (1991–1995), when depictions of the so-called inner city menace became popular in entertainment and news media. I copied direct quotes from the digital archives of *The Virginian-Pilot* newspaper. I reconstructed my life script from the ones reported in the newspaper. I worked within the representational framework of

"the real" by using direct quotes at the same time working against it by using performance, which abandons chronology and notions of objectivity. The performance piece invites readers to consider the value we place on narratives produced by media organizations and by individual people. By (re)searching myself from the news wire, I was able to see how I—as the researcher/ed—was represented during the prime time of my life.

Leading Roles (Listed in Order of Appearance)

LaDonn McDonald...Junior high school crush
Robert Brown Big brother on my block who shared my asthma pump
Calvin J. Outlaw ...Diggs Town homeboy by association
Calvin Kelly.. "Cool pose" big hearted bully
Officer Richard "Pac-Man" James ...The State
City Councilman Herbert Collins..The State
Anthony Crish...Danny DeVito–like insurance agent
Former Virginia Gov. and Sen. George F. AllenThe State
Andrea Clark...........................Spiritual othermother and community organizer
Yolanda "Tasha" Scott... model fly girl

I

Late one night in mid-October, a 17-year-old Lake Taylor High School student
and his buddies drove to East Ocean View
to buy a handgun. It wasn't difficult. In a convenience
store parking lot, the student scored
a .38-caliber Colt Cobra revolver for $45—
about one-tenth its value in gun stores two weeks later, the Colt was one of two
guns confiscated by police.
during an investigation of the Oct. 26 shooting of a teenager
at Military Circle Mall,
a guy came up
and[3] when 15-year-old LaDonn McDonald bought his Patrick Ewing sneakers,
he didn't think
it would put him in danger.

but Friday evening, McDonald,
a student at Lake Taylor High School,

became part of a growing list of Norfolk teenagers
hit by robbers
for their high-priced shoes
or sports
jackets. McDonald was abducted,
kicked, then shot
with a shotgun
—all for the $70
shoes
that he thought
would make him
stand out. In a crowd,[4] Robert Brown said he was impressed
by the big guys
with their money,
gold jewelry
and expensive clothes.

I wanted to have that, too,

he said so
at age 14, Brown went into business for himself,
earning $250 a night selling crack

Cocaine in Diggs Town. Within Two years,
Brown was thinking
of dropping out
of school and making a career
of drug dealing. Brown is now
17, a high school freshman trying to turn

his life around. He has walked away

from drugs[5] this week,
Dorothy Brown cried
again
for her son,
Robert, the victim of an unsolved murder
nearly two years ago. Then
she moved ahead

with plans
for Friday's cookout for neighborhood children. I do it because of Robert
and
all
the other young men. She said,
> *I don't want what's happened to Robert to happen to the other young men*
out here. The cookout, held in the courtyard
behind Brown's apartment
in the Diggs Town neighborhood, celebrated[6]

a 15-year-old boy
was shot

by a teenager

in the Berkley neighborhood, police said the 15-year-old,
Calvin J. Outlaw of the 700 block of Johnson Ave., was shot
in the lower left leg and abdomen
with a handgun early Monday, police said he was taken
to Sentara Norfolk General Hospital, where he was listed
in serious but stable condition Tuesday evening, a hospital spokeswoman said
Outlaw, a Norview Middle School student,
was shot
about 3 A.M. Monday
in the 1500 block of Berkley Avenue.[7] In 1992,
authorities touted Calvin Outlaw as a star
of the Street Smart program, which helps youths
with drug convictions
straighten out their lives. The one-time crack dealer was president
of his Street
Smart class and sold more
Street Smart T-shirts than anyone else. He was befriended
by a local auto dealer who made him her special project
and gave him a job
as a lot attendant. The aim of the Street
Smart program is happy endings.

Calvin Outlaw's story has no happy endings[8]

II

[In] Diggs Town
residents pleaded with police brass
Thursday to end the alleged racial and physical harassment
by some officers that has marred
the city's anti-drug program in that neighborhood
in a two-hour meeting
dubbed a reasoning session
by a civic leader, about 25 residents detailed allegations
of unwarranted searches,
beatings of young criminal suspects,
reckless driving
and the endangerment of children
by officers.
they said
the incidents occurred[9] in the school day
ended in panic and bloodshed
Thursday as three students boarding a bus
at Lafayette-Winona Middle School
were shot with a handgun
and others ran screaming as the gunman fired
into the crowd neighbors and students alike said they had feared such violence
at the school all year. The school is in an area beset by gang violence
and
gun
and
drug
sales.

A friend of Calvin L. Kelly, one of the wounded teens,
saw four alleged members of a youth gang approach

Kelly. They were kids[10] in Diggs Town once

[when they] called Officer Richard James "Pac Man" because he was
such a fast runner and could chase
down bad guys
like the video game character.

That was eight years ago.

But recently, when James returned to the public housing community to set up
a mini-station in a vacated apartment,

<div align="right">*someone remembered*</div>

his former nickname
and yelled
hey, Pac Man.
James, 31, is one of eight Norfolk police officers and two supervisors
who recently volunteered[11] two

suspects have been arrested in connection
with the fatal shooting Wednesday night
of 28-year-old Ronald G. Bonney Jr.,
Police said. Bonney,
of the 800 block of Morgan Trail in Virginia Beach, was found
in the 1500 block of Vine St. in the Campostella section.

He died a short time later

at Sentara Norfolk General Hospital. Calvin J. Outlaw,
18, of the 1700 block of Greenleaf Drive was arrested Friday night
and charged with murder,
attempted robbery
and two counts of using a gun[12]

during his trial last month,
prosecutors and witnesses characterized Jean Claude Oscar
as a swaggering, cold-blooded crack dealer who tortured
and murdered two
people after a drug ripoff
a year ago.
Stick around, fellas, Oscar had told a packed house during a surreal night
in Norfolk's Diggs Town. I'm going to show you how we do things in New York
when people f—— up. Oscar's victims were burned with a hot fork and shocked
with a live electrical cord
before[13] tensions

in a neighborhood targeted by the city's new anti-drug program escalated
this week
into a melee between residents and officers assigned to drive out drug dealers.

The Wednesday incident was followed a day later by complaints to the NAACP
and the Police Department's internal affairs division
on Thursday 11 residents of the Diggs Town public housing community
in the Campostella section alleged that two teenagers
were verbally and physically abused by
two[14] narcotics officers

arrested 20 people over the weekend in three undercover drug operations,
police said. The stings, called reversals,
involved police who posed
as street-level drug dealers. Most of the alleged USERS WERE CHARGED
with attempting to possess

cocaine or heroin, police said.

III

On Saturday[15] Diggs Town will be the first public housing community here
to be redesigned in hopes of
blending it into surrounding neighborhoods
and improving security.
Norfolk Redevelopment and Housing Authority officials on Monday unveiled
the new look for the 30-acre, 428-unit Diggs Town.

> *It's a chance to change*
> *the image of a project*
> *and test how important that is in*
> *changing people's lives.*[16]

We have developed a subculture
that's not acceptable, Collins said Tuesday.
These people
are the MOST UNDEREMPLOYED,
the MOST UNDEREDUCATED,
the MOST UNDERCHURCHED,

they are
The MOST UNDERDISCIPLINED PEOPLE
In our society.

Collins nearly got caught in a drive-by shooting
in Diggs Town public housing in Campostella Thursday at
about 10^{17} city officials who tout PACE
as a success point to the 10 percent
decline in crime
in three targeted neighborhoods.
but
some residents say they can't tell
the difference.

A longtime Diggs Town resident, who asked to remain anonymous,
said PACE has moved drug dealing a few blocks away from her home.
Drug activity has decreased tremendously
right here
in our neighborhood, the woman said. But when I go to the store
up on Vernon Drive and Berkley Avenue,

I notice[18] less than a decade ago
it was a nightmare.

Drug dealers plied their trade and hookers made dates in plain view of children.
No one,
not even armed police officers, felt safe
at night. Diggs Town, circa 1989.

The third largest public housing project in Norfolk,
with more than 1,400 residents, was arguably the city's most violent. The
 community
may have reached its nadir one day
in February
that year, when
Anthony Crish, a [white] 60-year-old insurance
salesman was shot
and[19]

Gov. George F. Allen
walked through a public housing neighborhood Wednesday,

sat in the living room of a longtime resident
and even answered the telephone
in the tenant management office—all in the spirit of welfare reform in Virginia.

I think we should be obviously on the forefront of welfare reform, Allen said
after visiting the 422-unit Diggs Town community during a morning drizzle.
As for devising a plan, Allen is leaving that to the Governor's Commission[20]

Abell Mack's small grocery store near Diggs Town could lose more than half
its patrons if the federal government reduces the number
of mom-and-pop stores that can accept food stamps.
It's crazy, said Mack,
56 wondering where the poor people in his Chesapeake/Norfolk neighborhood
would shop.
I'm the only store around here,
and they have to buy everything to last them

IV

For a while,[21] City Councilman Herbert Collins refused Monday to retract
statements decrying a subculture of tenants in public housing.

I'm not going to retract a thing, Collins said Monday. As a matter of fact,
I'm going to add to it. Collins said
he observed too much trash
on the streets and sidewalks of four public housing neighborhoods[22]

Norfolk's Southside will hold a celebration of unity and pride
This weekend beginning at 10 A.M. Saturday, streets
in Campostella and Berkley will showcase
the second annual "Restore The Pride On The Southside"
Parade Members from civic groups, churches and businesses have worked on
the event for months. This parade is a symbolic and functional expression
of our hopes
and needs,[23] [and]

Andrea Clark
has asked for
RIGHTEOUS POLICE WORK
in the Diggs Town public-housing project where she lives.
On April 3, police launched a second round of drug sweeps in the crack-infested
 project as part of PACE, Norfolk's Police Assisted Community Enforcement
 anti-drug program.
But while attempting to bring residents long-sought relief,
PACE's increased police presence
has brought more fear
to Diggs Town. In a recent meeting, Ms. Clark,
president of a tenant organization[24] [and] Congress
has public housing in its sights, and the debate
over whether funds should be drastically cut moved to Diggs Town
on Monday when a top federal official dropped by on
a quick tour through Virginia,
HUD's acting deputy secretary, Dwight Robinson, visited
the award-winning public housing project in Campostella, recently renovated
with $17 million in HUD money.
The 400-home development now features Jeffersonian-style front porches
with white columns,
new roads,
spruced-up.[25]

 Somebody had to do it.
On Monday, Yolanda 'Tasha' Scott became the first

in her family to graduate from high school.
Scott, 18, lives in the Diggs Town public housing community. She saw her sister
drop out in
the 11th grade
when she became pregnant.
Her brother, whom she considers one of her closest friends,
dropped out in
the 10th grade.
After getting involved with drugs.
He is now
in jail. My brother,
he let my mom down[26]

Crime, corner drug dealers and unwed teenage mothers
gave Aisha Durham strength,
tenacity and determination to want a better way of life. In an age plagued
by high school dropouts,
Durham, 18, has beaten the odds. She graduated
with honors last month from Lake Taylor High School. She finished
with a 3.27 grade-point average
and expects to study journalism when she leaves
for Virginia Commonwealth University in the fall.
Lake Taylor High teachers awarded her the English Award[27]
[while]
five black students, ages 10 to 14, talked football,
grades and girls and guns.

LISTEN UP,
LISTEN UP,
LISTEN UP,

(Coach) Hassell said in staccato,
trying to keep the group
focused.

Are you scared?
when you hear shooting?

I ain't scared, Jay,
a tall 14-year-old, said with a shrug.

You're used to it?
Yeah. . .
As long as I don't get hit.[28]

Chris Meissel had heard about the drugs and violence

when he arrived in 1991
at the Diggs Town public housing neighborhood
to teach
at a promising new preschool.

but
the reality
didn't sink in until he heard it
from a 4-year-old girl.
Her mother, the girl told Meissel, had instructed her to hit the deck
whenever she heard pops—
the bullet sounds of a gun.

It really hit me,
Meissel recalled.
I realized then. . .

so many of these
kids.[29]

Between Us

A Bio-Poem

I

I got two braids, a dozen neon bangles and a pair of plastic pink
jellies jumping across the hot concrete cracks behind
Dee-Dee doing damage
to old Cadillac passers-by appraising P.Y.T.s* in
denim shorts hiking up
to the down
town
Granby Plaza.

At a pit-piss-stop at a bar up the block
from Grandma's house I guzzle
ice-cold cups of Coke courtesy of the balding black bartender
who tends to talk with his eyes like the cook from the Chinese joint
dishing out free and greasy egg rolls as my eyes roll
from the kind of out-of-place grin
mamas warn girls
to get away from.
But, Dee-Dee nudges me
forward, I muster a thanks,

* Pretty Young Things

look down,
ball up
feeling corrupt like
the dollar bill crammed in my hand for keeping quiet
when
she followed her
boyfriend to the backroom to talk
for a minute. I kept quiet
when
she floated around
the corner scouting a fix, my eyes fixated on her missing tooth,
her bruises,
her...*baby girl,*
Don't tell your mama
I am here
in Lynchburg covering night cops watching
Oprah on one of her "O"ccasional light bulb moments,
the phone rings,
Mama says,

 Dee-Dee dead

and, I got this
two-ton cement block
of guilt weighing on me. I had to
white-out her black body
long before the detectives outlined the murder scene with chalk.
long before the drugs,
I just prayed
to let us be (re)membered in our familiar selves
before the hail
(of)

 II

Secrets
at Grandma's house
Uncle Willie slouched in the sticky pear vinyl kitchen chair
his oily hands sliding a cheap pipe between the empty space where
teeth were supposed to be.
He

patted his right thigh for me
to sit right there
to listen to a lisp-full of small talk of nonparticulars until I
couldn't stand sitting NO MORE. He fumbled
with his weathered brown leather
wallet to barter some change for some sugar. And I got
some stinky slobber of whiskey syrup slathered over my cheek
for two quarters
I kept quiet
about the kitchen, until my cousin
Kesha pulled my earlobe to slip me some
fresh off the grapevine gossip, and
without looking into my eyes
she got a whiff of everything that went on inside.

We erased it,
laughed it off,
ran up the block to the frozen-cup-candy-ice-cream lady to O.D.
on some sugar, to rid me
of a clear case of Cooties
caught
at Grandma's house. He slid through the cracks
in the crowd awaiting the one-time family ride in the limousines
a half-hour before Dee-Dee's funeral. He called Kesha's kid
to the kitchen.
Michael could not creep a half-step to the corridor
before all the cousins could hear
Kesha swearing,
NO MORE
silence
in the back of my head,

III

In the back of my kitchen,
I called her out.
Slammed my two cents on the three-legged table, picked up
a handful of clothespins to hang her
should-of-could-of-would-ofs out to dry

like the dingy white cotton draws she didn't want
her Christian neighbors to see.
and I put it out there,
in the open.
I came home from one high school second-wave feminist class,
turned into Frankenstein to attack the nameless black iron maiden
who breastfed me
with the take-no-stuff-spitfire
I hurled at her, the venom
she concocted for me so I could learn to fend for myself
in this poor-black-woman-hating world. She stands
in her faded flower housedress curling
Over the steel sink sinking
in a wail where my tears are still frozen.

I am good too,
She said. For the first time I saw my mother
frying fish and chicken making ends meet, raising
funds for school field trips, for better clothes, for better days,
for silent nights, after
she hosted the absolute last Tupperware-lingerie-dance-card party,
still standing
all week working for no pay in my elementary school PTA,
doing customer service
at a hotel overworked, underpaid and looked past for promotions,
still standing
in the kitchen, hot combing, jheri-curling, perm pressing
Black heads before the start of the work-school-week.
still standing
to do it all in-spite of
my apparent Ms. Fortune to have mistaken her
for some kind of Mary,
Superwoman, or Sojourner Truth. I am
Your mother, the one
who can save you from yourself.

IV

On the block
Tims* get scuffed, white tank tops get tucked
inside name brand boxers bulging from
sagging blue jeans too small for a hustler's big time dream
to live out or out live
the ghetto. Old winos
at the corner store
warn brazen black boys, it's a crap(s) game. Fools
rush in love
coaxes the boy-daddy to slang in the wee hours to try to buy me.
On the bus,
I can't escape him even as my teeth tear
his skin. Pressed, he slammed me against the kitchen door
for refusing a tongue kiss, I see him eight years earlier
over me, against a wall under a back-porch light showing me
his sure thing
spreading his legs, his tongue poking perpendicular to tattooed arms
cutting through 90-degree heat,
the panting K-9 nosing up his inner thigh, and
Officer friendly makes
a fool
out of him, ordering him to unbuckle and bend over
to check his black ass (for) crack. In front of a gang of on-
lookers, the boy-daddy pulls his head up, fighting
his frown for a half-smile to show all of his boys
The Man
didn't break him down

V

On the block
U.S. home girls huddle
to talk crap and take shots of cheap wine to chase
the Uncle Willie boogiemen and the 40 oz. spirits that haunt us.
we drink for an excuse to cut a fool

* Timberland boots

to be the 13-year-old girls we really are. We sit around retelling the
"remember when" stories
so many times they turn into project folklore. We camp out
on the block like it is our private pajama party. We dig
backyard dirt and sift for that solid rock
to chalk an elaborate hop-scotch designed
purposefully to take all night to
play. We promise
one day
we'll get over

those days
when
streetlights come on
and Niecey don't have to rush home
to watch JJ and Demonte
when Mrs. Joanne signs up for another night nurse
shift duty,
when Meeka don't have to throw some
beans, franks, bologna, or oodles-of-noodles
on the stove for her sister
when Ms. Tee wants to be Ms. M.I.A.
When we don't have to hunt down
Trinia's daddy at the bootleggers because we know he'll blow it all
on brandy in a heartbeat.
In ten years we'll retell these stories
like we heard them for the first time
on cell phones on free-night minutes 900 miles away
where some blackgirl on the block
outside the kitchen at Grandma's house
in her two braids, bangles, pink jellies
can eavesdrop, and
pick up the ends and outs
and learn to leap
'cross cracks.

(Re)membering the Homegirl

Textual Experience

TEXTUAL EXPERIENCE (RE)MEMBERS. IT IS AN ACTIVE, INTERPRETIVE PROCESS OF bridging lived experience with living memories embedded in words, acts, objects, or sounds to generate temporal, plural, partisan, and partial meaning that is filtered through a historically produced subject or a situated speaking position. It hinges on interpretation, interaction, and relationality. Part 2 places the popular performances of blackness with Queen Latifah and Queen B(eyoncé) alongside representations of other women of color from the hip hop generation. As a form of interpretive interactionism, I emphasize experience rather than the term analysis to bring together the researcher body with the researched (textual) body to make explicit the interpreter role of the researcher and to highlight the performative act of "reading culture" as part of an interactional, ethnographic enterprise because meaning-making requires reflexive researchers to engage with the self and/as the other through shared living memories. It is the interaction, the relationship that activates what we call "text," and it is the interpretation that gives it life.[1] More than a qualitative method to decode, discover, or demystify, textual experience is a political project that aims to support marginalized bodies of knowledge and to challenge systems of power in order to transform hierarchal relations of being.

I reconfigure the body in the introduction to *Paper Voices*[2] to describe textual experience. Stuart Hall's three steps or guidelines to read text can be reworked to describe the interaction of bodies: the full soak, popular assessment, and contextuality. He recommends the researcher initially absorb as much as possible through what he calls a "long preliminary soak."[3] Larry Grossberg elaborates on

this process by adding that a full reading encompasses a critical analysis of the content, structure, attitudes, values, and assumptions of the text.[4] For example, in chapter 5, I explain how the black-and-white vacuous setting and seemingly one-take recording constructs the hip hop aesthetic marker of "the real." The audience is invited to ignore this marker when Beyoncé brandishes her actual wedding ring in her music video performance of Sasha Fierce in "Single Ladies." Her open disguise is managed in the album photographs and dual music videos so she can maintain her image of the respectable black lady while "playing" the virtual freak. There are multiple moments when Beyoncé as the "real" lady and Beyoncé as Sasha the stage(d) freak converge. Some convergences are deliberate, using choreography and costuming, while others are accomplished by position-ing her body within and against her dancers and broader discourses about black female desirability. A full reading of Beyoncé's real-staged body requires the re-searcher to negotiate the hegemonic elements of the text as well as the lived ex-perience that the interpreter brings to memories encoded in her performances. The soak is perhaps the most visceral level of knowing. It is the ethnographic component of what has otherwise been understood as a text-based method. It is the step that initiates the interpretive process.

After performing a full reading, Hall suggests the researcher consider why the word, act, object, or sound is popular and then place it within its cultural and social setting.[5] Latifah and Beyoncé are bookends to popular brands of feminisms associated with women of color from the hip hop generation. The "pro-woman" black female hip hop icons are popular because they can perform difference and a type of subalterneity for a pop culture–consuming audience familiar with nar-ratives of postrace and postfeminism, which employ strategic representations of "positive image makers" such as Latifah and Beyoncé in entertainment me-dia to show that we have achieved actual race and gender parity.[6] Latifah and Beyoncé have transcended their early hip hop and soul music affiliation, which is supposed to signal that the two can transcend race too. Put another way, their bodies have the ability to be marked and unmarked when necessary.

At times, both queens actively construct these representations. Film schol-ars examining race suggest the early trappings of racialized representations are inescapable. Televisual and cinematic productions rely on a historical memory of the mammy and hot mama to make Latifah and Beyoncé not only intelligi-ble to mainstream, majority white audiences but also to minoritized ones in hip hop culture by remixing the colonial constructions through the dualisms of the queen/ho and the lady/freak. In *Reading Race*, for example, Norman K. Denzin suggests both visual and vocal excess became central to a racialized perfor-

mance vocabulary seen in costuming, performance style, and musicality in early cinema, and this vocabulary forms familiar tropes to interact with blackness in the films *Bringing Down the House* and *Chicago* and the music video "Single Ladies."[7] The race-gender shorthand reworked today has the potential to undercut what could be an "empowering" and critical performance, especially from the two musicians known for woman-centered work. A part of symbolic work of postrace, then, is to offer audiences seemingly progressive images and scripts of racially marked bodies that appeal to hip hop sensibilities but ultimately work to reify the racial status quo.[8] In part 2, I wrestle with identifying the possibility of a hip hop feminist media text while understanding how racist media memories make up spectacular performances in popular culture.

Along with addressing interpretation and interaction, textual experience relies on relationality. Ella Shohat recognizes a feminist of color project as a "situated practice in which histories and communities are mutually complicated and constitutively related, open to mutual illumination," and relationality serves as an approach to explore "dialogic encounters of differences" that enables me to see how multiple performances of black womanhood play out in popular culture and everyday life across social class.[9] One of the reasons why I place chapters about spectacular bodies between those of ordinary black women is to illustrate how these performances sometimes serve as a stand-in for all black women and stand in-between black women (re)membering each other as part of an interdependent, politically defined group. Across each section, I show how class performances rehearsed in popular culture become ways for wealthy, middle-class, and working-class women to present authentic blackness and respectability. Relationality—understood in the placement or sequence of bodies, memories, or experiences—reminds the interpreter that the interaction comprises shared moments and shared meaning between bodies. Ultimately, interpretation, interaction, and relationality make textual experience a part-ethnographic one that can flesh lived and imagined reality.

From Hip Hop Queen to Hollywood's Mama Morton(s)

Latifah as the Sexual Un/desirable

LATIFAH[1] IS A HIP HOP ICON.[2] SHE IS PART OF THE FIRST GENERATION OF RAP superstars with a distinct aesthetic via the music video to ride the cinematic hood wave of the early 1990s and to presently carry major motion pictures and television series that depend less on ghettocentricity and more on an urban hip hop sensibility that Latifah and her black male counterparts Ice Cube, Ice-T, LL Cool J, and Will Smith successfully translate to a wider audience.[3] Hip hop culture gets read through blackness, which is inscribed with racist ideologies of deviant black sexuality.[4] In mass media, both black women and men represent a racialized group with uncontrollable, animalistic sexual appetites.[5] Physicality, movement, dress, and language become ways to talk about deviant black sexuality as well as hip hop culture.[6] It is through the lens of hip hop that the black body, and the black female body especially, is visible in the public imagination. Most visible is Latifah, the self-proclaimed Queen of Hip Hop. With a career that spans more than two decades, she represents the maturation of hip hop culture from the margins to the mainstream, and her music career is credited with developing hip hop feminism, or at the very least a feminist and womanist aesthetic in hip hop culture.[7] All good? Not quite. In this chapter I explore racialized discourses of the black female body that frame Latifah in two blockbuster films and discuss the ways her most profitable movie roles work against her celebrated rap persona in hip hop feminism.

Latifah is one of the most talked about women in hip hop culture. From her two self-titled talk shows and her womanist lyrics to her endorsements with major plus-sized clothing labels such as Curvation and Lane Bryant, Latifah's body is

taken up in popular culture to challenge hegemonic constructions of beauty, femininity, womanhood, and blackness. In the academy, she is aligned with complementary and often competing discourses about race, gender, and sexuality, such as Afrocentrism,[8] womanism,[9] black feminism,[10] black lesbianism,[11] female masculinity,[12] gangsterism,[13] and hip hop feminism.[14] Latifah has identified as a womanist and an artist whose work is woman-centered rather than a feminist—a debated political identity among black women in popular culture and the academy.[15] She is also constructed as queer because she has eschewed hegemonic representations of straight black femininity in her rap career and early acting roles. However, the Queen has positioned herself outside this space by asserting heterosexuality by claiming in *Vibe* magazine that "I'm not a dyke"[16] and by clarifying that she did not come out at the 2012 New York gay pride festival.[17] The memoir writer[18] who has often refused to talk about her personal life used a *Chicago* promotional press interview to suggest her future husband would have to buy a bigger wedding ring than the one she bought herself.[19]

These contradictory and complementary interpretations of her interrelated personas make Latifah an important celebrity to explore gender and sexual politics. Gwendolyn Pough contends Latifah has the ability to "bring wreck" or to command attention in the public sphere to counter the stereotypes defining black womanhood.[20] In the 1993 song "U.N.I.T.Y.," Latifah does three things: She skillfully reclaims her black female identity apart from the black bitch and ho stereotype within hip hop culture, addresses the community impact from physical abuse and the real life consequences for individual black girls performing gangsterism, and intervenes in the dialogue between the sexes by affirming community-based problem-solving.[21] The chorus commands listeners to love black women and black men to infinity. This song and her body of work in rap music make up a part of women's collective hip hop memory.[22] Since that 1993 Grammy Award–winning rap song, her successful ventures in multiple media genres have increased her visibility in the academy and mainstream popular culture. Yet it may be the multiple ways her black female body can be read that has propelled her from a hip hop femcee to a pop icon.

Latifah's iconic body in *Bringing Down the House* and *Chicago* appeared when debates had resurfaced in the public sphere about black female representations in hip hop. The debates pitted the once-Afrocentric Queen Mother[23] rapper against herself as the minstrel-like buffoon in the 2003 comedy *Bringing Down the House* and the blues woman feminist prototype in the 2002 musical *Chicago*.[24] The goal of this chapter is not to chart film criticism to talk about positive or negative representations. I want to describe how her body gains meaning in two profit-

able films where she is hypervisible. *Chicago* and *Bringing Down the House* debuted within months of each other and rank as some of Latifah's highest grossing non-animated films—domestically earning $170.7 million and $132.7 million, respectively.[25] Together, these two movies reintroduced Latifah to younger hip hop community members who were unfamiliar with the interventions Latifah made as a rapper.

Commenting on "old school" female rappers Latifah and MC Lyte, Latina, a 19-year-old hip hop head from the Norfolk Diggs Town public housing community, said:

> As a matter of fact today on the radio they were talking about female emcees from back in the day and I was like, man, they kinda whack, even though back then they might have been jumping. They might have been jumping back in the day, but I was like dang, they need to get some.

Latina is familiar with Latifah as a generic hip hop personality and as an actress in the now-syndicated *Living Single* sitcom.[26] Her comments might illustrate the aesthetic and historical gaps that exist among three distinct subgroups within the hip hop generation: The beginning group comes of age during decolonization movements in the United States and the Caribbean. Now 56, the Barbadian-born Grandmaster Flash and others like my DJing brother would help to cultivate the hip hop aesthetics from this African diasporic tradition. The middle group grows up on hip hop and watches it move from the underground to the mainstream during the dawn of new racism. The end group—Latina's group—might not recall a moment when hip hop was not one of the most viable, visible forms of American postrace popular culture in which women participate.[27] Working from Latina and Bakari Kitwana, I speak from the middle. Having been raised on her rap record, Latifah *is* hip hop feminism for me. Still, her rhymes might not be relevant for Latina and other younger women whose affinity for the Queen of Hip Hop is associated with her empowering image.

Other than reintroducing Latifah to a new crop of hip hoppers, *Bringing Down the House* and *Chicago* have solidified her position as a serious Hollywood actress. Although Latifah received critical acclaim for her dramatic lead role as the gun-toting, bank-robbing butch lesbian Cleo in the 1997 film *Set It Off*, she remained under the radar. Until *Bringing Down the House*, the bulk of her acting roles had been coded "black" by virtue of assumed audience (*Brown Sugar*), cast (*Mama Flora's Family*), plot (*Hoodlum*), and/or director (Spike Lee's *Jungle Fever*). Both blockbusters thrust Latifah into another stratus of superstardom,

particularly because of her palatability to white audiences. Her entrée into Holly-
wood was cemented when she was nominated for an Academy Award (in 2002 for
Chicago) and rewarded with a star on the Hollywood Walk of Fame before Halle
Berry. As such, I am interested in these popular films because I want to explore
what they might tell us about racialized gender, class, and sexuality. Her seem-
ingly different roles might recuperate rather than resist hegemonic constructions
of black womanhood in movies targeting white audiences. My reading presents
more questions than answers as I place my memory against the empowering im-
age of the hip hop Queen Mother alongside her cinematic ones.

Hypervisibility, Mass Media, and Black Feminist Thought on the Sexual Un/desirable

Since her 1989 hip hop debut, Latifah has been the visible female rapper bringing
wreck in popular culture. I use the term *hypervisibility* in two ways: I use it to mark
her increased visibility in white-centered popular culture after her leading film
roles. I also use it describe how her subaltern black body is strategically deployed
to promote colorblindness, which depends upon seeing race without recognizing
racism. The hypervisibility of Latifah and hip hop culture in transnational media
and U.S. popular culture not only calls attention to the process by which media
makers can appropriate alternative and/or indigenous cultural formations (and
bodies) to create a symphony of difference absent exploitive power relations, but
it also speaks to a type of recolonization for national minorities whose images
continue to be recalled and called upon to facilitate white supremacy.[28]

Latifah presents such a case. Like Beyoncé, she serves as pop culture's body
double. On one hand, her commercial success in mainstream films such as
Chicago represents assimilated urban blackness; on the other hand, her high visi-
bility in the prison musical calls attention to continued marginalization of black
women who are ensnared by uneven criminal enforcement and caught in an un-
just prison system. In both movies her body is supposed to represent difference.
Sasha Torres argues that the nexus of race, representation, and media construct
the visual *and* political logic of so-called multiculturalism where seeing racial
harmony on screen translates to celebrating difference off screen.[29] It is the sex-
ualized African American body from hip hop culture that provides a visual sign
of difference for media consumers searching for "new ethnicities" signifying the
new cool today.[30]

Mass media makers reproduce racist ideologies about black sexuality through
controlling images or power-laden representations to justify exploitation.[31]

Through institutional power, media makers have the ability to define groups using controlling images; they also have the material resources to disseminate and provide the preferred ideological framework for audiences to consume and/or interpret.[32] Mass media are formidable pedagogical tools for teaching audiences about their distinct social worlds. As bell hooks argues, "the most powerful covert teacher of white supremacy is mass media."[33] Interpersonal interactions ground how audiences experience that world, and these interactions are communicated via media technologies that have become central in an increasingly connected world where the home, work, and religious life of racial groups remain largely segregated.[34] A project of deconstructing controlling images, then, is dismantling the ideological systems that facilitate white supremacy.

Central to black feminist theorization of power is a critique of controlling images that define blackness and thwart the self-determination of black people.[35] In *Black Feminist Thought*, Collins contends that power can be seen as dynamic and structured in systems of domination that are inextricably linked to social constructions, such as race, class, and gender.[36] Collins not only adds historical specificity to the development and strategic deployment of controlling images such as the mammy and hot mama (jezebel) from the colonial to postrace era, she also talks about the way these representations function in other spaces of society to further marginalize real black female bodies. Black feminist thought helps me talk about Latifah's body as the sexual un/desirable. Rather than depicting black women as either the desexed mammy or the oversexed hot mama, the black artist is now expected to perform both in major media productions. This both/and is a departure from previous research, and it speaks to the dual roles that gender and race minorities must make under postfeminism and postrace.

Implicit in Collins' discussion of black feminist thought is the Western binary.[37] The binary *is* problematic; it remains a formidable way white supremacy is maintained. The black-white model used to analyze power and difference has been acutely criticized for its deliberate erasure of other communities of color. An understanding of racial logics or the three pillars that support white supremacy—genocide, slavery, and orientalism—can help communities of color recognize our particular histories of colonization while seeing how our resistance struggles are connected and interdependent.[38] White supremacy is a global ideological system tied to imperialism and patriarchy. How blackness gets defined might look different across cultures, but it is no less the dominant sign of otherness. Because antiblack racism anchors every aspect of American life, it is no wonder why white and nonwhite people alike have worked throughout history to be (treated as) anybody but black.

This is white supremacy. This is the binary. Black female bodies carry the ideological weight of otherness. I wrestle with the binary because my body is bound by it. The binary organizes power. To reorder power, it is important to demystify the black-white dualism. This means not only speaking about its constructed nature but also speaking about appropriation of the black body to uphold white supremacy as well.[39] In both films, Latifah's black body is juxtaposed with white ones to say something specific about blackness. Her characters do not dismantle the binary; the films not only rely on our understanding of racial difference but also gender and sexual difference as the hip hop queen performs the mammy and the hot mama for a new generation.

The mammy and the hot mama are archetypes of black female sexual desirability. Latifah represents both through form and function. Form and function refer to appearance and social role. Much of media studies scholarship about minority stereotypes examines form.[40] For example, the mammy is typically represented as a dark-skinned, overweight black female. The mammy's function, or social role, however, is also important. The happy black woman serving the white family in popular culture can be connected to the continued need for the exploitable cheap labor that black women provide. Black women's unpaid labor was critical to the maintenance of colonialism just as her low-wage work in health care and service jobs are needed under late capitalism.[41] In either case, black women provide a kind of racialized domestic service to the U.S. white patriarchal system. Her position inside and outside designated white spaces, as well as her relation to white bodies, grounds the construction of the mammy.

The mammy is desexed or rendered asexual in the intimate spaces she shares with straight white men and women. She is nonthreatening. The mammy's supposed asexuality is tied to her sexual undesirability. Her appearance and social role as an (enslaved domestic) worker help to define the mammy in relation to white women and men. The white woman is the fragile, feminine lady—the dependent homemaker who is the desirable partner for a white gentleman. The mammy's unattractive appearance is supposed to repulse white men and reassure the privileged white wife and/or mother. Experiences of rape, sexual harassment, and sex labor in the white home as well as consenting interracial relationships with white men tell a different narrative about the intimate lives of black women.[42] The mammy is both masculinized and feminized through gender and sexual labor.[43] Her sexual undesirability is not only because of her form or appearance, it is because of the racial, gender, and sexual work she performs in the white home and society.

The hot mama represents the mammy's othered half. Branded as hypersex-

ual, the hot mama seduces white men with her combination of black and white physical traits. Her thin (but) voluptuous body and light skin (pejoratively represented as a "tragic mulatto"), along with her insatiable sexual appetite, make her desirable to straight white men.[44] Again, highlighting her appearance or form can limit the multiple ways we can talk about the image of the hot mama in contemporary cinema. Latifah has light skin, but her body does not fit the mold of the hot mama. Latifah functions as the hot mama in both films because she engages in sexual relationships that fall outside white heteronormativity.

Other than Latifah, characters played by Halle Berry also provide another example of the form and function of the black female body as the sexual un/desirable. The biracial former beauty queen invokes the image of the hot mama through form in her roles in *Jungle Fever*, *Losing Isaiah*, and *Monster's Ball* when she plays unpretty, unlady-like, underclass addicted women. In *Losing Isaiah*, Khaila Richards (Berry) works to regain custody of her son from the state foster-care system by serving as a nanny for a white suburban family. Richards is declared unfit to care for *her* son but responsible enough to care for a white child without the direct supervision of his parents or the state.[45] Berry's character functions as the mammy by taking care of the white family at the expense of caring for her son *and* as a jezebel because she is sexually irresponsible for having a child out of wedlock. Khaila prostituted her body for drugs, which resulted in an unplanned pregnancy. The recall of prostitution is relevant to Latifah's *Chicago* character, Mama Morton, who, through her solo music performance in the film, says she accepts money in exchange for sexual favors. Through form and function, both black female bodies represent the mammy and hot mama—the sexual un/desirable.

Today, mass media makers draw from hip hop culture to refashion the sexual un/desirable. Most prevalent in popular culture are the hoochie (freak), baby mama (neglectful single mother), and hoodrat (criminally prone ghetto girl).[46] These images, once relegated to rap songs and music videos, are fully incorporated into mainstream media to the point that a daytime television ad featuring a young black woman pole dancing on a city bus can be used to sell cell-phone service.[47] To be clear, all black women may be classified as hos/whores, but only those from the underclass can be attributed as hoochies and hoodrats. Hoochies and hoodrats are potential welfare queens—modern-day mammies who are married to the state or white patriarchy. Their children are the economic responsibility of the state. Moreover, these neglectful mothers scam the welfare system and plot schemes to get money from (and with) black men. Interestingly, Latifah planned to take on this stereotype as the star and co-producer of a movie called

Welfare Queen.[48] The welfare queen, along with the hoochie and hoodrat, is a controlling image that is unified through the construction of the black underclass as a threat to the white patriarchal state and family.[49]

Throughout part 2, I suggest hoochies and hoodrats are freaks because of *what their bodies are* (stereotypically represented with a big butt wearing vibrant colors and long nails with elaborate hair designs) and because of *what their bodies do*. Again, this recalls form and function. Like the black woman pole dancing on the city bus, hoochies and hoodrats perform sexual favors outside white heteronormativity.[50] There is nothing redeemable about these images according to the group of Diggs Town women who describe them as lazy, nasty, and dirty in "(Re)definitions" in chapter 6. A hoochie mama (like the baby mama) might perform sex work to provide financially for her children. A hoodrat may perform sexual favors at her man's command. Both are considered sexual deviants and may be marked as the sexual un/desirable because each is a freak at the same time she is a potential neglectful mother who places her desires before the needs of her children. In both films, Latifah is defined by a racialized gender, class, and sexuality. Through black feminist thought, I describe Latifah's outsider-within position within the white patriarchal family and prison. I also address how the hip hop black female body is made meaningful within racialized discourses that frame the Queen as the sexual un/desirable in *Bringing Down the House* and *Chicago*.

Film Synopses: 'Chicago' and 'Bringing Down The House'

In *Chicago*, Matron Mama Morton serves as the warden for the Cook County women's prison during the 1920s. Her connections on the outside and her authority in the prison as the warden give her limited power over the female convicts. Mama smuggles contraband, arranges legal counsel for vaudeville performers Velma Kelly (Catherine Zeta-Jones) and Roxie Hart (Renée Zellweger), and orchestrates a tour upon their release to capitalize on their sensationalized murder cases. Charlene Morton is not a prison warden but a prison escapee in *Bringing Down the House*. Charlene accepts an online blind date invitation from divorced tax lawyer Peter Sanderson (Steve Martin). She arrives at the Sanderson suburban home outfitted in cut-off denim shorts and a graffiti-tagged shirt. Charlene refuses to leave the home of the uninterested Peter until he agrees to reopen her case to clear her criminal record. In exchange, Charlene plays nanny to the Sanderson children. During her stint in the Sanderson home, she befriends Peter's best friend, Howie (Eugene Levy). Charlene's role in the Sanderson home

and with Howie is to free them of social conventions that prevent them from living as they choose.

READING LATIFAH: [A]SEXUAL BLACK FEMALE BODY

Surrogate Mammies

In *Bringing Down the House* and *Chicago*, Mama Morton and Charlene Morton are nurturers by design. They refuse to be completely exploited, considering they use the racist construction to their advantage. For example, becoming a nanny guarantees that Peter will work on Charlene's case. The Matron permits the female convicts to call her "mama" so they may become emotionally dependent on her. When the prisoners are most vulnerable, Mama manages to exploit them. Her power, however, is limited to the interaction with the prisoners for specific activities, such as smuggling merchandise. She has no power in larger sociopolitical and economic systems. We see the ways racialized and sexualized bodies are policed in the film. In both films, Latifah provides comedic relief and represents the sexual un/desirable because of her role as caretaker and her failed performance of white femininity.

The mammy is the surrogate mother. The matron in *Chicago* is responsible for convicts on murderess row. Charlene's responsibility is to care for the Sanderson children. Charlene teaches Georgey (Angus Jones) to read and avenges Sarah's (Kimberly Brown) honor. She occasionally cooks and sews. Her speech is exaggerated, and it is reminiscent of old minstrel performances. Charlene does the latter to show white folks outside the Sanderson circle that she knows her place. Both Morton characters provide emotional support for their white counterparts. They are motherlike. Mothering is unattractive. Perhaps it is why we do not see Peter's ex-wife, Kate (Jean Smart), take on specific child-rearing responsibilities as Charlene does. Throughout the film, we see Kate with or talking about her younger boyfriend, affirming her sexual desirability not only to Peter but to the audience as well.

In *Chicago*, lawyer Billy Flynn (Richard Gere) advises the otherwise conventionally attractive Roxie to pretend to be pregnant and to wear a black dress and black opaque stockings. Roxie puts on black, which in turn signifies her putting on corporeal blackness. Flynn wants to mammify Roxie and make her less sexually desirable to bolster her plea of innocence, which demands she don black femininity but remain tied to white patriarchy through the pretense of pregnancy. In both cases mothering is represented as undesirable yet redemptive through whiteness.

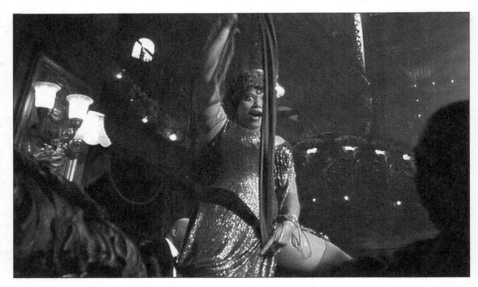

Figure 1

In her solo music performance in the movie Chicago, *Queen Latifah uses a napkin as a prop to demonstrate her insatiable sexual appetite.*

Roxie and Kate are sexually desirable because they represent a successful performance of white femininity. Both women are blond. When Roxie can cop contraband, she requests hair dye first.[51] Roxie's blond waves becomes so popular, Mama bleaches her hair blond, too. While both women reveal the performance of white femininity, only Mama's refashioning is seen as comedic and unnatural. On one level, Mama represents the unsuccessful black performance of ideal white femininity through the politics of hair. In this way, her blackness fails her. In *Bringing Down the House*, Charlene cannot lure Peter. He is appalled when the prison escapee does not look like the blond white lawyer in the foreground of the online photo. When Peter opens the door to see Charlene's black body, she immediately is rendered undesirable. Whiteness, even through performance, gets privileged through the designated white body. (Interestingly, the one woman hanged in *Chicago* is a Russian immigrant—a marked ethnic white body racialized as offwhite through language.) Kate and Roxie, and Velma for that matter, are sexually desirable because of their successful performance of white femininity.

Hot Mamas, Hoochies, and Hoodrats

Exaggeration makes Charlene Morton in *Bringing Down the House* and Mama Morton in *Chicago* hot mamas. Put another way, the contorted body parts and sexual overtures along with the black body as taboo frame their appeal. In both films sexuality is represented as excess. For example, we are introduced to Matron Mama Morton by first meeting her breasts. The audience is invited through a close-up to objectify her as soon as we can connect the gray uniformed bosom to the black hip hop queen. In the prison and during her solo musical performance, Mama's breasts consume much of the visual landscape. The camera rarely frames her face without closing in on her cleavage. At several points, she cups her breasts and crams cash in her cleavage. Before she shimmies off-stage, she pulls knotted napkins from her corset, calling attention to the historic fetishization and commodification of the breast for enslaved and poor black women who served as wet nurses for propertied white families. The corset literally contorts the body, making the waist disproportionate to the bust. There is a doubling of voyeurism when moviegoers watch the concertgoers be titillated by the hot Mama in the film. Here, the black exotic can be desired at a distance.

The taboo of miscegenation lingers in her 1920s burlesque blues performance emphasizing her breasts. Her performance recuperates the image of African women who were forced to bare them on auction blocks to an audience of predominately white male slaveholders. The black breast not only signifies the reproduction of chattel slavery but also speaks to the fetish of the black body in the white imagination. This fetishization can be seen in rap music videos today where black female bodies are put on display for mainly young white male audiences gazing at the sexual images of us in the privacy of their homes.[52] The white male gaze can be colonizing. Latifah's performance recalls the black female body as an exotic commodity to be desired at a distance.

Black sexuality is in excess in *Chicago* and *Bringing Down the House*. For example, Mama has an insatiable appetite for sex and cash. Under-the-table deals and over-the-top sexual innuendoes relayed to prisoners and jazz patrons further illustrate this point. It is no wonder the knotted napkins she pulls from her breasts are green. Green reminds us of money or wealth in the United States; the knotted napkin alludes to her unending sex drive. Mama welcomes "favors" from men and women. We are encouraged to read her on-stage and prison performance as a performance of female masculinity. Serious contenders vying for the role were Rosie O'Donnell, Bette Midler, and Kathy Bates—actresses who are popular in queer cultural spaces. The queer reading of Mama is part of her

character makeup. Bisexuality and female masculinity are already inscribed on her black female body, which has been historically represented as sexually deviant and emasculating.[53] Because deviant sexuality is racialized through the black body, what could have been seen as potentially oppositional is diluted.

Mama's performance is significant for other reasons: the performance(s) of Ma Rainey via Latifah. Mama's solo musical performance riffs off Ma Rainey, a blues singer who is widely known for her sexually explicit lyrics.[54] I previously mentioned how Latifah has sidestepped media reports about her sexual identity. She told *Essence* magazine, "If I'm not going to tell you what guy I'm dating, I sure wouldn't tell you I'm dating a girl." After buying her wedding ring, Latifah said she would maintain her vow of silence about her sexuality but added that she had turned down multiple marriage proposals and is in a fulfilling relationship.[55] Since her *Set It Off* days, Latifah has had a breast reduction and has lost a considerable amount of weight. What is most fascinating about her current self-presentation is the movement of the corset from the Hollywood stage to the runway, where she has been seen donning straight, long, blond-highlighted hair that works to reframe her once black butch-presenting body. Apart from the narrative reconstruction of her identity in her autobiography and interviews, she disciplines her body through diet, wardrobe, and surgery to conform to sexual desirability within the lens of ideal white femininity that is not butch, not bisexual, and not excessive.

These performances by Latifah on and off the screen—along with the persona of Ma Rainey—inform the way I see Latifah as the Hollywood hot mama. My reading of the solo music performance does not trump transgression or close the polysemic, polyvalent possibilities of the text/character. The sexualization of the black female body in the contexts I have provided, however, adds more layers to read her characters.[56] In this scene, and throughout part 2 of this book, I am asking the reader to consider how blackness intersects, recuperates, and at times limits radical readings of Mama and other black women in popular culture because the sexual deviance of Mama Morton is inextricably linked to earlier performances and representations of black female sexuality in popular culture.

Latifah reprises the image of the hot mama in her role as Charlene Morton in *Bringing Down the House*. More aptly defined as the hoochie mama, Charlene characterizes black women from the underclass, stereotyped as criminally prone and hypersexual. Charlene simply is uncouth or without class; according to Peter's sister-in-law she looks "welfarish." The body of the welfarish queen appeals to Howie. When Peter's partner first sees his "cocoa goddess," she is decked out in a denim corset and miniskirt, her head lined with synthetic hair

Figure 2

In Bringing Down the House, *it is Queen Latifah's performance as the black freak that serves as the conduit for the self-actualized desires of Peter (Steve Martin) and Howie (Eugene Levy).*

tracks, her red lips outlined in black, and her neck circled with gold that compliments her hoop earrings. Charlene stands in the country club entranceway, and she invokes underclass ghetto fabulousness.[57] The camera grazes her body. Howie's jaw drops while the sound of a baboon echoes in the background. As the '80s Morris Day and The Time song title implies, Howie experiences "jungle love." The song works alongside the image of Charlene as the exotic, the taboo of miscegenation, and the working-class black woman as the hot mama.

Charlene's relationship with Howie and Peter emphasizes the image of the hot mama. For example, Charlene affectionately calls Howie "Freakboy." His nickname is supposed to fit his awkward sexual fantasies—one of which is a lust for a poor voluptuous black woman. Like Peter and his son, Howie should want white women. His attraction for Charlene is odd because *he* is odd. He is the freak who initially tries to loosen the straight-laced Peter, but it is the black freak who serves as the conduit for Peter's and Howie's self-actualized desires. Charlene ignites Howie's jungle fever and reinvigorates Peter's passion for his wife—thereby cementing white heteronormativity. She shows Peter how to get in touch with his animal side by inviting him to touch her breasts. As the late R&B singer Barry White croons in the background, Peter becomes the beast. The mock love scene ignites a spark between the two that must be smothered for two reasons: His

loyalty to Kate and Howie, and the overall narrative structure of the film, which depends on the reunification of the white patriarchal family. Peter is wedded to Kate under white patriarchy, so whatever momentary attraction he has for Charlene can be blamed on the drunkenness that unleashed his base sexual urges. He also respects his relationship with Howie. Secondly, the mock love scene is part comedy, similar to the interactions between Charlene and Howie. We are not supposed to take these relationships seriously. Nor should we take seriously the hip hop Queen Mother gyrating on a *Chicago* stage. When Howie finds a freak that can fulfill his fetishistic sexual desires, it's supposed to be "strange love"—or jungle love. Latifah does not bring down the house in either film. Popular culture houses whiteness and contains blackness, and Latifah has little wiggle room within the framework that boxes in her black female body as the sexual un/desirable. It may not be the Queen I remember bringing wreck in popular culture at all. Her remixes of the mammy and hot mama reign.

Conclusion

Latifah reprises the mammy and hot mama in her roles as Charlene Morton in *Bringing Down the House* and Mama Morton in *Chicago*. In both films, she operates as the sexual un/desirable according to her position to and relationship with whiteness. Her body is juxtaposed to the white ones to say something specific about blackness. Blackness is both different and cool in contemporary popular culture. Latifah brings hip hoppers to the mainstream and the mainstream moviegoing audience to hip hop. Both audiences have to draw upon racist ideologies of the black female body to read the film and her performances, which are supposedly satirical.[58] Her performances do not provide points of laughter for this moviegoer. Consider, the only African American women to win an Academy Award before Latifah's nomination played a mammy, a magical negro, and a hot mama—Hattie McDaniel as "Mammy" in *Gone With the Wind*, Whoopi Goldberg as Oda Mae Brown in *Ghost*, and Halle Berry as Leticia Musgrove in *Monster's Ball*. I wonder whether Tinsel town has any roles for black women apart from the sexual un/desirable we already play in society today.

It is telling that Latifah has received accolades for movie roles that explicitly affirm white patriarchy and capitalism. Latifah's visibility in popular culture introduced me to a feminist politic in hip hop that is best articulated in her early music. Latifah's hypervisibility in her most lucrative mainstream motion pictures has created what Alice Filmer describes as an "audio-visual jam"—when what we hear does not match what we see.[59]

Speaking on the in/visibility of black women in visual culture, black feminist scholar Michele Wallace notes:

> There is presently a further danger that in the proliferation of black female images on TV, in music videos, and to a lesser extent, in film, we are witnessing merely a postmodern variation of this phenomenon of black female "silence."[60]

The absent presence that Wallace describes does characterize Latifah in *Bringing Down the House* and *Chicago*. Latifah garners a kind of in/visibility even as she receives top billing in both films. Her mainstream success suggests that black women can achieve superstardom by bartering silence. Queen Latifah is subject to absent presence as other black women in mainstream popular culture productions where our bodies are always used to define someone else. We could be the (some) body used to define the hypermasculinity of the male rapper in the music video or, in the case of Latifah, we could be the black queer body used to define the ideal white femininity of the vaudeville performers in *Chicago* or the hoochie-hot-mama used to define two socially awkward best friends (Howie and Peter) as cool in *Bringing Down the House*. Silence or absent presence calls attention to spaces of knowledge production in dominant society that black women still do not command or control when it comes to telling our stories.

In reading the sexual un/desirable, I have tried to find spaces of hip hop feminist possibility—the moments when the Queen brings wreck. Even after conversations with friends who recognized the satiric qualities of *Bringing Down the House* and the powerful homoeroticism in *Chicago*, I could not see Latifah without reading her as others have read my black female body: un/desirable. Feminist cultural critic Bonnie Dow contends the arguments put forth by the researcher tell much more about the researcher than the text itself.[61] I am inclined to think that my claim of Latifah's performances as the sexual un/desirable is my way of dislodging her newfound movie superstardom from the rap persona locked in my hip hop feminist memory. Gwendolyn Pough recalls a collective feminist memory of Latifah that is situated in hip hop through her early rap and film career.[62] Just as the collective hip hop feminist memory provides me with different angles to see Latifah's interrelated personas, the memory of "U.N.I.T.Y." can serve as my prison. It can prevent me from imagining the possibility that the Latifah today moves Diggs Town Latina and other young women in ways I cannot yet recognize.

My failure to locate moments of rupture is a powerful testament to the preferred reading. While no sign or text is ever closed, reading against the grain or

adopting an alternative lens to analyze Latifah's movie roles takes media literacy and subjugated knowledge as well. bell hooks suggests black women have always had to read against the grain to consume products where our bodies are misrepresented or absent.[63] I applied a black feminist standpoint to show the way images circulate in popular culture to frame black women's absent presence. Ultimately, I see my analysis as not only an oppositional reading of the characters Matron Mama Morton or Charlene Morton. I see it as an oppositional reading of Latifah's role in Hollywood, which boxes black women into digestible mammies and hot mamas and denies a historical memory even as it tries to market her multiple personas across various media platforms. No matter what Oscar says, I am remembering the Queen who used to bring wreck. My ability to wrestle with that memory and these arresting images frees me—even if that freedom only decolonizes my mind.

"Single Ladies," Sasha Fierce, and Sexual Scripts in the Black Public Sphere

WITH ONE ARM STRETCHED IN FRONT TO SHOWCASE HER $5 MILLION WEDDING RING and the other sleeveless arm extended behind to spank her black booty, Beyoncé bridges sexual scripts of the respectable lady and the freak in the "Single Ladies (Put a Ring on It)" music video. The Atlanta-based J-setting, Bob Fosse–inspired choreography has generated a media afterlife on television, film, and the Internet since its 2008 debut. From football players parading during halftime on the television series *Glee* to music video parodies by male pop singers Justin Timberlake and Joe Jonas donning black leotards and pumps to the theatrical rendition by Liza Minnelli singing at the wedding ceremony of a tuxedo-wearing Carrie Bradshaw in *Sex in the City 2*, "Single Ladies" is largely celebrated in white-defined popular culture for its gender play.

When a lanky brief-wearing male dancer records his version of "Single Ladies," posts it on YouTube, and attracts more than a million views, however, his bedroom performance is not met with the same glee. After some YouTube users (read: straight users) flag the video as "inappropriate," Black Entertainment Television (BET) programmers request Shane Mercado redo his routine with pants and a shirt before airing it. Both Shane and Beyoncé remind us about the particular bodies that are able to transgress boundaries of gender. It is the bad girl Sasha Fierce who has to do Beyoncé's "dirty" work. When she directs our attention to her ring and booty, Beyoncé signals to her audiences that she is aware of her cultural currency as a black female entertainer and her social value as a black lady or a woman of a protected class in the black public sphere. In this chapter, I unpack the two performative acts by Beyoncé in "Single Ladies" to describe how

she carefully choreographs black female desirability in her music video similar to Queen Latifah in her blockbuster films *Chicago* and *Bringing Down the House*. Like Latifah with her dual role as the sexual un/desirable, it is Beyoncé's ability to play the freak and the lady that garners mainstream celebrity while maintaining respectability in the black public sphere.

In the black public sphere, real single ladies pose a potential threat to a perceived fragile black manhood and a broken black family because of their poor financial, reproductive, romantic, or professional choices or because of their unwillingness to conform to conventional gender performances of passivity, frailty, and subordination. Again, gender performance intersects race and class. Slim Thug, a Houston rapper who previously collaborated with Beyoncé on her song "Check On It," tells a *Vibe* magazine reporter that black women are undesirable partners because they beg, are disloyal, and do not "bow down" to black men who are treated like kings by white women.[1] Slim Thug recalls Kanye's rap about gold diggers and greedy baby mamas. Hip hop is an important site in the black public sphere where gender politics are tackled. Since Destiny's Child, Beyoncé has provided a much-needed female perspective. "Single Ladies" is another example. A song that could be billed as Beyoncé's new "Survivor" or "Independent Woman" anthem instead serves as soundtrack for a national forum on failed black womanhood. I want to marry Beyoncé's "Single Ladies" with hip hop feminism to discuss everyday gender performances by young black women in a post–Tip Drill moment when hip hop sexual scripts continue to dictate the (re)presentation of the black female self.

To situate "Single Ladies" within hip hop feminism, I locate Beyoncé in academic literature, particularly how she figures in gender scholarship. A brief discussion about sexual scripts is provided. Womanist scholars Dionne Stephens and Layli Phillips define eight main sexual scripts in hip hop: the Diva, Gold Digger, Freak, Dyke, Gangster Bitch, Sister Savior, Earth Mother, and Baby Mama.[2] These scripts are contemporary offshoots of foundational controlling images, such as the mammy and jezebel, described in the previous chapter. I adapt their categories of the freak and the diva, or what I am reworking as the lady, and apply them to Beyoncé in "Single Ladies" and other music videos. This analysis highlights the gender politics facing the hip hop generation.

Get Me Bodied

Academic literature has failed to fully theorize the cultural significance of Beyoncé Knowles, who is arguably one of the most influential female enter-

tainers since Madonna. She is a key figure to address gender representations in contemporary music videos, and the booty spectacle she spawned from her teen years in Destiny's Child has been useful to understand the changing contours of beauty and sexual desirability for diverse groups. In this moment, a particular brand of whiteness has been disrupted. Both ideal beauty and sexual desirability are mapped onto the curvaceous, ethnically marked female body. Beyoncé has, along with other hip hop personalities such as Queen Latifah and Jennifer Lopez, prompted the commercial marketing of "real women with curves" in film and fashion, which influenced policy changes for runway models who must meet a healthy weight according to the body mass index (BMI).[3] The inclusion of so-called curvy "sex" mannequins in major U.S. department stores[4] and the resurgence of shoulder pads with the new padded "bootiful" panties further illustrate this trend.[5] Beyoncé has helped to redefine ideal beauty—through language with the *Oxford English Dictionary* term *bootylicious*, which she made popular from its first mention in a Snoop Dogg rap song, and through practice with the five-fold increase in butt augmentations in a year by clients specifically requesting Beyoncé or Jennifer Lopez–like bottoms in the United States and the United Kingdom.[6] These shifts in culture alone warrant further exploration of Beyoncé as an iconic body.

Gender scholarship exploring body image and body satisfaction will have to consider hip hop culture as an important medium that communicates popular ideas about beauty and desirability across race and class. Decades of comparative research have routinely reported that black girls have a healthier body image than their white counterparts because of the within-group appreciation of a range of body types and the relative exclusion of black women and girls from mainstream media.[7] The media buffer that used to shield black women and girls no longer exists because of the marketing push for more multicultural media representations and the proliferation of hip hop culture and its accompanying booty aesthetics on a global stage. Today, black women and girls are susceptible to similar media messages about ideal beauty. A recent study correlating media exposure to body disturbance suggests black and white women have become more dissatisfied with their lower torso with increased television viewing.[8] Black middle-class girls who have little interaction with other blacks in predominately white neighborhoods have a lower self-perception than others from middle-class black neighborhoods where there are "real-life" counterimages to the objectifying images prevalent in hip hop media.[9] Researchers suggest ethnic and racial affiliation might be a better indicator to gauge body image disturbance for black women than media exposure to hip hop videos alone.[10] Despite the degree

of black pride or the frequency of black interaction, black girls still confront a cultural standard of the curvaceous thin woman. Kristen Harrison, for example, recommends redefining body image in terms of body parts (e.g., buttocks, breasts) to better assess black girls' attitudes toward the thin beauty ideal.[11] It is possible that black girls and women negotiate beauty standards by rejecting waif bodies but accept the thin waist and curvaceous bottoms, which is a different kind of unattainable beauty nonetheless. Not only has hip hop rearticulated this Beyoncé-like body type, it has provided cultural scripts on ways to perform this body type in music videos.

Hip hop music videos make the black female body intelligible by drawing from representations already entrenched in popular culture. To date, Queen Latifah and Lil' Kim are the most researched black female hip hop bodies in music video scholarship about gender representations because the two performers reprise clearly defined roles of the freakish jezebel and the respectable queen. Considering Beyoncé has been described as the Lolita or the child performing adult sexuality,[12] the hypersexual hoochie with working-class sensibilities,[13] or the over-the-top, attention-grabbing inaccessible diva,[14] she does not easily map onto either side of the queen–ho binary prevalent in hip hop.

Beyoncé's fluidity comes from her ability to manipulate her body primarily through dance practices and style choices. During a music video awards show, Beyoncé donned a dominatrix costume complete with thigh-high patent-leather boots and matching black briefs to re-enact the almost X-rated Sharon Stone leg-crossing interrogation scene from Basic Instinct. After a commercial break, she accepted her MTV award wearing a white evening gown without pause or a stain to her good-girl image as the Southern belle of hip hop culture. According to Rana Emerson, sexual objectification appears to be a "trade off" for Beyoncé and other black female entertainers who have historically performed the jezebel while creating ruptures in the way the freak body is read.[15] In her music video "Check On It," Beyoncé tells the assumed male voyeur that he can watch her booty as long as he does not touch it. As a speaking subject defining the parameters of engagement, Beyoncé potentially disrupts what could be interpreted as only a pornographic gaze. "Check On It" is one of many music videos featuring multiple roles of the black female body within the hip hop dreamworld, and she shows the different scripts the black female body is expected to perform on screen and in everyday life.

Beyoncé's Duel: The Lady and the Freak

Beyoncé performs sexual scripts of the lady and the freak in music videos. Sexual scripts are cultural messages that teach us how to perform sexuality, experience our sexual selves, and engage with others.[16] They operate at the level of the interpersonal, the intrapsychic, and the cultural.[17] William Simon and John Gagnon contend cultural scripts provide social actors with "instructional guides," interpersonal scripts enable social actors to become "scriptwriters" who co-create or modify cultural scripts for particular contexts, and intrapsychic scripts offer social actors an "internal rehearsal" to play out private wishes and desires that are usually a variation of dominant cultural scripts.[18] Sexual scripts reproduced in music videos, then, have the capacity to define roles by offering audiences predictable cues, gestures, or scenarios, and they can influence how we imagine desire.[19] Because they operate at multiple levels, sexual scripts are never static; rather, they are dynamic, relational, and contextual. For example, the modest middle-class lady gains meaning in relation to the freak, a script often associated with unrestrained working-class sexuality. In hip hop, it is the *public* performances of gender and sexuality that distinguish Sasha the freak from Beyoncé the lady, although both imagined bodies are sexually available to black men in the private sphere. Heteropatriachy defines the gendered spheres of the public and the private as well as the interrelated sexual scripts that Beyoncé performs in music videos.

Dionne Stephens and Layli Phillips use the concept of sexual scripts from symbolic interactionism instead of "images" from stereotype research not only to emphasize the performative but also to move beyond textual studies that focus on form or the visual representation of black girls and women.[20] They emphasize the form *and* function of sexual scripts. The two address the behavioral outcomes for black girls who model sexual scripts grafted from older controlling images, such as the jezebel remixed as hip hop culture's freak. Julia Jordan-Zachery also integrates womanism and black feminism with symbolic interactionism to examine the strategic deployment of the single black female (e.g., the urban teen mother) in the public sphere to push punitive policies such as welfare reform.[21] These studies use different terms to link imagined and real black female bodies. They attempt to account for power. The overarching concept of controlling images underscores uneven power relations and gender-specific representations or stereotypes of African-descended people in Western culture.[22] Controlling images and sexual scripts actively engage and shape each other. This chapter explores how sexual scripts animate controlling images. It is through symbolic interactionism, or its later iteration interpretive interactionism, that we can identify

images and discuss how we make sense of sexual scripts reproduced at the cultural, interpersonal, and intrapsychic level.[23]

The Freak

The freak is the most prevalent sexual script in hip hop culture. The freak is a loose, sexually adventurous, and aggressive female who might engage in kinky or taboo sexual practices for pleasure or attention.[24] It is the emphasis on pleasure primarily that distinguishes the freak from other more specific hypersexual iterations, such as the skeezer, hoochie, hoodrat, or ho, who exchange sex for status, money, or drugs.[25] In a study exploring sexual scripts produced by black girls in cyberspace, the majority self-identified as a freak: a hard-core freak who might engage in risky sexual practices, a soft-core freak who is "freaky" (within relationships), an undercover freak who separates her screen identity from her private one to protect her public reputation, and an "assumed" freak whose pornographic media content conforms to the sexual script without explicitly claiming to be one online.[26]

Playing the freak is enough to be called a ho for some black women in Diggs Town in their definitions of video models and actresses (also called vixens by hip hop mediamakers). Still, one of the youngest members of the Diggs Town group, an aspiring forensics technician, wants to be a video model.[27] Latina, presented by her mother as a "good girl," recognizes a kind of visibility by acting out this sexual script in local music videos. For her and the younger women, the freak is a playful expression of sexuality and sexual subjectivity. That they connect (sexual) power with the high visibility of the freak points to the dwindling scripts available to a younger generation, which has little collective memory about the broad representation of homegirls in the culture. Their identification also points to the formidability of the freak in the hip hop imaginary and in the minds of black women and girls today.

The booty connects the hip hop freak to the controlling image of the jezebel. Epitomized by nineteenth century iconography of the South African performer Saartjie Baartman, dubiously dubbed the Hottentot Venus, the buttocks of African women have come to represent exotic beauty and primitive sexuality.[28] In her introduction to *Black Venus 2010: They Called Her "Hottentot,"* historian Deborah Willis contends at the same time Baartman is caged and exhibited as part of freak shows in London and Paris, she is celebrated in the popular for her beauty (and booty).[29] The celebration does little to disrupt political, religious, and scientific

discourses that continue to depict her and other black women as "animal-like, exotic, different, and deviant"[30] to justify the gender and sexual exploitation of black women. A significant body of hip hop feminist studies correlates the colonial construction of the "Hottentot Venus" to the revamped one in a hip hop era defined by Beyoncé and her bootyliciousness.[31] Elsewhere, Jillian Báez and I describe how Beyoncé crystallizes the colonial and contemporary portrayal of the freak through a "backward(s) gaze" in music videos by directing our attention to her booty through dancing, poses, and lyrics. This gaze visually frames the backside as an erogenous zone of racial difference, complementing the breast as a signifier of gender difference. Moreover, the backward gaze discursively reworks an old racial fantasy about miscegenation and insatiable, unrapeable black female bodies.[32] The booty becomes significant to mark the "freakish" body and to racialize sexual performances from Baartman to Beyoncé.

As a sexual script, the freak gravitates around a gyrating booty. Beyoncé is renowned for what her black booty is and for what her black booty does. Her signature "uh-oh" booty dance grafted from African diasporic vernacular culture is closely associated with the freak.[33] The freak is played out on the dance floor where raunchy raps, reggaetón, dancehall, and bass-heavy R&B instruct women how to perform the sexual script.[34] The music video for "Get Low" (2003) by Lil Jon & The East Side Boyz is an often-cited example. Women are visually depicted as mud wrestlers, suit-wearing strippers, and booty-dancing beauticians in the music video and are lyrically addressed as bitches, hoes, and ladies in the song. Regardless of the gendered space (e.g., the salon, bar, or strip club) or their place on a social hierarchy, all women can pose as freaks in this dreamworld. Lil Jon and others command women from their dreamworld and those on the dance floor to "bend over to the front and touch your toes, back that ass up and down [and] get low." It should be noted that female club songs provide similar instructions. In the remix to "Get Me Bodied" (2007), Beyoncé tells "ladies" to "drop down low and sweep the floor with it" and "drop to your knees, arch your back girl, (and) shake it like that alley cat." Both employ the freak, but they use the script and the moving booty accompanying it in markedly different ways.

Power and pleasure provide two departure points in the songs. Beyoncé dances *with* men for mutual male–female gratification as opposed to dancing *for* a group of men that expect a woman to "get low" for a man's money, attention, or sexual satisfaction. Moreover, her call sets the stage for the erotic or the *power* to define female sexual subjectivity in ways that are creative and egalitarian. "Get Low" reproduces the pornographic "plasticized sensation," a sexual objectivity that relies on unwanted domination and degradation.[35] At New York City hip

hop clubs, for example, black and Latina girls lament the uneven gender labor implied by performing the script from booty songs. Recalling the pornographic, the girls recount how some guys mount their booties without invitation or simply stand on the dance floor expecting girls to "grind" them.[36] These are scenarios ripped from the male-defined hip hop music video. Miguel Muñoz-Laboy and his colleagues contend sexualized dancing, like grinding, enables youth to perform gender roles, sexual assertiveness, and sexual appeal.[37] These performances, however, are limited for girls whose only power comes from triggering an erection from "dry sex," choosing a grinding partner, or simulating their "riding skills" for boys on the dance floor.[38] Together, these two club and cyber studies identify spaces where some black and Latina girls enact the freak, and the studies illustrate the power of the erotic and pornographic derived from the sexual script.

Researchers conducting the club and cyber studies address the limitations of performing the freak as well as the difficulties met by black and Latina girls who craft alternative versions of the sexual script for empowerment and visibility in hip hop culture.[39] Neither the freak nor the gyrating booty is the major concern for these researchers examining how girls develop their sexual subjectivity and make sense of their sexual selves. From hand-clapping games, cheers, to double Dutch, girls' play has always involved vulgarity.[40] The problem for researchers is the freak that the girls choose to perform is firmly rooted in the pornographic. Beyoncé's performance of the freak is significant because she is situated within a male-defined dreamworld but draws on girls' play, which resonates with her female fan base. The girls' play that Beyoncé mines is female-centered and can be "freer"[41] when performed in private, local sites. At a public recreational center, for example, young women and girls re-create a female-centered private space by forming a circle or a hip hop cypher to cheer a girl who accepts a group invitation to enter the cypher where she steps or does a "batty" or booty dance that the group must master. My initiation into the SOLHOT group is with Beyoncé's "uh-oh" dance. Hip hop feminist scholar and community organizer Ruth Nicole Brown contends this space is both a celebration of black girlhood and a reclamation of voices, bodies, and spirits.[42] The cypher the SOLHOT girls create hinges on consent and cooperation rather than a masculinist one defined by battle or competition. The SOLHOT cypher is where black girls call up the erotic—the *power* to share female-centered oral traditions across generations; celebrate booty power through the athletic, inventive, and skillful display of "fleshy muscularity;"[43] and name themselves.[44]

The Lady

The lady appears chaste or sexually reserved, models a form of middle-class respectability, and expresses independence yet remains dependent on men for sexual pleasure, self-validation, or romantic partnerships to be protected and to maintain her privileged social status. Her status is conferred by men, and it is contingent upon her ability to exude the sex appeal of the freak without explicitly acting on it in the public sphere. This script resembles the controlling image of the black lady in the public presentation of piety and professionalism only. The aberrant sexuality the hip hop lady embodies is a freakish rather than the frigid one described in earlier conversations about the black lady.[45] In several songs, for example, rapper Ludacris lauds the *financial* independence of the lady, a working woman. Most important, he lays out the public/private performance of this desirable black womanhood when he says that he wants a lady in the streets and a freak in the sheets.[46] Here, usurping the masculine role of the provider is justified as long as the lady serves him at home. Balancing sexual availability with modesty becomes a precarious performance of subtlety for black females perfecting the script. Should she refuse sexual advances by men who formally court her, the lady could be cast as the undesirable dyke or bitch—two representations of black women and girls who retain control of their sexuality and reject conventional codes of femininity. Still, the single lady who accepts male advances risks ruining her otherwise good reputation. Yvonne, a Houston clubgoer, said, "When guys see that some women don't want to be in a relationship or want to be single, guys think that they're whore hopping. They want to be with that man and that man. If you're not in a relationship, you may be whore hopping. In terms of power in the relationship, men have the power."[47] It is in her complicity with the hip hop heterosexual contract that the lady can be as desirable as the freak and as privileged as her respected contemporaries, such as the accommodating wifey, the sexually temperate good girl, and the racially uplifting sister and queen. By showing sex appeal, fidelity, and class, the lady is the celebrated sexual script in the culture.

Class defines the lady. For a group historically barred from accruing economic wealth, Black Americans used culture to stratify class. During the early twentieth century, for example, middle class had less to do with actual income than it had to do with class-specific taste and sexual restraint.[48] Addressing black women's activism, Deborah White writes: "Manners, morality, a particular mode of consumption, [and] race work—these were the criteria for middle-class status. For club women, chastity was at the top of the list."[49] Club women and other black

female reformers in the social hygiene movement employed a strict Victorian ideology of sexual activity for reproduction only within marriage and chastity outside of marriage to defend themselves against racist assumptions about hypersexuality and to demand resources for social improvement from the dominant culture using black female moral authority.[50] Single ladies migrating to the city became a target group for reformers who wanted to steer these vulnerable women away from urban vice, such as prostitution and lewd dancing at nightclubs.[51] At churches, boarding houses, and schools, the programs that the reformers established to protect women against sexual exploitation by black and white men unintentionally worked to establish guidelines to perform the middle-class respectability that would later characterize the sexual script of the lady.[52]

Remnants of middle-class respectability imposed by early reformers inform the rhetorical and performative strategies of the lady from the hip hop generation. Ladies can assume the moral authority to rightfully issue a redress for "good" women maligned by negative hip hop cultural imagery associated with working-class communities. In chapter 1, I argue that public reactions in two separate media spectacles relied on the rhetoric of "college" to convey middle-class respectability. First, college students were described as "ladies" in the news media after talk radio personality Don Imus called them "nappy headed hoes." Second, the Durham exotic dancer who accused Duke lacrosse players of assault was later depicted as a struggling college student to emphasize her victimization. Shanara Reid-Brinkley identifies similar rhetorical maneuvers of middle-class respectability by black women responding to an *Essence* magazine message board about hip hop misogyny. Reid-Brinkley suggests at the same time respondents aptly criticize gender stereotypes, they also reinscribe the good–bad woman binary, police the boundaries of appropriate black femininity, and deny other black women subjectivity by speaking from the class position of the princess and the queen.[53] Reid-Brinkley calls attention to the "social and cultural distance"[54] that black women must employ rhetorically to distinguish the respectable lady from the disrespected freak. Diggs Park residents recuperate respectability by talking about college as well as motherhood, marriage, and homemaking to counter negative stereotypes about poor black women. Across economic and social class, the lady provides a platform to engage in gender politics.

Beyoncé manufactures the freak and the lady in her third solo album when she channels her self-described "wild" alter ego Sasha Fierce. Fierce is the force behind the club sensation "Single Ladies" while Beyoncé is the belle who belts the ballad "If I Were a Boy." The two songs are featured on separate gold and silver discs from the double album titled *I Am . . . Sasha Fierce*, and they debuted

concurrently as music videos. The same-day release was a marketing ploy used to exaggerate the differences between the songstress and her new freaky persona. Excess defines Fierce. Beyoncé has said "Sasha Fierce is the fun, more sensual, more aggressive, more outspoken and more glamorous side that comes out when I'm working and when I'm on stage."[55] Similar to the teen girls who protect their "real" good reputations by creating virtual freaks for online consumption only, Beyoncé uses Fierce to protect her private self and to stage a femininity that is not bound by black middle-class respectability. The Fierce persona allows Beyoncé to enact the profitable, provocative hip hop sexual script in the "Single Ladies" music video without damaging her carefully managed celebrity. This section examines the two sexual scripts, which are explicitly illustrated in the album art and signified by dance practices in the music video. Rather than seeing the two scripts as separate as shown in the album art, I suggest the twin act of offering one's hand and spanking one's booty in the music video point to the expected gendered performances of Beyoncé and other black women.

The album art distinguishes Beyoncé from Sasha Fierce by juxtaposing nature against technology to visually produce the lady and the freak. Again, this is a false bifurcation, and the contrast relies on familiar tropes about racialized gender and sexuality. The first set of photographs, for example, shows Beyoncé nude near water or draped in flowing material shielding her body on plain sets with wind-blown hair, flesh-toned makeup, and a "rosary" bracelet to reinforce ideal femininity as natural and wholesome. Embroidered leaves cover her hips in one image. Such allusions to the suprahuman Mother Nature and the sacred Virgin Mother/Mary work when filtered through mythic whiteness, which reveres the feminine insofar as it can be harnessed as a (re)productive resource. Beyoncé replicates whiteness through photography—itself a technology used to capture difference. The gray-scale photographs are manipulated by tint, soft-white borders, and bright overhead lighting making her complexion unremarkable. Beyoncé appears angelic, white. This depiction differs significantly from historical representations of black women. Still imagery routinely paired the naked black female body with nature to conjure savagery and sexual wanton at the apex of European colonization when Christianity served as the "civilizing" force to enslave African-descended people. The "rosary" is the single item repeated in separate photographs, including the one with a solid black background where the lyrics for "Ave Maria" and her all-black garb work together to suggest Beyoncé has emerged from darkness. In addition to transforming a sacred Catholic hymn into a secular devotion to her "first" lover and husband, Jay Z, Beyoncé attempts to reconstitute black female embodiment with sexual modesty; the

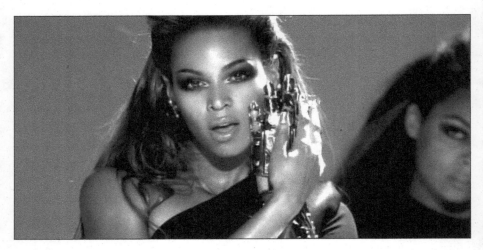

Figure 3
Beyoncé poses a potential threat to patriarchy when she uses technology to reconstruct a freak from the hip hop dreamworld that does more than titillate male audiences.

latter, however, is accomplished without necessarily delinking the racial binary that connects nature with purity and femininity with whiteness—all of which characterize the lady.

Sasha Fierce replaces the respectable Beyoncé by accessing technology as part masculine, modern, and machinelike to make an afrofuturistic, freakish female in the second set of photographs. Rather than complete alienation from nature and embodiment, technology brings Beyoncé a bit closer to her "more aggressive" and "more sensual" self by offering audiences another "othered" body that can express the carnal love and lust her ladylike one cannot.[56] Sasha Fierce is all body. No lyrics accompany full shots of Fierce, which suggests whatever we need to know about her electro-pop, funk-infused songs could be read by scanning her squats and hunches in thigh-high kinky boots, studded straps, motorcycle corset, and metallic "robo-glove" cupping her booty (see Figure 3).

The "womandroid" or hip hop cyborg revives the fears and desires associated with technology, female sexuality, and blackness at once. As a prototype for the cyborg, the black female body has been reconfigured over time to fit the needs of (white) patriarchy from plantation to postindustrial economies through unpaid and low-wage work, including sexual labor. Rather than "nursing white culture and maintaining patriarchal privilege," Robin James contends Fierce and other "robo-divas" use their freakish, cyborg bodies to assert independence. Herein lies

the paranoia about the single black woman, or the woman who is neither contractually committed by marriage nor intimately connected by sex to another man: She is independent. Beyoncé poses a potential threat to patriarchy when she uses technology to reconstruct a freak from the hip hop dreamworld that does more than titillate male audiences; as Fierce, Beyoncé attempts to build women's solidarity by calling on "all the single ladies" to embrace their bodies and express self-gratification.

Beyoncé fashions her cyborg body from artifacts of iconic masculinity rooted in American popular culture: the motorcycle and the metallic glove. Extending to her forearm, Fierce's robo-glove recalls the "cyborg-as-fighting-machine."[57] This cyborg is exemplified by state-manufactured robots, such as the Terminator performed by ex-bodybuilder Arnold Schwarzenegger and the Robocop outfitted with an attachable machine gun arm accessory. Whether it is the machine gun, state-military technologies, or brute strength, hegemonic masculinity is defined by violence and aggression. While Fierce's robo-glove gains much of its meaning from the robot, it also reminds us of an alternative masculinity embodied by the late Michael Jackson, whose trademark gem-studded white glove became the visual shorthand for the King of Pop. Postmortem, Jackson remains the freak for tabloid fodder not solely because of his peculiar interests but because of his increasingly Europeanized and androgynous physicality that deviated from the preferred representations of black manhood. Repeated cosmetic surgeries, chemical processes (e.g., hair straighteners), and natural skin lightening as a result of vitiligo made Jackson the ultimate race-gender-sexual hybrid and the cyborg.[58] Indeed, a part of his commercial success is attributed to his malleability. The glove, then, signifies Jackson's cultural power and reiterates his bodily transformations (via fashion and surgery), which conform or transgress ascribed markers of identity. Rumors of skin bleaching after becoming a platinum blond notwithstanding, Beyoncé tries out masculinities by trying on the glove and the cultural power it represents.

The motorcycle represents defiant, outlaw masculinity grafted from early film images of the rebel biker Marlon Brando in *The Wild One* (1953) and the hippie Dennis Hopper in the counterculture classic *Easy Rider* (1969). Fierce wears the motorcycle like body armor, but it is not to shield nakedness like Beyoncé does in the first set of photographs. Facing forward, Fierce grips the motorcycle handles at her hips and gives a "hard" facial expression to convey control. In what appears to be a longer leather-fringed motorcycle tassel on the right could be read as a flogger, a whipping device used in BDSM and kink culture. Here, Fierce is the sexual dominant, and the red and orange flames painted across her plated

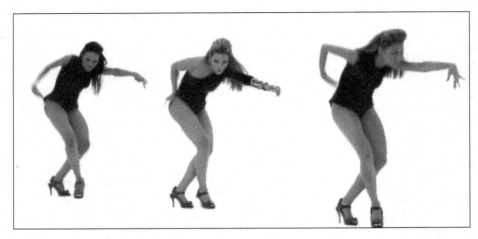

Figure 4

The positioning of her body between two dancers posing with one hand extended and the other spanking her booty demonstrates how Beyoncé connects passive black femininity with aggressive black female sexuality.

chest indicate her sexual readiness. She is hot. The retreat to sexual dominance as the source of women's power works in concert with the hip hop fantasy of the freak and more specifically the ride-or-die chick, which is a revamp of Clyde's Bonnie who risks everything for her man. Rather than freedom, the motorcycle constrains Fierce because it limits how she is able to access power. As a garment, the motorcycle literally restricts mobility. It resembles a corset, a man-made technology used to contort the torso to accentuate a thin waist and a fuller bust and hips for women. The motorcycle corset exaggerates her unnatural figure; more importantly, it emphasizes Beyoncé's deep investment in femininity whether she is the "natural" lady or the manufactured freak, considering both bodies gain recognition from a particular kind of desirability that is masculine defined.

The music videos animate the album art. They set in motion the masculine-defined sexual scripts of the lady and the freak for the same-day debut of the ballad "If I Were a Boy" and the up-tempo empowerment anthem "Single Ladies." The black-and-white narrative and song-and-dance video genres are supposed to distinguish the singer's real identity from her staged one; however, it is the low budget, seemingly one take, southern J-setting, Bob Fosse–inspired Fierce performance in "Single Ladies" where we witness the ways Beyoncé carefully choreographs black female desirability by appealing to both scripts. The

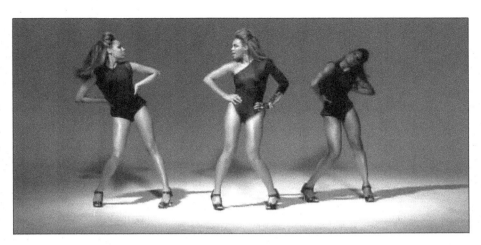

Figure 5

Ashley (left) mirrors Beyoncé to signify sameness, especially when the otherwise synchronized routine is not repeated with the dark-haired, dark-skin dancer, Ebony.

robo-arm ring bearer is the hip hop hybrid. In the center of the infinity cove, Beyoncé positions her body between two dancers when she poses with one hand extended and the other spanking her booty. The performative act not only demonstrates how she connects passive black femininity with aggressive black female sexuality, but this recurring act is central to show how she mediates disparate discourses of desirability, which are mapped onto the two differently marked dancers (see Figure 4).

Dancer Ashley Everett is Beyoncé's body double. By that I mean, the former Alvin Ailey ballerina becomes the lady from the hip hop binary because she shares the most close-up scenes whenever Beyoncé brandishes her bling, and she shares a close resemblance to the robo-diva. For example, their blond streaks and light complexion are magnified midway through the music video when Ashley pivots then pauses to mirror Beyoncé's stance (see Figure 5). This pivotal move signifies sameness, especially when the otherwise synchronized routine is not repeated with the dark-haired, dark-skin dancer, Ebony Williams. At the start of the video, Ashley dances to the viewer's left of Beyoncé so that the audience might read the sexual scripts on a lady-to-freak continuum. Depending on the camera angle or the choreography, the two share each other's dance space; their legs and arms frequently cross. In a final tight shot, Ashley is the lone dancer

standing behind Beyoncé with the ring. By the end of the video, Ashley moves from a kind of lady-in-waiting to one of the most desirable single ladies on the marriage market.

In addition to proximity, a part of the "ring dance" links Ashley to the lady. Bowed heads, crossed legs likening a curtsey, and extended hands are formal gestures grafted from Victorian-era gentility that demonstrate deference or passive femininity. Similar to the album cover, the dancers are enveloped by whiteness when they lean in the direction of Ashley, the light, or the invisible man requesting a hand to dance or marry. The frozen upper half that the dancers isolate is reactionary and stands contrary to the popular interpretations of a defiant feminist chorus championing choice. The lyrics from the official Beyoncé website suggest singlehood comes after a boyfriend bounces on Miss B, leaving her "actin' up" or acting out as Fierce in a nightclub. Despite repeated demands to "put a ring on it" in the music video, women are waiting to be chosen. Singlehood is acceptable as long as it is a temporary state of unbelonging along the "female lifecycle," which must include marriage and motherhood lest her unhitched status signals failed femininity.[59] The ring, then, is normative womanhood actualized. In both song and dance, Ashley and other desirable single ladies might put their hands up, but they also hold them out to be "wifed" like Mrs. Carter[60] one day.

Ebony, unlike Ashley, mirrors Mrs. Carter in movement only. In the music video, the more muscular, darker dancer shadows Sasha Fierce as she is cast farthest from the light and other signs associated with Beyoncé and the lady. Ebony has no extreme close-ups, a visual technique used to convey individuality or personhood. Instead the dancer, similar to Sasha in the album spread, is all body with the booty being the familiar shorthand for reading black female sexuality. The choreographed spanking does render Ebony freaky, yet it is her complexion that makes her freakish for some fans who catapult the dancer from the shadows to the virtual spotlight after they rumor the single lady might be a man. Here, dark skin makes femininity illegible. The online chatter about her music video performance and other subsequent gender-bending reenactments by men stage a broader discussion about the role of complexion used to defeminize and to stratify desire within a hip hop pigmentocracy where darkness is at best banal for some black women.

There is an extensive cultural repository archiving masculinity with dark skin.[61] From storied slavery-era tales of supersized phalluses of the Mandingo to the modern-day visual cliché of the tattooed, white-teed hip hop hard body, complexion has been the observable phenotypic feature to fuse ideas about sexual prowess and "brute" physical strength with an aggressive masculinity that

is both threatening and attractive. This characterization of masculinity is not confined to black men. Dark skin has been as important to emphasize difference within gender as it has been to show sameness across gender. Recall depictions of the mammy and sapphire or drag performances by black male comedians. Put plainly, some black women seem unlady-like (read: unlike light-and-almost-white women) because they possess a mythic melanin-manufactured version of masculinity reserved essentially for dark-skin black men.[62] Black men echo this refrain too. For decades, rappers and R&B crooners alike have lyrically pined for "yellow," "caramel," and "red bone" single ladies in clubs advertising *Twilight*-themed parties where women on Team Dark or Team Light vie to be the most attractive group. It is in this context where Ebony gains visibility. It is also where we see how the music video parodies and sensual performances reiterate the gendered color caste.

Black male comedians mine our collective commonsense about complexion when they perform perverted versions of black womanhood. Audiences are primed to see dark skin as masculine when they watch Eddie Murphy (Rasputia and Mama Klump) and Tyler Perry (Madea) play the cinematic "male mammy"[63] or Martin Lawrence (Sheneneh Jenkins) and Jamie Foxx (Ugly Wanda) revive their sitcom hoochie and hoodrat for the BET Awards. Some black women are seen as just men in drag. The anxiety surrounding Ebony comes from a form of unknowing. Audiences do not know whether to be aroused by her supposed gender queer presentation, to laugh at her apparent ugliness against the whiteness of the other dancers, or to cheer the near-perfect single lady performance by a transwoman or the male J-setting choreographer JaQuel Knight. *Chicago Tribune* entertainment writer Monica Eng reports Ebony and JaQuel share an "uncanny facial resemblance" and the gotcha Adam's apple that could discern sex is tucked under a turtleneck,[64] which led fans to read the *Saturday Night Live* parody with Beyoncé and Justin Timberlake as an inside joke. The joke, however, is not so much about white men such as Justin and Joe Jonas on YouTube fumbling in black pumps.[65] The lanky (white) Latino Shane Mercado mimics the choreography, too.[66] His YouTube version is neither funny nor seductive for the same BET that showcases Sheneneh, Wanda, and "video vixens." Mercado must temper his bedroom rendition by wearing pants instead of bikini bottoms because his suggestive attire is too titillating for BET. It is as if pants, like complexion, provide cultural cues for the audience. Shane Mercado, Justin Timberlake, and black comedians such as Eddie Murphy and Martin Lawrence elucidate gender as performance at the same time their media performances reinforce the impossibility of dark-skin women such as Ebony to be a lady because it remains

sutured by, as demonstrated earlier in the album art, notions of naturalness, whiteness, and femininity.

Dark complexion coupled with the booty-spanking choreography conveys sexual aggression that is emblematic of the freak. Before the emergence of the ugly, uncouth, unlady-like working-class ratchet, *tip drill* had been one of the most popular terms to characterize a woman who possesses no conventional beauty but remains sexually desirable because of her booty. Again, the booty not only serves as an erogenous zone of racial difference, but its size and movement confers the kind of lewd, taboo sex acts that are supposedly permitted with this kind of body and those other bodies that mime her. Where the ring hand dangles in midair to recall passivity, the spanking one demonstrates a form of agency in which dancers actively participate in their self-objectification and sexual gratification. In a bait-and-switch move, the dancers seduce suitors with their kinky (back)side in exchange for a kind of purity ring on the other. It is interesting to note that the spanking is simulated insofar as their hands rarely touch their behinds. That Beyoncé can spank herself to snag her suitor shows that *she can play the freak without being Fierce.* She can pose as the classless ratchet in photos and songs and still be Beyoncé Knowles. There is skin and class privilege in this form of race-gender drag, which is not afforded to Ebony and other women who are seen as freaks because of their complexion, comportment, or class location. Both the music video and the album art exploit color. In "Single Ladies," Beyoncé plays off colorism to perform the ideal sexual script of the freak-lady. She is a kind of hip hop goldielocks who can hold up competing notions of the racialized body with her two hands.

CONCLUSION

In her music video, Beyoncé fused the freak with the lady to offer women from the hip hop generation a new model of desirability. I highlighted her hybridized performance for three reasons. "Single Ladies" allowed me to shift the discussion from controlling images outlined in the previous chapter to sexual scripts to explore performance and performativity. The dance routine, along with her strategic choreography of racialized gender and sexuality, demonstrated how the singer can move between her two differently marked dancers and between her so-called real and staged persona to enact a particular form of black womanhood because of her color and class privilege. The spanking and ring-waving hand motions reflected the sexual scripts, and they demonstrated what single ladies must master to be desirable mates on the marriage market. In addition, I suggested the

singer redefined the lady from stereotype research. She might be career-minded, economically mobile, and modest in the public sphere, but privately she is freaky. At the same time Beyoncé held up the black–white, good–bad girl binaries (as illustrated by the album art), the singer also echoed the Ludacris hip-hop specific version of the respectable woman who must be a lady in the street and a freak in the sheets. Her sexual availability and acumen deviated from the prudish if not frigid image of the black lady.[67] That she is also a freak speaks to a different model of desirability for black women who typically are cast as either offshoots of the desexed mammy or the hypersexual jezebel. Beyoncé suggests the both/and demand for young black women who see the single-lady-turned-married-mother music mogul as having it all by being it all, which is a postfeminist highwire feat few women can accomplish even when balancing with both hands.

The catchy song-and-dance gave the music video a media afterlife. The dance hook and the choral refrain resonated with me because it signaled a retreat to traditional scripts under Beyoncé's Fierce guise of female empowerment. "Single Ladies" gained popularity during a moment when there were revived narratives about the unwed, undesirable black woman who was either in need of a strong patriarch (e.g., spiritual, familial, or romantic) or a man's perspective presented at televised townhalls, in motion pictures, and advice books. Rather than a celebration of independence, the song served as the soundtrack to recount the crisis of the black family through the gendered missteps of black women. For example, CNN's multipart television docu-series "Black in America" chastised a poor black woman for her reproductive choices and characterized the classic middle-class black lady as a desperate "hunter" of supposed scarce black men. Capitalizing on the "Single Ladies" sensation, ABC News used the song as its thematic tie-in for a prime-time *Nightline* special featuring comedian Steve Harvey and other black celebrities who discussed their dating woes before a predominately black female Atlanta audience.[68] Actor Hill Harper and others advised audience members, who comprised the "alarming" 42 percent of unmarried black women, to model themselves after Beyoncé and Michelle Obama, the first ladies of hip hop and politics. Harper suggested they lower mating standards, keep up physical attractiveness, maintain financial independence, and support black manhood regardless of class, educational, or criminal background. Both television shows use the song not only to manufacture a crisis about singlehood but also to provide instructions—or scripts—to teach otherwise dysfunctional black women how to be desirable ladies to black men.

In this chapter, I suggested the lady depicted in the album art and the music video was connected to notions of whiteness, femininity, and Christianity, which

shaped dominant ideas about black womanhood in the black public sphere. I read "Single Ladies" in this context. The script Beyoncé continues to perform has been in concert with those represented in Christian-based films produced by the Rev. T.D. Jakes and filmmaker Tyler Perry where the marriage-eligible, sexually modest, respectable lady is expected to follow her spiritual father and her husband (god-head). Divorced Christian comedian-turned-talk show host Steve Harvey, for example, makes plain the prescribed gender roles in his advice book titled *Act Like a Lady, Think Like a Man.*[69] Harvey said black women must allow men to "profess, provide and protect."

In his bankrupt Chapter 13, titled "Strong, Independent and Lonely Women," Harvey explained:

> We don't mind it if you have yourself totally together—you can have your own house, you can have your own money, you can own your own car. You can have the Brinks alarm system, the guard dog, and the pistol, too. But if the man who is pursuing your affection is never allowed by you to exhibit his ability to provide or protect, then how can he possibly see himself professing his love to a woman who has not allowed him to feel like a man? The things you've acquired and gained financially and educationally can never be bigger than the relationship with the man. His DNA will not allow for that. Translation: we appreciate it when women treat us like men, when you let us know that you need us. The need to feel needed is way bigger to us than we've let on; we have to feel needed by you in order to fulfill our destiny as a man.[70]

Indeed, Harvey imagines the role of the lady as one who helps a needy man fulfill his destiny. Implicit in his definition of the lady as a helpmate is his desire to see women do exactly what Beyoncé's hip hop music collaborator Slim Thug advised: bow down. From advice books and television news specials to motion pictures and music videos, bowing down sits at the core of black female singlehood for some in the black public sphere, and it became a chorus reprised across different media during the success of "Single Ladies," which stands with and against patriarchy. In this chapter, I demonstrated the ways the album art and the music video recall black female desirability, work to remember "empowerment" through a popular brand of feminism in hip hop, and represent old colonial constructs of racialized gender and sexuality in the contemporary. Like the motorcycle corset and the robo-glove Queen B(eyoncé) wears to play Fierce, the girl power that she offers to all of the single ladies is in part a play on well-rehearsed and well-worn masculine-defined scripts.

Representin' the Homegirl

Poetic Transcription as Performance Ethnography

"I shined light in some dark areas."

— TARESSA, DIGGS TOWN PUBLIC HOUSING RESIDENT

IN PART 3, POETIC TRANSCRIPTION STAGES REFLEXIVE INTERVIEWS AS PERFORMANCES that enact the lived experience of a group of Black American women from the Norfolk, Virginia, Diggs Town public housing community. As a method of ethnographic inquiry and an experimental, embodied writing form and representation strategy, poetic transcription encourages full sensory engagement with the text when the researcher-interviewer-interpreter-performer, who shapes the narrative, can manipulate language to create sound to render rhythm, evoke emotion, illustrate ideas, and incite action by using literary devices such as alliteration, repetition, or metaphor. Form also conveys meaning. For example, in "Every Day: Renisha and Nicole," the parallel, unpunctuated "laundry lists" by dry cleaner attendants Renisha and Nicole mimic the nonstop routine for the young mothers while a repeated quote by Latina in "Latina's Refrain" forms a male rap refrain or hook (typically associated with female vocalists) in her performance narrative. The richness of the word refrain visually lends itself to a song where Latina rejects the male rap/per (dance) directive and refuses narrow prescriptions of polite femininity. She works to trouble her angelic image of the virgin imposed by her mother in "Latina's Refrain" by attesting to her desire to dance suggestively, model in a local hip hop music video, and listen to gangsta rap. In each performance, poetic transcription provides another lens to see the lived experience of an otherwise stigmatized population misrepresented in both entertainment and news media (e.g., the hip hop hoodrat and welfare queen), and it also demonstrates the ordinary moments that punctuate daily life for a group of Black American women from the hip hop genderation.[1]

Poetic transcription can open interpretive space to deepen understanding and bridge experience. Similar to literary devices, word economy is another tool the researcher-interviewer-interpreter-performer can use to manipulate language to craft what Audre Lorde calls a "distillation of experience" by concentrating on the felt-sense or embodied knowledge that poetry privileges to illuminate, name, and make meaning.[2] The emphasis on the poetic is important. If language is no longer assumed to be a literal translation, then the value ethnographers assign to the transcript as a written (re)presentation of recorded accounts is concomitantly inflated. The transcript does not retell nor does it refer to the real. Rather, it is one route to access a representation of experience, which is always already in the process of remaking itself the moment we attempt to describe it.[3] Here, the poetic presupposes the transcript as part memory and part imagination and therefore is unbridled by social science truth claims and is disentangled from the web of methodological acrobatics deployed to author authenticity. Now anchored by narrative truth and emotional credibility,[4] the researcher-interviewer-interpreter-performer is free to experiment with language and form to illustrate the "interconnectedness of thought"[5] and show our interconnectedness whenever we recall another's (life) story.

The performative life story is best exemplified in "Every Day" and "Looking Up, Looking Down: Donna's Diggs Park–Place Familial Story," when the memory work by Taressa and Donna fold time, collapse space, and bring together seemingly disjointed bodies of knowledge to describe the hip hop genderation from the vantage point of the Black American mother. Mothering is a pronounced theme in part 3, and Taressa and Donna rely primarily on this identity to frame life epiphanies. The two echo downfalls because of misfortune and missteps as youths and intense poverty as adults. Taressa moves "down South" from the Bronx after the deaths of her biological mother and grandmother (her other mother) while Donna moves across town to Diggs Park from a neighboring community after "changes." Both lament their temporary relocation as a kind of dislocation—as a step down from the family-sense of home they had previously known. They reminisce to recount a lost innocence. They don't revel in that psychic space nor do they yearn to return to a physical homeplace. Both look back as a way of moving forward.

Their recall is a rhetorical move—a flashback deployed to foreshadow redemption and resurrection akin to biblical narratives. As storytellers, Taressa and Donna are in control of who they are and what happens to them in their story-world.[6] The narrative of the downtrodden is transformational when accompanied by triumph. For Taressa and Donna, mothering is the spiritual-polit-

ical act of caring when confronted by intimate and institutional forms of humili-
ation and dehumanization—forms of uncaring. Donna, for example, describes
family members who shun and "look down" on her because she lives in Diggs
Park even as she takes in needy extended kin in her cramped apartment. Both
mothers are professional caretakers as a cook and nursing assistant, and they
mention their certifications, trades, and skill sets to emphasize their indepen-
dence. They also mention them to challenge the public image of the poor black
mother as bad, lazy, negligent, and money-obsessed. Like poetic transcription,
Taressa and Donna draw on the evocative and emotive to draw the listener closer
to their human story of suffering and survival, pain and promise. "Every Day"
and "Looking Up, Looking Down" take the thematic journey with Taressa and
Donna as they recall moving down, moving up, and moving out (of the ghetto).

The stories Taressa, Donna, and others share in a Diggs Park apartment are
in part mine. Our shared physical location as past and present residents in the
Norfolk neighborhood and our shared social location as Black American women
are immediate ways to imagine our interconnectedness. Yet, anybody who bears
witness to their life story is implicated in its reproduction because our very pres-
ence impacts how the performative event of storytelling is delivered, interpreted,
represented, and enacted. Stories stand as the corporeality of memory. This is
one reason why performance ethnographers emphasize embodiment. When
we share our stories, we offer up a bit of ourselves. The researcher-interviewer-
interpreter-performer can reciprocate the teller's sacrifice not only by acknowl-
edging the researcher's presence but also by illustrating ways poetic transcrip-
tion can be constitutive of multiple histories, subject positions, and experiences
that overlap, intersect, and diverge. The "glossary" terms such as baby mama,
queen, and wifey in "(Re)definitions," for example, demonstrate group knowl-
edge culled from distinct, concrete experiences. The culminating performance
reintroduces the reader to shared knowledge that informs my iteration of hip
hop feminism as the poetics, praxis, and performances of everyday life.

Each performance in part 3 uses poetic transcription to transform the
teller-researcher-reader relationship by dissolving experiential distance. The mal-
leability of language enables the researcher to carve interpretive space and use
literary tools to craft a concrete, embodied text grounded in lived experience.
Eliciting the emotive from experience is imperative insofar as it becomes part
of the poetic thread to suture the performance. The poetic capitalizes on that
felt-sense or that embodied knowing. These features of poetic transcription en-
able it to be neatly mapped onto an already existing aesthetic honed in hip hop
feminism. Together, lyrics, poetry, spoken word, and rhyme continue to be an

important platform to inaugurate our interdisciplinary becoming.

The poetic in each of these forms remains the lifeblood of a burgeoning field, and its use by women-centered performers has resuscitated a near-lifeless black public sphere by providing engaged cultural critique about a morally bankrupt popular hip hop that is invested in the heteropatriarchal capital at the expense of black women's bodies. The use of the poetic by performers such as Jessica Care Moore, Toni Blackman, Sarah Jones, Angie Beatty, and Ruth Nicole Brown define the contours, the working contradictions, and the complexities of a hip hop feminist project by shaping how we can "represent" experience and by modeling how we might imagine deploying the poetic to make meaningful interventions in those places we call home. Hip hop culture, Diggs Park, and the academy are three homeplaces for me. Part 3 attempts to marry the ethnographic research-oriented method and writing strategy of poetic transcription with a culturally specific, politically viable aesthetic in hip hop feminism to produce a complementary body-work that represents the symbolic and material realities of young black women.

Every Day

Renisha and Nicole

Get up in the morning

Take my mom to work
Take my brother to summer school
Take my sister to camp

Go back home and go to sleep
Wake up, take a shower
Pick up my brother bring him home
 All before I go to work

I to 7 sometimes after 7

Pick up my mom, the manager
Get my babies, come back home
Eat

Go to sleep

Get up about 6
Get everybody up

Two of my kids go to summer camp
Got a daughter that goes 'cross town
Got a son that goes to the Boys
 & Girls club

Got to be to work at 9
Got to have everybody out by 8
Get everybody up, I go to work
I sweat for about 8 to 10 hours

Get off and then, come home

Cook
Get clothes together

I might want to go outside
 for a few hours
And try to
You know
Make time
For people who might want
To come over

Every day

Looking Up, Looking Down

Donna's Diggs Park Place Familial Story

I have family.
Some family look down.

I never grew up in Diggs Park. I had to come here
later on in life because I went through changes
of my own.
> *She looks at her daughter, Latina. She places her hand over her chest.*
> *The cacophonous group chatter quells.*

I've only been here for three years. I think it's because of the downfall
that I've had, maybe, because of where I'm living now,
you know?

Just now, been a stay-at-home
mom and I have seven children. But before,
my life consisted of working 12-hour days cooking in (a) retirement
community. I am a certified cook
in the state of Virginia.

and now,
I get up in the morning, get everybody up.
Feed the kids.

Taking care of a nephew
 about to drive me a little bit crazy.
I love him.
I get up.
Feed the kids.

Sit on the porch.
Let'em play.
 Once it cools down,
come in,
get'cha bath,
get'cha dinner,
go to bed.

I'm a homebody myself. I'm
thankful. I thank you
Jesus. You know, that
I have this, that. I have
a roof to be put over my head. But,
I have some family members
that I used to see more often that I haven't seen
much of, you know, coming to visit
because of where I live. I think
it's because of, like, we have to deal
with the scenery. Like, you come home and then you see
a whole bunch of people outdoors.

 "Trash," Nicole said.
 "Drug dealers," Taressa added.

And, people standing around on corners and
that's not what I was used to. I've always lived in nicer places. Always.

 "But it's still not, I mean, it's not that bad," Latina said.
 "Park Place is worse. I mean, it's not that serious.
 It's the same people staying on the street. It's the same thing."

It doesn't bother me, myself. I'm happy
because once I walk in my door and I shut my door,

I don't have anything else
to do with what's going on outdoors.
Like I said before,
I have seven children and I have a little bit of help
sometimes. I'm a very stern parent.
The boys get a little tiny bit more leniency. I've always been strict
on my girls,
on my boys.
Lord knows.

Wraps her right arm around Latina.

I'm proud of you baby. I am so proud of you. You a girl
and I know what it is to be a young girl 'cause I've been out there
and done that, and don't want you to follow
in my footsteps. This a good girl. I'm proud to say
my baby is still a virgin.

Smart, pretty, intelligent, and everything.

"Thank you," Latina said.
"You did well and it shows," Taressa said. "It really does.
It shows that your parents raised you. I see you
outside, observing all the time."

I just try to raise them the best I can. 'Cause I want them to do good.

Latina's Refrain

Shake it fast. Shake it fast. Shake that money [maker].
As long as your butt in the air, you straight.
As long as your butt's in the air, you straight.

That's how I feel. That's all you get for real.
If you go out to the club—that's why I don't
really like going—well I go—but I don't
dance with nobody because when you in there,
all they expect you to do is
bend over
and just drop it.
Get yo' eagle on.

Shake it fast. Shake it fast. Shake that money [maker].
As long as your butt in the air, you straight.
As long as your butt's in the air, you straight.

I don't like my butt and stuff out. I got on some pants.
It ain't shorts or no skirt. It ain't
like my butt hanging out. It's covered.
I can see if it was that, but I don't see
nothing wrong with tight pants and shirts.

I
be
looking fly.

I'd be in a video,
my cousin's a rapper. If they shoot a video, and
[if] he asked me to be in it,
I would check—he would check
what I had on and what I was doing in the video,
but I don't relate myself to girls in the video,
no. Yeah.
[They] be like, look at her butt. Her butt look like *her* butt.
She gotta a big butt like J-LO or that girl on TV.
Her body banging like a backyard caddy (Taressa adds).
"Ah, you see how she did that?"
"Do it like Ciara did it."
I'on dance like that. I DON'T DANCE LIKE THAT. I mean maybe
when I was younger. I do it in my room where my Daddy can't see it.

It's just dancing.

Shake it fast. Shake it fast. Shake that money [maker].
As long as your butt in the air, you straight.
As long as your butt's in the air, you straight.

I got Too Short CD in the car right now, be singing it and learn the
 words
and everything

and you don't [?]

think about what you're saying.

Shake it fast. Shake it fast. Shake that money [maker].
As long as your butt in the air, you straight.
As long as your butt's in the air, you straight.

Yeah, get rid of that.

Taressa

A Rasta Mother's Answer(s) Rap

Brooklyn

my view of hip hop is
just what it is
i'm from new york so
you know
i'm down

back in the day we was talking
about self
destruction some kind of unity
nowadays hip-hop is not, it's not
leaving
that message

i vibe off of the beat
and the rhythm but
i like to listen to
words and I like songs that leave
a message

i'm more

of an r&b chick
anyway
'cause I like
to listen to words

i'm more

of a rasta

i just want *my* music
to have some *kind*
of meaning

 i'm not asking for a whole lot

what about our people?
what about where hip-hop was founded?

From The Projects of New York to the Projects of Virginia
i moved
to diggs park in 2000 i moved
to virginia in 1990
i went
to north carolina for a little while
i went
to baltimore dc i made some little adjustments
to get myself ready for virginia once
my grandmother passed away i just
moved
down
here.

i just never been back
to new york since then because i feel like things won't be
the same

i know that [reed] avenue is not
gonna be the same, because i can't walk down the street

and go to my grandmother's house—
i could survive
because my grandmother was my main reason for being
in new york
that was a part of me
and now that's behind me.

i don't wanna go back.

not one time have I had to open up my hand
and go in the street
and beg
for money and
you know
and those are the things i did
in new york.

i don't wanna go back.

back in the day we was talking
about self-destruction, some kind of unity

i want better things for my kids.
my mother
was an intravenous drug user she was
in the street so it wasn't like she was
around too much
my grandmother
actually
raised
me
so

it—
i can't—
even really

i'm gonna say

she was
my mother
once

my grandmother passed away,
i just moved
down
here

so
with both of them passing, it has made me become
who i am. i know how to stand
on my two i know how to go out there
and fend for my kids
if i have to
and i never was
a mother before.

it has made me
a very, very strong person.

my grandmother died
—and i've always had a heart to help.

the medical field was just for me
i done been—
i'm a licensed cosmetologist—
so, i've done that
i know how to lay carpet
i know how to lay tile
i've tried different trades
to see what fits me and helping people is just
you know
what seems to work
for me.

i just been on a power move, trying to make some changes
for me and my girls for real.

The World Is So Stereotypical

because i'm living in this old screwed up world
i had to do what was necessary
for my family. i had to cut my locks.
i'm more of a rasta, reggae
[and] i don't even have my locks anymore.

because i'm in the medical field, i felt like i was going to run into
 problems:
one because i live in public housing—
one because i have locks
and i'm a single parent
people are very stereotypical—

i have had a job that was paying $11 an hour
and i feel like once they figured out where i lived at
the little private meetings and the little private social gatherings
and things
that didn't include me.

it says a lot where you live and it says a lot about who you are.
i mean
i'm not going to let hair [keep me] from making me no money
i still have two mouths to feed
but, if i had to fight for rights
say for instance, harriet tubman or martin luther king [or] malcolm x
you know
if i had to fight for my rights
and i had the time to literally fight
for the fact that I did not want to cut my hair
because of a job
i would stand behind that
because my hair meant a whole lot to me
and my hair has a lot to do with my culture
and i felt like [they] took a part of that from me.

i had to cut my locks.

it's like i did it to satisfy somebody else i didn't do it for myself
i felt like i was cutting my hair for all the wrong reasons

but it also added a part to me because without my locks
i have a chance to do different things to my hair

i could use it in a negative aspect or i could use it in the positive
 aspect.
i just choose to use it
in a positive aspect.

for us to be suffering so much as we are as a population and as a race,
[rappers] need, you know, to be focusing more on the positive things.

i feel like when i turn on the radio i'm just listening to a whole lot of
gibberish. i don't even listen to hip hop
nowadays

what about where it all originated from
and the positive messages that hip hop used to send?
and
they don't send no positive messages
no more
there is no message
for the youth
it ain't [all] about fuck this
and do that—
bend over
and this
that
and
the third

talk about how they can get their grades up
talk about how they can stay off the street

honey i love
my jill scott my india aire

i'm a natural girl
anyway so my thing is
i'm down
with everything that's natural
and anybody
that's sending a positive message.

so that's my whole thing

i moved to diggs park in 2000
i'm only here for the moment.

i don't plan on dying here.

[ten years from now i'll be]
living in a house
owning a home
letting my kids go in the back yard playing with their own things so
they don't have to share
and they don't have to worry
about if they put their bike[s] on the porch and it being taken.
they don't have to worry about when they go to the play-park,
and pick up a hypodermic needle that might [be] AIDS infested
you know
i'm satisfied with just having a home
having peace,
having a peace of mind, you know.

(Re)definitions

BABY MAMA
> Anybody who got kids. [1]

CHICKENHEAD
> [A type of ho:] No [self]respect. They just wil' out for no good reason. You can take her to McDonald's, smash, [2] and you don't get nothing else out of them—no relationship.

DOWN ASS CHICK
> A girlfriend, close friend, or associate that's down for whatever. Don't matter if he got a girlfriend, she'll do whatever you want her to do: Bend over, lick it, stick it, rub it down, flip it—she go'n' do it. Somebody who's there with you through thick and thin, not somebody that ain't go'n' be there with you—who just wants what they can get from you.

EARTH
> Nas [rapper] be saying it. [3] You can think about Rastafarianism. You think about locks. You have you to have knowledge of self. The opposite of an Earth would be a down-ass chick.

FEMINIST
> Somebody who don't like men. Somebody who has a lot of negative

feelings about men. If-I-didn't-have-to-deal-with-them-I-wouldn't type. A girly, girl. A girl that wanna dress up all the time. Hair done, nails done, jewelry. [4] [Or,] college, women's organizations. [Believes] women deserve as many rights as men.

GANGSTA BITCH

She'll probably shoot a nigger, go to jail for a nigger. Different word for it: Ride or die.

HIP HOP

You think of black and white young men walking around rapping. It could be rap: Kurtis Blow, Lauryn Hill, Erykah Badu, India Aire, Missy. Hip hop could be reggae, dancehall. Dancing, breaking—the electric boogaloo back in the day. It's just dance. It's dress. Poetry. Clothing, your whip, everything—your ice. It's a feeling. Attitude. It's just life. Everything is hip hop.

HOOCHIE

Nasty. Girls with breasts hanging out. No underwear on. No bra on. Low-riding pants with the thong showing through. Shorts on [with] thongs hanging up out the shorts.

HOODRAT

Dirty. In the hood. Don't care what they put on, what they do. They go get their hair braided just to take it all out looking like Buckwheat. [They] don't want a job, just sit around, ride the bike asking for dollars and a cigarette, or they might want a burger. [They] just chill in the hood.

QUEEN

Women in general.[5] People with knowledge of self use those words. Muslim [term].

VIDEO MODEL

Wouldn't that be the ho? [6]

WIFEY

A positive term for somebody that stays at home and takes care of the kids as a parent and mother. No ho'ing. Don't club too much. Goes to respectable clubs with gentleman. [7]

SPEAKING THROUGH/TO HIP HOP DEFINITIONS
OF BLACK WOMANHOOD

[1] [To daddies:] "You'n take care of your kids, you feel like we give you dra-
ma, because we call you and harass you, and want child support. I wouldn't
have to harass you if you just did what was necessary," Taressa said.
"You one?" Latina asked.
"I'm not no baby mama," Donna said.

[2] Humping. Having sex. Chickenhead and not wifey. As in: "We smashed. I
dropped you off, went to the hotel, then I dropped [you] off back at home.
You ain't get no outfit, no nails done, no nothing. And, I'm going to call
you tomorrow and we're gonna smash again."

[3] "I haven't heard that before," Donna said.
"Me either," Renisha said.

[4] "Well what is the real definition of feminist?" Taressa said.
"It's whatever you think," Aisha said.
"It's whatever I think?" Taressa asked.
"I can tell you what I think after we get off. But, um, some people would say
a feminist is just a woman or a man who works on, um, social justice for
women and basically children," Aisha said.
"See that's why I asked. I was thinking of college, women's organizations,"
Taressa said.
"But don't necessarily have to be like within college, but what, you think
feminism is a college term?" Aisha said.
"I mean, not really, an educated person [and] an uneducated person
can be classified as a feminist," Donna said.
"Yeah. You don't have to go to college to be educated," Latina added.
"Would any of you identify as a feminist? And a feminist as I just described it
working on behalf of getting equal rights for women and children?" Aisha
asked.

Latina, Donna, Renisha, Nicole, and Taressa shake their head, no.

"Not necessarily," said Taressa. "I guess I speak like them. I mean, I proba-
bly would like to do something in reference to working towards that but
I don't think I'm in action doing it yet. ... I don't know, it's like, I can go

out and talk to my community and try to make changes, you know, but I haven't really done anything."

[5] "You don't hear it too much," Donna said.

"That's what my daddy calls me," Latina added.

"I haven't heard people use it," Nicole said.

"Some people don't hear those terms," Taressa said.

"I hear them," Latina said.

"I don't hear people say hello my beautiful queen. You get: 'What's up yo?'" Nicole said.

[6] "Don't nobody know that you a model. Don't nobody know that you spend time with your husband and staying at home with the kids, and you're not giving a blow job after each show. Everybody see you the same way. They see you [specifically referencing Melyssa Ford] on television with your ass everywhere. What makes you so different from the rest of them?" Taressa said.

[7] "I'm a wifey," Nicole said.

"Me too," Taressa said.

"Me too," Donna said. "I don't mind being no wifey."

"Yeah, I'll be a wifey any day," Taressa added.

The Fundamentals of a Hip Hop Feminist Approach

WHEN I VISITED A GROUP OF BLACK WOMEN FROM DIGGS TOWN, I ANTICIPATED MAP-ping multiple perspectives about controlling images. I did not expect revisiting home would bring a new set of methodological and conceptual concerns to describe my hip hop feminist becoming. It did. I grappled with identity and the politics of location. I had to think through my sense of "unlocation"[1] as an old project girl claiming a place where I no longer lived, as a young academic bracketing a field in its interdisciplinary infancy, and as an ordinary black woman whose experiences jibed with those sensationalized in news media and popular culture. Writing about home, then, has meant reconfiguring my body (of knowledge) in spaces where I might be overlooked, misperceived, or unrecognized. I blended voices, mixed memory-driven auto/ethnographies and media studies analyses, and assembled interpretive interactionist texts that traversed time and media platforms and genres. In my attempt to describe epiphanic moments when the so-called real and imagined body converged or collided, I pointed to a fundamental part of my hip hop feminist project: recall, (re)member and represent. The three Rs, or the fundamentals, is one interconnected approach to examine researcher/ed experience in relation to representations or living memories.

A set of narrative and performance autoethnographies introduced hip hop as a homeplace. As a Joan Morgan–generation black feminist, I told "flat-footed truths"[2] with a hip hop sensibility to marry memory with local media accounts of a race riot or uprising, new urbanism in public housing, punitive welfare reform, and the immediate, intimate impact of drug wars waged in Diggs Park.

The Park was a real place of refuge; it was also a space shaped by violence. Bodily violence was just one. Poverty permeated. Perceptions of poor people helped to justify symbolic violence with stereotypes and state violence with policies that formally resegregated black communities. It took sifting through library books and journals to recall the afternoon when my mother marched downtown to protest court-sanctioned neighborhood schools. The end of crosstown busing marked the beginning of Reagan rollbacks on civil rights, including school integration. The return to neighborhood schools in Norfolk would be seen as a major Republican win that was replicated throughout the country.[3] The recall invited me to use personal flashpoints like this one to show *how I am* rather than *who I am* as the researcher/ed reading representations about racialized gender and class that seemed too close to home. I needed to show that my hip hop feminist interpretive "I"[4] came from someplace.

(Re)membering rested on recall. I relied on memory to create new stories from the past that could place representations in a hip hop context, such as the hoochie and hoodrat played by Latifah in *Bringing Down the House*. (Re)membering worked in two ways. First, it brought together my researcher/ed body with others at a particular historical, cultural moment. The postfeminist, postrace generation is seduced to live in the moment and forget the past. I remembered. For example, the funny ex-felon character called Charlene could be humorous if we divorced it from Latifah's politicized hip hop persona, from the news coverage about actual incarcerated, poor black women and from a long history of minstrelsy in mainstream movies. Second, (re)membering invited me to read her character in relation to her pro-woman persona, and it transformed how I thought about media representations. A text was not a lifeless language that I decoded to discover a truth; (re)membering suggested a reflexive, embodied, and engaged conversation about the researcher/ed relationship with media, with living memories. My interpretation could change whenever my memories changed. Because of this shift, I opted to use the term *textual experience* rather than *textual analysis*. I was present in part 2 even if the "I" was not as pronounced as it was in the autoethnographic recall. By placing myself in relation to other bodies, I was implicated in the reflexive process. The researcher/ed could humanize an otherwise detached method of textual analysis. I was a member of the world I constructed, and I had to live with the consequences of how I read another black woman.

I saw Queen Latifah turning her back on a legacy of hip hop feminism in favor of commercially successful films. I offered an unsympathetic read of Latifah, which had everything to do with my deep investment with her old rap persona.

I could have emphasized another moment of rupture, such as her performance of black queer sexuality in *Chicago*. Instead, I described Latifah and Beyoncé as the sexual un/desirable because they reproduced old representations of black womanhood for new audiences applauding their postfeminist girl power. Making sense of their appeal signals there is more work to be done with these two hip hop icons. I moved from the either/or model of the queen and the freak to a both/and model. Here, the queen and the freak that Latifah and Beyoncé represent are roles that all black women should perform to be appealing and powerful today. Bringing wreck and reprising the minstrel has been a necessary tension throughout part 2. Beyoncé and Latifah are supposed to be seen as two sides of the same coin—the queen and the freak. (Re)membering brought the bodies Beyoncé and Latifah together to address sexual un/desirability, and it placed me in conversation with these spectacular bodies so I could talk about dominant representations and scripts circulating in popular media.

Representation completed my hip hop feminist project. This part emphasized form. Poetics in prose and performance pieces engaged in another kind of politics: writing. Each genre of writing is a socially and politically constructed category.[5] Each carries conventions to convey narrative authority. Privileging the researcher/ed body and poetry enacted narrative breaks in what counts as scholarly research. All research is a story. My story relied on a "narrative collage"[6] that called attention to a participatory black oral tradition crafted in both rap music and literary works by women. Writing, theory, and method are inextricable, embodied processes of knowledge production.[7] Interpretive interactionism not only guided how I could study experience, but it also helped me to consider the multiple ways that I could display experience. Poetry was one way. It was pragmatic and democratic. In a follow-up interview, for example, Taressa admitted she would read my poem before other chapters in the book. Poems use word economy to distill experience.[8] The sound and imagery enable her to engage with the form differently. Most important, Taressa's attraction to poetry was all about time. Similar to her neighbors in "Every Day," she worked from sunup to sundown with little leisure time to read books. Writing in multiple forms had the potential of reaching multiple audiences.

Recall, (re)member, and represent defined a hip hop feminist approach. As book sections, they staged interpretive interaction between black women. The chapters about Latifah and Beyoncé disrupted a linear Diggs Park auto/ethnography about home. I placed them in the center of the book to call attention to ways these ordained hip hop queens stand in for ordinary Black American women. In both popular media and academic literature, they have become the foci for hip

hop feminist studies. In one way, the two chapters served as a narrative hook to reel in readers who might be more familiar with the international icons but have less investment in local homegirl tales. In another way, the hook served to bring together the thematic threads about in/visibility and un/desirability that were highlighted in the two chapters and woven throughout the book. Whether I talked about Latifah or Latina, each chapter explored the politics of representation and each section spoke to the regimes of representation defined by racialized gender, sexuality, and class.

The fundamentals that I have outlined integrate theory, method, and writing practices that make the researcher/ed body part of the research process to describe an experience in multiple narrative forms that speak to the fluidity, contradictions, and movement of culture. *Home with Hip Hop Feminism* calls attention to the centrality of media and popular culture representations in articulating experience. It extends black feminist thought and challenges the discourse of difference celebrated in third wave feminism (and postfeminism). By revisiting spaces and places where we are, we not only can articulate how living memories gain meaning in our everyday, but we can reimagine hip hop and the dynamic possibilities of a feminist politics that can help homegirls survive, escape, and dismantle colluding exploitive systems that render us in/visible. By writing myself into a place called home, I have arrived at the end of a chapter of a new beginning where I can say: I am here.

Notes

INTRODUCTION

1. Black and African American are racial categories, but the terms are not synonymous. I use *black* as an umbrella racial identity marker for various ethnic groups that make up the African diaspora. Carole Boyce Davies suggests the African diaspora is made up of different forms of migrations—voluntary, forced, and induced as well as migrations made through trade and military service. See Carole Boyce Davies, *Encyclopedia of the African Diaspora: Origins, Experiences, and Culture*, 3 vols. (Santa Barbara, CA: ABC-CLIO, 2008). I use the term *African American* as both a specific racial category and an ethnic group. For example, African American functions as an ethnicity when positioned in relation to other black ethnicities in the United States, such as Black Jamaicans or Ghanaian Americans who might not identify as African American. I identify as African American. I only use the term for those who claim this identity and for those who might be represented as such within the dominant racial makeup in the United States. Otherwise, black is used. I am aware that both *black* and *African American* are contested terms that are under construction as scholars and laypersons push the boundaries of how we see and understand race and ethnicity. For an extended discussion of representation of black as a racial category in the United States and abroad, see Yaba Blay, *(1)ne Drop: Shifting the Lens on Race* (BLACKprint Press, 2013).

2. bell hooks, *Yearning: Race, Gender, and Cultural Politics* (Boston: South End Press, 1990), 41–49.

3. Patricia Hill Collins, *Black Feminist Thought: Knowledge, Consciousness, and the Politics of Empowerment*, Rev. 10th anniversary ed. (New York: Routledge, 2000), 10–13.

4. I use the term *lived experience* to emphasize the interpretive body that is used to flesh

out how we make sense of our social world. "Lived" implies embodied and felt sense.

5. Chela Sandoval, *Methodology of the Oppressed* (Minneapolis: University of Minnesota Press, 2000).

6. Patricia Hill Collins, "Distinguishing Features of Black Feminist Thought," in *Black Feminist Thought: Knowledge, Consciousness, and the Politics of Empowerment*, ed. Patricia Hill Collins (New York: Routledge, 2000), 299.

7. Aisha Durham, "Using [Living Hip-Hop] Feminism: Redefining an Anwer (to) Rap," in *Home Girls, Make Some Noise: A Hip-Hop Feminism Anthology*, ed. Gwendolyn Pough, et al. (Mira Loma, CA: Parker Publishing, 2007), 305–306.

8. Jacqueline Bobo, *Black Feminist Cultural Criticism* (Malden, MA: Blackwell, 2001); Cherríe Moraga and Gloria Anzaldúa, *This Bridge Called My Back: Writings by Radical Women of Color*, 1st ed. (Watertown, MA: Persephone Press, 1981); Gwendolyn D. Pough, *Check It While I Wreck It: Black Womanhood, Hip Hop Culture, and the Public Sphere* (Boston: Northeastern University Press, 2004); Gwendolyn D. Pough et al., *Home Girls Make Some Noise: Hip Hop Feminism Anthology* (Mira Loma, CA: Parker Publishing, 2007); Barbara Smith, *Home Girls: A Black Feminist Anthology*, 1st ed. (New York: Kitchen Table—Women of Color Press, 1983); Michele Wallace, *Invisibility Blues: From Pop to Theory* (New York: Verso, 1990).

9. Patricia Hill Collins, *From Black Power to Hip Hop: Racism, Nationalism, and Feminism* (Philadelphia: Temple University Press, 2006), 8–9; Jimmie Reeves, "Re-Covering Racism: Crack Mothers, Reaganism, and the Network News," in *Living Color: Race and Television in the United States*, ed. Sasha Torres, *Console-ing Passions* (Durham, NC: Duke University Press, 1998), 103.

10. *The Negro Family: The Case for National Action* (Office of Policy Planning and Research, U.S. Department of Labor, 1965).

11. Jimmie L. Reeves and Richard Campbell, *Cracked Coverage: Television News, the Anti-Cocaine Crusade, and the Reagan Legacy* (Durham, NC: Duke University Press, 1994), 95.

12. Ibid., 99.

13. Charles A. Gallagher, "Color-Blind Privilege: The Social and Political Functions of Erasing the Color Line in Post Race America," *Race, Gender & Class* 10, no. 4 (2003).

14. Feminists of color such as Mia McKenzie from the blog *Black Girl Dangerous* criticized Allen and her music video for the appropriation of black culture and black women's bodies. McKenzie and others also responded to some white feminist bloggers (*Jezebel*) who tried to explain that it was a gender critique of the objectification of women in popular culture (albeit through the objectification of black women). Allen issued a numbered statement on Twitter refusing to apologize and noted that the dancers, who she tagged in her response, were paid. Basically, Allen replied that they were paid for their service. See Kate Dries, "Lily Allen's 'Hard Out Here' Is Scathing Pop Culture Commentary," *Jezebel* (blog), November 12, 2013, http://jezebel.com/lily-allens-its-hard-out-here-

is-scathing-pop-cultu-1463035628; Emilee Lindner, "Lily Allen Fires Back At 'Hard Out Here' Racism Claims," *MTV News*, http://www.mtv.com/news/articles/1717384/lily-allen-hard-out-here-racist-critics.jhtml; Mia McKenzie, "Easy Out There For A (White) Bitch: A Few Words On Lily Allen and the Continued Use of Black Women's Bodies As Props," *Black Girl Dangerous* (blog), November 13, 2013, http://www.blackgirldangerous.org/2013/11/easy-white-bitch-words-lily-allens-new-video/.

15. Bakari Kitwana, *The Hip Hop Generation: Young Blacks and the Crisis in African American Culture*, 1st ed. (New York: Basic Civitas Books, 2002).

16. Wallace, *Invisibility Blues*, 5. Patricia Hill Collins also identifies the twin issue of invisibility and hypervisibility to characterize the hip hop generation. In the introduction to *From Black Power to Hip Hop*, she writes: "What are the effects on Black American youth of being simultaneously ignored and so visible? Recently, sociologists have begun to define cohort effects in a more specific way that may shed light on the Black hip-hop generation's curious position of invisibility and hypervisibility. This work stresses the impact of specific historical events on the character of generations. Public events experienced at a critical period in the life course, usually defined as the years of adolescence and early adulthood, may produce a specific set of attitudes in an entire generation that persists throughout its lifetimes. Sharing great events may create distinct generational consciousness. Within this framework, American youth of varying social classes, races, genders, ethnicities, and sexual orientations who came of age after the victories of the Civil Rights era and became adults during the dual process of economic decline and the failure of racial integration may share generational consciousness." Collins, *From Black Power to Hip Hop*, 4.

17. Shani Jamila, "Can I Get a Witness?: Testimony from a Hip Hop Feminist," in *Colonize This!: Young Women of Color on Today's Feminism*, eds. Daisy Hernández and Bushra Rehman (New York: Seal Press, 2002).

18. Pough, *Check It While I Wreck It*, 21.

19. Jeff Chang, *Can't Stop Won't Stop: A History of the Hip-Hop Culture* (New York: St. Martin's Press, 2005), 13.

20. Kitwana, *The Hip Hop Generation*, 37–43.

21. For a genealogy of hip hop feminism, I recommend Aisha Durham, "Hip Hop Feminist Media Studies," *International Journal of Africana Studies* 16, no. 1 (2010); Aisha Durham, Brittney C. Cooper, and Susana M. Morris, "The Stage Hip-Hop Feminism Built: A New Directions Essay," *Signs* 38, no. 3 (2013); Whitney A. Peoples, " 'Under Construction': Identifying Foundations of Hip-Hop Feminism and Exploring Bridges between Black Second-Wave and Hip-Hop Feminisms," *Meridians: Feminism, Race, Transnationalism* 8, no. 1 (2008). Blogs such as *Crunk Feminist Collective*, *Feminist Wire*, and *Colorlines* provide powerful cultural criticism about representations of women of color in current popular media.

22. Joan Morgan, *When Chickenheads Come Home to Roost: My Life as a Hip-Hop Feminist*

(New York: Simon & Schuster, 1999); Michele Wallace, *Black Macho and the Myth of the Superwoman* (New York: Dial Press, 1979). Also see Wallace's "'The Politics of Location: Cinema/Theory/Literature/Ethnicity/Sexuality/Me," *Framework* 36 (1989). The title for this section has been adapted from her paper, which later became a journal article, that was presented at the Third Cinema Focus symposium addressing exile and displacement.

23. "The Politics of Location," 48.

24. Joan Morgan, "Afterword," in *Home Girls, Make Some Noise: A Hip-Hop Feminism Anthology*, ed. Gwendolyn Pough, et al. (Mira Loma, CA: Parker Publishing, 2007), 478.

25. Patricia Hill Collins, *Black Sexual Politics: African Americans, Gender, and the New Racism* (New York: Routledge, 2004); Joy James, *Shadowboxing: Representations of Black Feminist Politics*, 1st ed. (New York: St. Martin's Press, 1999); T. Denean Sharpley-Whiting, *Pimps Up, Ho's Down: Hip Hop's Hold on Young Black Women* (New York: New York University Press, 2007).

26. Johnnetta B. Cole and Beverly Guy-Sheftall, *Gender Talk: The Struggle for Women's Equality in African American Communities* (New York: Ballantine Books, 2003).

27. Tricia Rose, *Black Noise: Rap Music and Black Culture in Contemporary America*, Music/Culture (Hanover, NH: University Press of New England, 1994), 149.

28. Ibid., 152, 182.

29. Morgan, *When Chickenheads Come Home to Roost.*

30. Collins, *Black Feminist Thought.*

31. Patricia Hill Collins, *Fighting Words: Black Women and the Search for Justice*, (Minneapolis: University of Minnesota Press, 1998), 9–10.

32. Ibid., 10.

33. Carolyn Randolph, "Discursive Ruptures as Productive Failures: A Critical Multicultural Paradigm in Communications Studies" (paper presented at the International Communication Association, San Francisco, CA, May 27, 2007).

34. Alisha L. Menzies, "Opening the Doors: HIV Discourse in the Black Church" (paper presented at the National Communication Association, New Orleans, LA, November, 2011).

35. Durham, Cooper, and Morris, "The Stage Hip-Hop Feminism Built."

36. Brittney Cooper, "The Beyoncé Wars: Should She Get to Be a Feminist?," *Salon*, January 29, 2014.

37. Brittney Cooper, "Excavating the Love Below: The State as Patron of the Baby Mama and Other Ghetto Hustles," in *Home Girls Make Some Noise: Hip Hop Feminism Anthology*, ed. Gwendolyn Pough, et al. (Mira Loma, CA: Parker Publishing, 2007); Tia Smith Cooper, "Can a Good Mother Love Hip-Hop?: Confessions of a Crazysexycool Baby Mama," in *Home Girls Make Some Noise.*

38. Feminism is overwhelmingly understood through the wave. The mother-daughter model carries the wave across generations. While the third wave emerges distinctly

through engendering Generation X and/or hip-hop, it is best understood as an ideological shift from the second wave, represented as a prudish-white-mother. The mother-daughter model, along with the sister(hood) model, has been thoroughly interrogated by feminists of color for whitewashing feminist theory and praxis and rendering the feminist of color invisible through the reproduction of racist relations. Other than racism that underscores the mother-daughter and sisterhood models informed by the wave, feminists of color also argue these modes of relation are based on essentialized heterosexuality and a transfer of property to offspring. In spite of the consistent and systematic theorizations by feminists of color throughout the latter half of the twentieth century to escape, disrupt, and dismantle these models, it would appear a white-centered third wave has been wholly unimaginative in developing a new set of relations that is not contingent on the erasure of cultural and intellectual work by feminists of color. In her essay "White Woman Listen! Black and Feminism and the Boundaries of Sisterhood," Hazel Carby addresses the way history makes the black woman invisible. She becomes visible when history recalls her. It is usually racist constructions of the black female that reiterate her difference with and inferiority to white women. Hazel Carby, *Cultures in Babylon: Black Britain and African America*, (New York: Verso, 1999), 67.

39. Rory Dicker and Alison Piepmeier, "Introduction," in *Catching a Wave: Reclaiming Feminism for the 21st Century*, eds. Rory Cooke Dicker and Alison Piepmeier (Boston: Northeastern University Press, 2003); Stacy Gillis, Gillian Howie, and Rebecca Munford, "Introduction," in *Third Wave Feminism: A Critical Exploration*, eds. Stacy Gillis, Gillian Howie, and Rebecca Munford (New York: Palgrave Macmillan, 2004); Astrid Henry, *Not My Mother's Sister: Generational Conflict and Third-Wave Feminism* (Bloomington: Indiana University Press, 2004); Leslie Heywood and Jennifer Drake, "Introduction," in *Third Wave Agenda: Being Feminist, Doing Feminism*, eds. Jennifer Drake and Leslie Heywood (Minneapolis: University of Minnesota Press, 1997).

40. Heywood and Drake, "Introduction," 3.

41. Dicker and Piepmeier, "Introduction," 16.

42. Daisy Hernández and Bushra Rehman, eds., *Colonize This!: Young Women of Color on Today's Feminism* (New York: Seal Press, 2002).

43. Jennifer Baumgardner and Amy Richards, *Manifesta: Young Women, Feminism, and the Future*, 1st ed. (New York: Farrar, Straus and Giroux, 2000).

44. Henry, *Not My Mother's Sister*, 168. See also Ann duCille, "The Occult of True Black Womanhood: Critical Demeanor and Black Feminist Studies," *Signs* 19, no. 3 (1994).

45. Earlier third-wave publications featuring feminists of color, such as *Listen Up: Voices from the Next Feminist Generation* and *To Be Real: Telling the Truth and Changing the Face of Feminism*, are written off as autobiographical, experiential, anecdotal writing for the reading public that "rarely provides consistent analysis of the larger culture that has helped shape and produce these experiences." Heywood and Drake, "Introduction," 2; Barbara Findlen, *Listen Up: Voices from the Next Feminist Generation* (Seattle, WA: Seal

Press, 1995); Rebecca Walker, *To Be Real: Telling the Truth and Changing the Face of Feminism* (New York: Anchor Books, 1995). See also Deborah L. Siegel, "The Legacy of the Personal: Generating Theory in Feminism's Third Wave," *Hypatia* 12, no. 3 (1997): 50.

46. Sandoval, *Methodology of the Oppressed*, 49.

47. Kimberly Springer, "Third Wave Black Feminism?," *Signs: Journal of Women in Culture and Society* 27, no. 4 (2002).

48. Responding to an e-mail inquiry about the outcome of *The Third Wave*, transnational feminist scholar Jacqui Alexander noted many of the original manuscripts were published in another book. See M. Jacqui Alexander et al., eds., *Sing, Whisper, Shout, Pray!: Feminist Visions for a Just World* (Fort Bragg, CA: Edgework Books, 2003).

49. In *Black Sexual Politics: African Americans, Gender and The New Racism*, Patricia Hill Collins defines a controlling image as the "gender-specific depiction of people of African descent within Western scholarship and popular culture. The terms *representations* and *stereotypes* also describe this phenomenon. Representations need not be stereotypical and stereotypes need not function as controlling images. Of the three, controlling images are most closely tied to power relations of race, class, gender, and sexuality." Collins, *Black Sexual Politics*, 349–350.

50. Kimberlé Crenshaw, "Traffic at the Crossroads: Multiple Oppression," in *Sisterhood Is Forever: The Women's Anthology for a New Millennium*, ed. Robin Morgan (New York: Washington Square Press, 2003); bell hooks, *Feminist Theory: From Margin to Center*, 2nd ed., (Cambridge, MA: South End Press, 2000); James, *Shadowboxing*; Imani Perry, *Prophets of the Hood: Politics and Poetics in Hip Hop* (Durham, NC: Duke University Press, 2004); Tricia Rose, *Longing to Tell: Black Women Talk About Sexuality and Intimacy*, 1st ed. (New York: Farrar, Straus and Giroux, 2003); Sharpley-Whiting, *Pimps Up, Ho's Down*.

51. Cynthia Tucker, "Who Are the Hos Here?," *Time*, April 12, 2007.

52. Brian Cross, *It's Not About a Salary: Rap, Race, and Resistance in Los Angeles* (New York: Verso, 1993); Jeffrey Louis Decker, "The State of Rap: Time and Place in Hip Hop Nationalism," in *Microphone Fiends: Youth Music, Youth Culture*, eds. Andrew Ross and Tricia Rose (New York: Routledge, 1994); Joseph D. Eure and James G. Spady, *Nation Conscious Rap* (New York: PC International Press, 1991); S.H. Fernando, Jr, *The New Beats: Exploring the Music, Culture and Attitudes of Hip-Hop* (New York: Doubleday, 1994); Russell A. Potter, "History, Spectacle and Resistance," in *Spectacular Vernaculars: Hip-Hop and the Politics of Postmodernism* (New York: State University of New York Press, 1995); Mtume Salaam, "The Aesthetics of Rap," *African American Review* 29 (1995); Hashim A Shomari, *From the Underground: Hip Hop Culture as an Agent of Social Change* (New Jersey: X-Factor Publications, 1995).

53. Glenn Jordan and Chris Weedon, *Cultural Politics: Class, Gender, Race, and the Postmodern World* (Cambridge, MA: B. Blackwell, 1995).

54. Theresa A. Martinez, "Popular Culture as Oppositional Culture: Rap as Resistance," *Sociological Perspectives* 40 (1997).

55. Vibe Magazine, ed. *Hip Hop Divas* (New York: Three Rivers Press, 2001).

56. Diggs Town is a public housing community in Norfolk, Virginia. It was named after black attorney and civil rights leader J. Eugene Diggs. Before it underwent a facelift during an urban renewal initiative in the mid-1990s, the public housing community was called Diggs Park. It is still commonly called "The Park" by its residents. Both names are used throughout the book.

57. In the focus group, I asked: What is hip hop? The group identified popular artists, dances, and non-rap music. *Whip* and *ice* are slang terms for car and diamond jewelry.

58. I adapt the term *body culture* from Devika Chawla, who talks about "bodying" the ethnographic field through performance. See Devika Chawla, "Performance or Theory?: Ethnographic Re/Solutions and Dilemmas" (paper presented at the Third Congress of Qualitative Inquiry & Couch-Stone Symposium, Urbana, IL, May 5, 2007).

59. Laurel Richardson, "Writing: A Method of Inquiry," in *Turning Points in Qualitative Research: Tying Knots in a Handkerchief*, ed. Yvonna S. Lincoln and Norman K. Denzin, *Crossroads in Qualitative Inquiry* (Walnut Creek, CA: AltaMira Press, 2003), 187.

60. Norman K. Denzin, *Interpretive Interactionism*, 2nd ed., (Thousand Oaks, CA: Sage, 2001).

61. Ibid., xi.

62. Ibid., 34–38.

63. Ibid., 78; *Performance Ethnography: Critical Pedagogy and the Politics of Culture* (Thousand Oaks, CA: Sage, 2003), x. While interpretive interactionism was adapted from Chicago School criminologists and sociologists who developed and employed symbolic interactionism as a way to examine signifying practices and the lived experience of local (within-group) subcultures, Denzin rearticulates interpretive interactionism as part of performance ethnography. For a discussion of the Chicago School, see Richard Gil Musolf, "The Chicago School," in *Handbook of Symbolic Interactionism*, ed. Larry T. Reynolds and Nancy J. Herman-Kinney (Walnut Creek, CA: Altamira Press, 2004).

64. Denzin, *Interpretive Interactionism*, 32.

65. Laurel Richardson, "Writing: A Method of Inquiry," in *The Sage Handbook of Qualitative Research*, eds. Norman K. Denzin and Yvonna S. Lincoln (Thousand Oaks, CA: Sage, 2000), 924.

66. Laurel Richardson and Elizabeth Adams St. Pierre, "Writing: A Method of Inquiry," in *The Sage Handbook of Qualitative Research*, eds. Norman K. Denzin and Yvonna S. Lincoln (Thousand Oaks, CA: Sage, 2005), 967.

67. Ibid., 963–970.

68. Audre Lorde, *Sister Outsider: Essays and Speeches* (Trumansburg, NY: Crossing Press, 1984), 37.

69. Also see D. Soyini Madison, "That Was My Occupation: Oral Narrative, Performance, and Black Feminist Thought," in *Exceptional Spaces: Essays in Performance and His-*

tory, ed. Della Pollock (Chapel Hill: University of North Carolina Press, 1998), 320.

70. Denzin, *Interpretive Interactionism*.

71. Norman K. Denzin and Yvonna S. Lincoln, *The Qualitative Inquiry Reader* (Thousand Oaks, CA: Sage, 2002), 155.

72. Madison, "That Was My Occupation," 335.

73. Zora Neale Hurston, *Their Eyes Were Watching God: A Novel*, 1st Perennial Library ed. (New York: Perennial Library, 1990).

74. Denzin and Lincoln, *The Qualitative Inquiry Reader*, 155–156.

PART I: AUTOETHNOGRAPHY

1. Autoethnography is a method and writing genre that examines a vulnerable, situated self in relation to culture. For a detailed discussion of autoethnography, see Carolyn Ellis, *The Ethnographic I: A Methodological Novel About Autoethnography*, (Walnut Creek, CA: AltaMira Press, 2004); Deborah Reed-Denahay, *Autoethnography: Rewriting the Self and the Social* (New York: Berg Publishers, 1997). Autoethnography, personal narrative, reflexivity: Carolyn Ellis and Arthur Bochner, "Autoethnography, Personal Narrative, Reflexivity: Researcher as Subject," in *Handbook of Qualitative Research*, ed. Norman K. Denzin and Yvonna S. Lincoln (Thousand Oaks, CA: Sage, 2000). Interpretive biography: Norman K. Denzin, *Interpretive Biography*, (Newbury Park, CA: Sage, 1989). Performance autoethnography: Denzin, *Interpretive Biography*; Stacy Holman Jones, "Autoethnography: Making the Personal Political," in *The Sage Handbook of Qualitative Research*, ed. Norman K. Denzin and Yvonna S. Lincoln (Thousand Oaks, CA: Sage, 2005); Tami Spry, "Performing Autoethnography: An Embodied Methodological Praxis," *Qualitative Inquiry* 7, no. 6 (2001). Reflexive ethnography: Carolyn Ellis, "Creating Criteria: An Ethnographic Short Story," *Qualitative Inquiry* 6, no. 2 (2000). Auto-anthropology: Noel Dyck, "Home Field Advantage? Exploring the Social Construction of Children's Sports," in *Constructing the Field: Ethnographic Fieldwork in the Contemporary World*, ed. Vered Amit (New York: Routledge, 2000). Autobiographic ethnography: Ronald J. Pelias, *Writing Performance: Poeticizing the Researcher's Body* (Carbondale: Southern Illinois University Press, 1999). All these works privilege the social self to interpret cultural encounters.

2. Irma McClaurin, "Theorizing a Black Feminist Self in Anthropology: Toward an Autoethnographic Approach," in *Black Feminist Anthropology: Theory, Politics, Praxis, and Poetics*, ed. Irma McClaurin (New Brunswick, NJ: Rutgers University Press, 2001), 52–53.

3. Linda T. Smith, *Decolonizing Methodologies: Research and Indigenous Peoples* (London: Zed Books, 1999).

4. McClaurin, "Theorizing a Black Feminist Self in Anthropology," 52.

5. Dalia Rodriguez, "A Homegirl Goes Home: Black Feminism and the Lure of Native Anthropology," in *Black Feminist Anthropology: Theory, Politics, Praxis, and Poetics*, ed. Irma

McClaurin (New Brunswick, NJ: Rutgers University Press, 2001), 234.

6. Claudia Tate, "Audre Lorde," in *Black Women Writers at Work*, ed. Claudia Tate (New York: Continuum, 1983), 115.

7. Smith, *Home Girls: A Black Feminist Anthology*, xix.

8. Ibid., xix–xxxv.

9. hooks, *Yearning*, 42, 49.

10. Denzin, *Performance Ethnography*; Anna Deavere Smith, *Twilight–Los Angeles, 1992*, 1st ed. (New York: Anchor Books, 1994).

11. See Henry, *Not My Mother's Sister*. Drawing from Henry, I suggest when white-centered third-wave feminist genealogy claims third world or women of color feminists as intellectual foremothers, hip hop feminism is orphaned having no intellectual tradition. This manuscript, presented at a national conference proceeding, is referenced by Sharon Mazzarella in the preface to Ruth Nicole Brown, *Black Girlhood Celebration: Toward a Hip-Hop Feminist Pedagogy*, (New York: Peter Lang, 2009), ix–xii.

12. bell hooks, "Writing Autobiography," in *Flat-Footed Truths: Telling Black Women's Lives*, ed. Patricia Bell-Scott and Juanita Johnson-Bailey (New York: Henry Holt, 1998), 11; Irma McClaurin, "Salvaging Lives in the African Diaspora: Anthropology, Ethnography and Women's Narratives," in *Transnational Blackness: Navigating the Global Color Line*, ed. Manning Marable and Vanessa Agard-Jones, *Critical Black Studies* (New York: Palgrave Macmillan, 2008), 231. The quote from Ruth Nicole Brown came from a February 2, 2010, e-mail message to the author.

13. Ellis, *The Ethnographic I*.

CHAPTER I

1. Pough et al., *Home Girls Make Some Noise*; Sharpley-Whiting, *Pimps Up, Ho's Down*.

2. Kitwana, *The Hip Hop Generation*; Perry, *Prophets of the Hood*.

3. Derrick P. Alridge, "From Civil Rights to Hip Hop: Toward a Nexus of Ideas," *The Journal of African American History* 90, no. 3 (2005); Todd Boyd, *The New H.N.I.C. (Head Niggas in Charge): The Death of Civil Rights and the Reign of Hip Hop* (New York: New York University Press, 2002); Yvonne Bynoe, *Stand and Deliver: Political Activism, Leadership, and Hip Hop Culture* (Brooklyn, NY: Soft Skull Press, 2004).

4. Stuart Hall, "What Is This 'Black' in Black Popular Culture?," in *Black Popular Culture: A Project by Michele Wallace*, ed. Gina Dent (New York: The New Press, 1998).

5. Boyd, *The New H.N.I.C.*

6. hooks, *Yearning*, 41–49.

7. FEMA, "Report of the Joint Fire/Police Task Force on Civil Unrest: Recommendations for Organization and Operation During Civil Disturbance," (1994), 24–25.

8. Before major renovation to the public housing community, Diggs Town was called

Diggs Park. Both names are used throughout the book. For background information about the public housing development, see the Norfolk Redevelopment and Housing Authority's Web site at www.nrha.us.

9. Sujata Moorti, "Desperately Seeking an Identity: Diasporic Cinema and the Articulation of Transnational Kinship," *International Journal of Cultural Studies* 6 (2003).

10. Lola Ogunnaike, "Clipse Get Their Day in the Sun," *Daily News*, August 29, 2002.

11. Both scenes in the documentary talk about class by deploying notions of the street: man-on-the-street interviews to represent the so-called real, street, or gangsta rap to emphasize racial authenticity, and women walking (on) the street to categorize femininity.

12. Rose, *Black Noise*.

13. Mike Knepler, "Councilman Takes Aim at Public Housing," *The Virginian-Pilot*, September 21, 1994.

14. Robin D.G. Kelley, "Looking for the 'Real' Nigga: Social Scientists Construct the Ghetto," in *That's the Joint!: The Hip-Hop Studies Reader*, eds. Mark Anthony Neal and Murray Forman (New York: Routledge, 2004).

15. Chris Barker, *Cultural Studies: Theory and Practice*, 2nd ed. (Thousand Oaks, CA: Sage, 2003), 161–162.

16. Mary Patillo, "Black Middle-Class Neighborhoods," *Annual Review of Sociology* 31 (2005): 307.

17. Shawn A. Ginwright, "Classed Out: The Challenges of Social Class in Black Community Change," *Social Problems* 49, no. 4 (2002): 546–547.

18. Ibid.

19. Karyn R. Lacy, "Black Spaces, Black Places: Strategic Assimilation and Identity Construction in Middle-Class Suburbia," *Ethnic and Racial Studies* 27, no. 6 (2004).

20. Hazel Carby, "Policing Black Women's Body in an Urban Context," *Critical Inquiry* 18, no. 4 (1992): 746.

21. For a detailed discussion about the construction of the black underclass and its relation to culture debates about hip hop, see Robin D.G. Kelley, *Yo' Mama's Disfunktional!: Fighting the Culture Wars in Urban America* (Boston: Beacon Press, 1997).

22. Douglas S. Massey and Nancy A. Denton, *American Apartheid: Segregation and the Making of the Underclass* (Cambridge, MA: Harvard University Press, 1993), 117.

23. Ibid., 117–126.

24. Kelley, "Looking for the 'Real' Nigga," 120.

25. Patillo, "Black Middle-Class Neighborhoods," 207.

26. Kelley, "Looking for the 'Real' Nigga," 120.

27. Barker, *Cultural Studies*, 162.

28. Murray Forman, " 'Represent': Race, Space, and Place in Rap Music," in *That's the Joint: The Hip-Hop Studies Reader*, eds. Mark Anthony Neal and Murray Forman (New

York: Routledge, 2004).

29. Edwards Helmore, "Oprah's Worst Enemies: Rappers Clipse Take Their Inspiration from Their Previous Career as Drug Dealers," *The Guardian*, April 27, 2007, 6.

30. Carby, "Policing Black Women's Body in an Urban Context."

31. I define hip hop feminism as a sociocultural, intellectual, and political movement grounded in the situated knowledge of women of color from the post–civil rights generation who recognize culture as a pivotal site for political intervention to challenge, resist, and mobilize collectives to dismantle systems of exploitation. See Pough et al., *Home Girls Make Some Noise*.

32. Carby, "Policing Black Women's Body in an Urban Context," 747–750.

33. Farah Jasmine Griffin, "Black Feminists and DuBois: Respectability, Protection, and Beyond," *Annals of the American Academy of Political and Social Science* 568 (2000).

34. Ginwright, "Classed Out."

35. An earlier version of the Greekfest narrative is included in Aisha Durham, "Recalling, Re-membering, and (Re)Visiting Hip-Hop/Home/Bodies," in *Globalizing Cultural Studies: Ethnographic Interventions in Theory, Method, and Policy*, eds. Cameron McCarthy, et al. (New York: Peter Lang, 2007).

36. Bruce Seeman, Lynn Waltz, and Tracie Finley, "Students Voice Their Concerns as Tension Lingers," *The Virginian-Pilot and the Ledger Star*, September 5, 1989; Bruce T. Seeman, "Merchants Pick up Pieces in Aftermath of Looting," *The Virginian-Pilot and the Ledger Star*, September 4, 1989; Beverly Shepard and Marc Davis, "Revelry Turns to Mayhem: Police Use Force on 2nd Night of Clash," *The Virginian-Pilot and the Ledger Star*, September 4, 1989; Jason Skog, "Beach Tries to Get Black Guests Back: 15 Years after Greekfest Riots, City's Ban Still Leaves a Bad Taste," *The Virginian-Pilot and the Ledger Star*, September 6, 2004.

37. "Blacks in South Africa Protest Whites-Only Beach," *The Virginian-Pilot and the Ledger Star*, September 4, 1989; "S. Africa Blacks Strike to Protest Today's Election," *The Virginian-Pilot and the Ledger Star*, September 6, 1989.

38. "Hostility Greets N.Y Protestors: Residents Jeer Parade Prompted by Racial Killing," *The Virginian-Pilot and the Ledger Star*, September 5, 1989.

39. P Jordan, "Some of 100 Detainees Allege Random Arrest, Mistreatment," *The Virginian-Pilot and the Ledger Star*, September 5, 1989.

40. Marc Davis, "Mayor Raised for Beach Riot Control: Oberndorf Radio Show Draws Supportive Callers," *The Virginian-Pilot and the Ledger Star*, September 7, 1989.

41. Buckwheat was a child character from the *Little Rascals* film series. The black character harkens the offensive racial stereotype called the picaninny and is sometimes deployed within the African American community to refer to a person with unkempt hair.

CHAPTER 2

1. C. W. Marshall and Tiffany Potter, "'I Am the American Dream': Modern Urban Tragedy and the Borders of Fiction," in *The Wire: Urban Decay and American Television*, eds. Tiffany Potter and C. W. Marshall (New York: Continuum, 2009).

2. Ryan Brooks, "The Narrative Production of 'Real Police,'" in *The Wire: Urban Decay and American Television*, eds. Tiffany Potter and C. W. Marshall (New York: Continuum, 2009).

3. Joe Jackson, "'Gun Central': Norfolk Street Sales Linked to Murder Rate, Drug Trade," *The Virginian-Pilot*, November 17, 1991.

4. Joe Jackson, "Norfolk Thieves Target Costly Athletic Clothes," *The Virginian-Pilot*, October 23, 1991.

5. Mike Knepler, "With Help from Club, Youth Begins Turning Life Around," *The Virginian-Pilot*, February 23, 1992.

6. Mike Knepler, "Woman Lost Son, but Works to Help Others: A Diggs Town Activist Carries on for the Neighborhood after Her Son Is Slain," *The Virginian-Pilot*, June 15, 1996.

7. "Teen Shot in Berkley Area," *The Virginian-Pilot*, June 5, 1991.

8. June Arney, "Streets Crush Teen's Potential: He Had Street Smarts in His Corner, but Now He's Back in the Norfolk Jail," *The Virginian-Pilot*, December 12, 1994.

9. Joe Jackson, "Tensions High in Diggs Town Drug Fight: Police Harassment Is Alleged," *The Virginian-Pilot*, May 10, 1991.

10. Joe Jackson, "Gunfire Rips School Crowd 3 Teens Wounded," *The Virginian-Pilot*, January 24, 1992.

11. Larry W. Brown, "Police to Patrol Public Housing: Officer Richard James Is One of Eight Norfolk Police Officers and Two Supervisors Who Volunteered to Patrol the City's Public Housing Communities on Foot and Bicycle," *The Virginian-Pilot*, March 18, 1995.

12. "Arrest in Fatal Shooting," *The Virginian-Pilot*, September 3, 1994.

13. Joe Cosco, "Defense Attorney Depicts Murderer as an Abused Child: Jean Claude Oscar Is the Most Likely of the Three Defendants to Be Sentenced to Death," *The Virginian-Pilot*, March 18, 1994.

14. Joe Jackson, "Abuse Alleged During Anti-Drug Sweep," *The Virginian-Pilot*, April 20, 1991.

15. "20 Arrested in Norfolk in Police Drug Stings," *The Virginian-Pilot*, April 2, 1991.

16. Mike Knepler, "Norfolk Plan Designed to Tighten Security," *The Virginian-Pilot*, March 19, 1991.

17. Knepler, "Councilman Takes Aim at Public Housing."

18. Sonsyrea Tate, "Does PACE Work? It Depends Whom You Ask," *The Virginian-Pilot*, May 24, 1992.

19. Jon Frank, "Diggs Town, Portsmouth: A Porch Here, a Road There Helped Clean up One Project," *The Virginian-Pilot*, October 5, 1995.

20. Mike Knepler, "Allen Visit Puts a Face on Welfare: Diggs Town Residents Put Safety High on Their Property List for Reforms," *The Virginian-Pilot*, June 30, 1994.

21. Larry W. Brown, "Food-Stamp Plan May Hurt Small Stores: Federal Officials Say the Proposal Would Help Reduce Fraud," *The Virginian-Pilot*, January 8, 1995.

22. Mike Knepler, "Councilman Won't Retract Slam on Tenants," *The Virginian-Pilot*, September 27, 1994.

23. Scott McCaskey, "Parade a Celebration of Southside Pride: A Current of Enthusiasm Is Flowing through the Citizenry of the Neighboorhoods," *The Virginian-Pilot*, December 7, 1995.

24. "Norfolk's Drug Fights: Working Together [Commentary]," *The Virginian-Pilot*, May 19, 1991.

25. Alex Marshall, "Public Housing on the Block: HUD Official's Visit Brings Budget Debate to Diggs Town," *The Virginian-Pilot*, August 22, 1995.

26. Steve Suo, "She'll Be the First in Her Family to Graduate: Scott's Reversal Done for Mom," *The Virginian-Pilot*, June 23, 1991.

27. Claudine R. Williams, "Hard Work Pays Off in Scholarship Aid for Student," *The Virginian-Pilot*, July 6, 1995.

28. Rodney Ho, "His Job: Helping Kids in a 'War Zone,'" *The Virginian-Pilot*, January 17, 1993.

29. Jon Glass, "The Earlier, the Better: A Preschool Program Serving the Berkley and Campostella Areas of Norfolk Is Helping to Raise the Expectations—and Hopes—of Parents and Students," *The Virginian-Pilot*, November 5, 1995.

PART 2: TEXTUAL EXPERIENCE

1. Denzin, *Performance Ethnography*, 111–112. Addressing reading texts with audiences, Robin R. Means Coleman suggests interpretations are experientially based, transactional and subjective, and based on a relationship with others that create emergent, collaborative meaning. Robin R. Means Coleman, *African American Viewers and the Black Situation Comedy: Situating Racial Humor*, (New York: Garland Publishers, 2000), 12–13.

2. Stuart Hall, "Introduction," in *Paper Voices: The Popular Press and Social Change, 1935-1965*, ed. A. Smith, E. Immirzi, and T. Blackwell (Totowa: Rowman & Littlefield, 1975).

3. Ibid., 15.

4. Lawrence Grossberg, "The Formations of Cultural Studies: An American in Birmingham," in *Relocating Cultural Studies: Developments in Theory and Research*, ed. Valda Blundell, John Shepherd, and Ian Taylor (New York: Routledge, 1993), 36.

5. Ibid.

6. David J. Leonard, *Screens Fade to Black: Contemporary African American Cinema* (Westport, CT: Praeger Publishers, 2006), 13.

7. Norman K. Denzin, *Reading Race: Hollywood and the Cinema of Racial Violence* (Thousand Oaks, CA: Sage, 2002), 22–23. In *African American Viewers and the Black Situation Comedy*, Robin R. Means Coleman contends, "The domination and subordination over African Americans, through cultural representations, results in objectification, caricature, or an exotic casting of Blackness that calls racial identity and relevancy into question." Means Coleman, *African American Viewers and the Black Situation Comedy*, 8–9.

8. Matthew W. Hughey, "Cinethetic Racism: White Redemption and Black Stereotypes in 'Magical Negro' Films," *Social Problems* 56, no. 3 (2009); Leonard, *Screens Fade to Black*.

9. Ella Shohat, "Area Studies, Gender Studies, and the Cartographies of Knowledge," *Social Text* 20, no. 3 (2002).

CHAPTER 4

1. For a detailed discussion of Latifah and her hip hop persona, see Kristal Brent Zook, " 'Living Single' and the 'Fight for Mr. Right': Latifah Don't Play," in *Gender, Race, and Class in Media: A Text Reader*, ed. Jean McMahon and Gail Dines Humez (Thousand Oaks, CA: Sage, 2002). Zook discusses the way the young urban black body signifies hip hop culture in popular culture. Like other forms of designated black expressive culture, hip hop and the bodies that make (up) the culture are sexualized.

2. A version of this chapter was presented at the 2005 International Communication Association conference in New York City. I would like to thank Dr. Angharad N. Valdivia, University of Illinois at Urbana-Champaign, for her initial review and thorough feedback throughout this research endeavor.

3. In the late '80s and early '90s, each of these breakout artists introduced a particular aesthetic to the hip hop generation and helped to carve specific genres within hip hop. For example, Latifah is closely associated with Afrocentrism and womanism, at one time donning Kente cloth and leather medallions. Ice Cube and Ice-T are affiliated with gangsterism. Ice Cube is a former member of the defunct rap group Niggaz With an Attitude (NWA). Although credited with the introduction of a West Coast gangster identity, the group also was nationalist in tone, drawing from Islam. See Eure and Spady, *Nation Conscious Rap*. Like the Black Panthers, NWA also became famous for wearing all-black street fashion. Ice-T helped solidify the image of the pimp and ho, which has become an archetype for black representations of men and women in hip hop culture. LL Cool J, whose acronym stands for Ladies Love Cool James, is widely known as hip hop's first sex symbol. Will Smith, known to an earlier hip hop audience as the Fresh Prince, has morphed from a comedic rapper to an action hero in major motion pictures. These particular bodies demonstrate the movement of hip hop from the margins to the mainstream.

4. Boyd, *The New H.N.I.C*; Collins, "Distinguishing Features of Black Feminist Thought."; *Black Sexual Politics*; Rose, *Black Noise*; " 'Two Inches or a Yard': Silencing Back Women's Sexual Expression," in *Talking Visions: Multicultural Feminism in a Transnational Age*, ed. Ella Shohat (New York: MIT Press, 1998); *Longing to Tell*.

5. Cole and Guy-Sheftall, *Gender Talk*; Collins, *Black Sexual Politics*.

6. Zillah R. Eisenstein, *Hatreds: Racialized and Sexualized Conflicts in the 21st Century* (New York: Routledge, 1996); Carla L. Peterson, "Foreword: Eccentric Bodies," in *Recovering the Black Female Body*, ed. Michael Bennett and Vanessa D. Dickerson (New Brunswick, NJ: Rutgers University Press, 2001); Rose, *Black Noise*.

7. Cheryl Keyes, "Empowering Self, Making Choices, Creating Spaces: Black Female Identity Via Rap Music Performances," in *That's the Joint!: The Hip-Hop Studies Reader*, eds. Mark Anthony Neal and Murray Forman (New York: Routledge, 2004), 266–267; Mark Anthony Neal, *What the Music Said: Black Popular Music and Black Public Culture* (New York: Routledge, 1999), 166–168; *Soul Babies: Black Popular Culture and the Post-Soul Aesthetic* (New York: Routledge, 2002), i; Layli Phillips, K. Reddick-Morgan, and Dionne Stephens, "Oppositional Consciousness within an Oppostional Realm: The Case of Feminism and Womanism in Rap and Hip Hop, 1976–2004," *Journal of African American History* 90, no. 3 (2005).

8. Decker, "The State of Rap."; Robin Roberts, " 'Ladies First': Queen Latifah's Afrocentric Feminist Music Video," *African American Review* 28, no. 2 (1994).

9. Keyes, "Empowering Self, Making Choices, Creating Spaces."; Kierna Mayo, "The Last Good Witch," in *Hip-Hop Divas*, ed. Vibe Magazine (New York: Three Rivers Press, 2001); Queen Latifah, *Ladies First: Revelations of a Strong Woman* (New York: William Morrow, 1999).

10. Murray Forman, " 'Movin' Closer to an Independent Funk': Black Feminist Theory, Standpoint, and Women in Rap," *Women's Studies* 94, no. 1 (1994); Gwendolyn D. Pough, "Love Feminism but Where's My Hip Hop?: Shaping a Black Feminist Identity," in *Colonize This!: Young Women of Color on Today's Feminism*, ed. Daisy Hernández and Bushra Rehman (New York: Seal Press, 2002).

11. Kara Keeling, " 'Ghetto Heaven': *Set It Off* and the Valorization of Black Lesbian Butch-Femme," *Black Scholar* 33, no. 1 (2003).

12. Judith Halberstam, *Female Masculinity* (Durham, NC: Duke University Press, 1998), 227–230.

13. Angie C. Beatty, "What Is This Gangstressism in Popular Culture?: Reading Rap Music as a Legitimate Hustle & Analyzing the Role of Agency in Female Rappers" (Dissertation, University of Michigan, 2005).

14. Pough, *Check It While I Wreck It*.

15. In social media, Beyoncé has reignited the conversation about the popular use of feminism when she used an excerpt from an online talk by Nigerian author Chimamanda Ngozi Adichie in her song "Flawless." See Cooper, "The Beyoncé Wars."

16. Halberstam, *Female Masculinity*, 228; Zook, " 'Living Single' and the 'Fight for Mr. Right' "; Danyel Smith, "Ooh, La, La: Heads Ain't Ready for Queen Latifah's Next Move," *Vibe*, December 1996/January 1997, 102.

17. "Queen Latifah Says She Did Not Come Out At Long Beach Pride Festival," *Huff-Post Gay Voices*, June 4, 2012, accessed January 29, 2014, http://www.huffingtonpost.com/2012/06/04/queen-latifah-did-not-come-out-pride_n_1529566.html

18. Queen Latifah, *Ladies First*; *Put on Your Crown: Life-Changing Moments on the Path to Queendom* (New York: Grand Central, 2010).

19. Connie Chung. "Interview with Queen Latifah." *CNN Connie Chung Tonight*, anchor Connie Chung, January 10, 2003.

20. Pough, *Check It While I Wreck It*.

21. Ibid. Also see Zook, " 'Living Single' and the 'Fight for Mr. Right,' " 133.

22. See Smith Cooper, "Can a Good Mother Love Hip-Hop?"

23. Cheryl Keyes defines the "Queen Mother" as the rapper who is African-centered in dress and lyrics. Latifah demands respect. Pointing to how the body invites us to read gender representations, Keyes suggests it is her "maternal demeanor, posture, and full figure" that characterize her as queen mother. Keyes, "Empowering Self, Making Choices, Creating Spaces," 266–268.

24. Allison Samuels, "Minstrels in Baggy Jeans?," *Newsweek*, May 5, 2003. This article includes commentary from hip hop cultural critic Kevin Powell, scholars Todd Boyd and Donald Bogle, filmmaker John Singleton, and rap artists and producers Snoop Dogg and Damon Dash. Also see Neal, *Soul Babies*, 158.

25. "Chicago," Box Office Mojo, http://www.boxofficemojo.com/movies/?id=chicago.htm; "Bringing Down the House," Box Office Mojo, http://www.boxofficemojo.com/movies/?id=bringingdownthehouse.htm.

26. For a detailed discussion of this sitcom, see Zook, " 'Living Single' and the 'Fight for Mr. Right.' "

27. In the *Hip Hop Generation*, Bakari Kitwana coins the term *hip hop generation* not only in an attempt to talk about hip hop as an epistemology but as a moniker that could add historical specificity to the experiences of young women and men of color in the United States born between 1965 and 1984. See Kitwana, *The Hip Hop Generation*, xiii. He takes hip hop away from the white-oriented label "Generation X." He extends the discussion of the hip hop generation's signifying practices (break dancing and graffiti) and consumer products (rap albums) to talk about the identity politics that play out in the everyday lives of those who identify with hip hop and who are among the hip hop generation. He suggests this generation is informed by class warfare, police brutality, the explosion of gangs and drugs, racial animosity, and the deferment of the American dream (after the 1964 Civil Rights Act granting full legal enfranchisement) and a misunderstanding of complex race relations between the civil rights generation and the "post" generation. See ibid., 37–43.

28. Lauren Berlant addresses how images of national minorities are represented in pop cultural and political discourses. See Lauren Gail Berlant, *The Queen of America Goes to Washington City: Essays on Sex and Citizenship* (Durham, NC: Duke University Press, 1997). Her chapter on diva citizenship focuses on black women, sexuality, and citizenship. She problematizes the private/public dichotomy that black women never experience. Berlant contextualizes Anita Hill and the slave narrative of Linda Brent (Harriet Jacobs) to discuss the interrelationship between black women's sexuality and citizenship(s). According to Berlant, African American sexuality was always a point of public discourse. For black feminists, such as Dorothy Roberts, it is the public discourse surrounding deviant black female sexuality that continually impedes U.S. women of color from experiencing full political and economic citizenship. Roberts identifies media representation as central to facilitating black women's exploitation. See Dorothy E. Roberts, *Shattered Bonds: The Color of Child Welfare* (New York: Basic Books, 2002). When the image of colonized people is used to support neocolonialism, third world feminist scholar Chela Sandoval suggests it serves as a type of recolonization. See Sandoval, *Methodology of the Oppressed*.

29. Sasha Torres, "Introduction," in *Living Color: Race and Television in the United States*, ed. Sasha Torres (Durham, NC: Duke University Press, 1998), 1–11.

30. Aisha Durham and Jillian Báez, "A Tail of Two Women: Exploring the Contours of Difference in Popular Culture," in *Curriculum and the Cultural Body*, ed. Stephanie Springgay and Debra Freedman (New York: Peter Lang, 2007), 136–145.

31. Mass media makers are those people who are a part of media systems (music, television, and film industries) that have access to institutional forms of power that provide them with the ability to mass promote, create, and distribute media products such as records, films, newspapers, and magazines. I am less concerned with media makers as individual agents performing racist acts or as conspirators working in concert with rich heterosexual white able-bodied men who deliberately create stereotypes to oppress black people; rather, I am interested in discussing how these representations work to facilitate racism, which is an ideological system grounded in a structure of domination that exploits racialized vulnerable bodies to horde and organize resources for a privileged few.

32. Marita Sturken and Lisa Cartwright, *Practices of Looking: An Introduction to Visual Culture* (Oxford: Oxford University Press, 2001), 56–67.

33. bell hooks, *Writing Beyond Race: Living Theory and Practice* (New York: Routledge, 2013), 18.

34. Collins, *Black Sexual Politics*; Massey and Denton, *American Apartheid*.

35. Collins, "Distinguishing Features of Black Feminist Thought," 69–96.

36. Collins, "The Tie That Binds," 8; "Distinguishing Features of Black Feminist Thought," 10–12.

37. Collins, "Distinguishing Features of Black Feminist Thought," 70–72.

38. Andrea Smith, "Heteropatriarchy and the Three Pillars of White Supremacy:

Rethinking Women of Color Organizing," in *Color of Violence: The Incite! Anthology*, ed. Incite! Women of Color Against Violence. (Cambridge, MA: South End Press, 2006).

39. Rosa Linda Fregoso talks about the miscegenation between white men and Mexican women. She argues Mexicans were seen as a mongrel race, and the fear of race mixing was informed by racist ideologies about blacks. See Rosa Linda Fregoso, *MeXicana Encounters: The Making of Social Identities on the Borderlands* (Berkeley: University of California Press, 2003), 133–136. Patricia Hill Collins suggests the popular discourse surrounding the posterior of Jennifer Lopez is because she is racialized as black because of her affiliation with hip hop (designated as black culture in popular culture) and her relationship with African American rapper Puff Daddy. See Collins, *Black Sexual Politics*. The butt represents the hypersexuality of black women. Its size alone feeds into the racist ideologies of the black female body as perverse and her sexual appetite as insatiable. See Angela M. Gilliam, "A Black Feminist Perspective on the Sexual Commodification of Women in the New Global Culture," in *Black Feminist Anthropology: Theory, Politics, Praxis and Poetics*, ed. Irma McClaurin (New Brunswick, NJ: Rutgers University Press, 2001), 150–186; bell hooks, *Black Looks: Race and Representation* (Boston: South End Press, 1992). Multicultural feminist Ella Shohat addresses processes of racialization and ethnicization for those bodies unmarked as black in other spaces. Ella Shohat, "Introduction," in *Talking Visions: Multicultural Feminism in a Transnational Age*, ed. Ella Shohat (New York: MIT Press, 1998). Also see Chandra Talpade Mohanty, *Feminism without Borders: Decolonizing Theory, Practicing Solidarity* (Durham, NC: Duke University Press, 2003).

40. Donald Bogle, *Toms, Coons, Mulattoes, Mammies and Bucks: An Interpretive History of Blacks in American Films*, 4th ed. (New York: Continuum, 2001). In his reading, Bogle relies heavily on physicality to describe female stereotypes. I draw from his discussion of physicality because it enables me to examine the visual logic of particular ethnic bodies.

41. Collins, "Distinguishing Features of Black Feminist Thought," 46–67.

42. Vednita Carter, "Prostitution=Slavery," in *Sisterhood Is Forever: The Women's Anthology for a New Millennium*, ed. Robin Morgan (New York: Washington Square Press, 2003); bell hooks, *Ain't I a Woman: Black Women and Feminism* (Boston: South End Press, 1981); Harriet A. Jacobs, *Incidents in the Life of a Slave Girl* (New York: AMS Press, 1973).

43. Peterson, "Foreword: Eccentric Bodies," ix.

44. Bogle, *Toms, Coons, Mulattoes, Mammies and Bucks*.

45. Roberts, *Shattered Bonds*, 68.

46. Collins, "Distinguishing Features of Black Feminist Thought"; *Black Sexual Politics*.

47. Here I am referring to commercial advertising Amp'd cell-phone service. In a 2006 commercial, a black woman dances on the pole. A black man wrestles a white man behind her. The commercial suggests you can get what you want when you want it. It implies accessible black female hypersexuality and black hypermasculinity. See http://www.youtube.com/watch?v=JLwrsuqbmxg. In addition, Comedy Central's cartoon sketch comedy *Drawn Together* (2004–2008) features a caricature of a young black

female outfitted in go-go boots, a visible G-string, fox ears, and a tail. Foxxy Love reifies the freak. The text accompanying the Foxxy Love character reads: "Promiscuous, melodious, and possibly infectious, Foxxy Love is a sexy, sassy, tambourine-wielding mystery solving musician. Quick to pick up the case and even quicker to drop her drawers, she's every man's fantasy and every criminal's worst nightmare." See http://drawn-together. tripod.com/id12.html

48. Michael Fleming, "Rogue Dishes 'Welfare,' " *Daily Variety*, April 12, 2006. In mid-2010, Latifah's IMDb page listed this movie as "in development." However, in early 2014, the project no longer appeared on her IMDb page. "Queen Latifah," IMDb: The Internet Movie Database, http://www.imdb.com/name/nm0001451/.

49. James, *Shadowboxing*, 127.

50. Collins, "Distinguishing Features of Black Feminist Thought," 81–83.

51. In "Hey Girl, Am I More than My Hair?: African American Women and Their Struggles with Beauty, Body Image, and Hair," Tracey Patton uses Rose Weitz to talk about ideal white beauty: "The three most common standards of White beauty in the United States that women are subject to include: (1) women's hair should be long, curly or wavy—not kinky—and preferably blond; (2) women's hair should look hairstyled—this requires money and time; and (3) women's hair should look feminine and different from men's hair." Tracey Owens Patton, "Hey Girl, Am I More Than My Hair?: African American Women and Their Struggles with Beauty, Body Image, and Hair," *NWSA Journal* 18, no. 2 (2006): 30.

52. Collins, *Black Sexual Politics*, 29–33.

53. Paula Giddings, *When and Where I Enter: The Impact of Black Women on Race and Sex in America*, 1st ed. (New York: W. Morrow, 1984).

54. Angela Y. Davis, *Blues Legacies and Black Feminism: Gertrude 'Ma' Rainey, Bessie Smith, and Billie Holiday* (New York: Pantheon Books, 1998).

55. See Jeanine Amber, "She's the Boss," *Essence*, October, 2006. In the *Essence* interview, Latifah called herself "the ultimate runaway bride, the bachelorette of life."

56. Bonnie Dow suggests any text has the possibility to be polysemic or polyvalent but narrative and cinematic techniques make it difficult to depart from hegemonic readings. See Bonnie J. Dow, *Prime Time Feminism: Television, Media Culture, and the Women's Movement since 1970* (Philadelphia: University of Pennsylvania Press, 1996), 1–23.

57. Roopali Mukherjee, "The Ghetto Fabulous Aesthetics in Contemporary Black Culture: Class and Consumption in the *Barbershop* Films," *Cultural Studies* 20, no. 6 (2006).

58. Commenting on the use of stereotypes in *Chicago*, Latifah says: "It was a question of what's funny and what's too much. I think you can laugh at things that may be racist or classist because some of it is so ridiculous that it's just funny. But there are some things that are completely offensive that have to go. We didn't want to have protesters boycotting the movie. So we got rid of as much of that as we could. The rest was just chemistry and us playing with each other and coming up with different things and dif-

ferent words, letting it happen in rehearsal and letting it happen on the set." See Ciaran Carty, "Moma Knows Best: Queen Latifah Proved She Could Act Playing Sassy Prison Warder Moma in *Chicago*," *The Sunday Tribune*, June 8, 2003.

59. Alice Filmer uses the theory of acoustic identity to describe the interplay between auditory and visual cues to understand racial and ethnic identity. See Alice Filmer, "The Acoustics of Identity: Bilingual Belonging and Discourses of Trespassing," in *Globalizing Cultural Studies: Ethnographic Interventions in Theory, Method, and Policy*, ed. Cameron McCarthy, et al. (New York: Peter Lang, 2007). I draw from Filmer's work to consider my disconnect listening to the pro-woman, black feminist songs and watching rapper Latifah-turned-actor perform roles that perpetuate racial stereotypes about black womanhood.

60. Wallace, *Invisibility Blues*, 242.

61. Dow, *Prime Time Feminism*, 5.

62. Pough, *Check It While I Wreck It*.

63. hooks, *Black Looks*, 115–132.

CHAPTER 5

1. Starrene Rhett, "Slim Thug: 'Black Women Need to Stand by Their Man More,' " *Vibe Magazine*, http://www.vibe.com/article/slim-thug-black-women-need-stand-their-man-more.

2. Dionne Stephens and Layli Phillips, "Freaks, Gold Diggers, Divas, and Dykes: The Sociohistorical Development of Adolscent African American's Sexual Scripts," *Sexuality & Culture* 7, no. 1 (2003).

3. Fran Yeoman, Carolyn Asome, and Graham Keeley, "Skinniest Models Are Banned from Catwalk," *The (London) Times*, September 9, 2006.

4. Maureen Jenkins, "Model Figure: Mannequins' Tushes Are Getting a Little Rounder," *Chicago Sun-Times*, July 5, 2005.

5. Kathie Lee Gifford and Hoda Kotb, "Today's Talk: Current Events Discussed," *The Today Show*, NBC, May 23, 2011. Also see Bubbles Bodywear: Take Your Gluteus to the Maximus. http://www.lovemybubbles.com/padded-panty-boyshorts.shtml (accessed January 6, 2013).

6. Jacqui Goddard and Nicola Davidson, "British Women Cast Aside the Skinny Look in Quest for a Superior Posterior," *The (London) Telegraph*, August 29, 2005, 3.

7. See Kamille Gentles and Kristen Harrison, "Television and Perceived Peer Expectations of Body Size among African American Adolescent Girls," *Howard Journal of Communications* 17, no. 1 (2006); Kristen Harrison, "Television Viewers' Ideal Body Proportions: The Case of the Curvaceously Thin Woman," *Sex Roles* 48, no. 5/6 (2003).

8. Thomas F. Cash et al., "How Has Body Image Changed? A Cross-Sectional Investi-

gation of College Women and Men from 1983 to 2001," *Journal of Consulting and Clinical Psychology* 72, no. 6 (2004).

9. Maya K. Gordon, "Media Contributions to African American Girls' Focus on Beauty and Appearance: Exploring the Consequences of Sexual Objectification," *Psychology of Women Quarterly* 32, no. 3 (2008): 254.

10. Yuanyuan Zhang, Travis L. Dixon, and Kate Conrad, "Rap Music Videos and African American Women's Body Image: The Moderating Role of Ethnic Identity," *Journal of Communication* 59, no. 2 (2009).

11. Harrison, "Television Viewers' Ideal Body Proportions."

12. Debra Merskin, "Reviving Lolita? A Media Literacy Examination of Sexual Portrayals of Girls in Fashion Advertising," *American Behavioral Scientist* 48, no. 1 (2004).

13. Aisha Durham, " 'Check on It': Beyoncé, Southern Booty, and Black Femininities in Music Video," *Feminist Media Studies* 12, no. 1 (2012).

14. Stephens and Phillips, "Freaks, Gold Diggers, Divas, and Dykes."

15. Rana Emerson, " 'Where My Girls At?': Negotiating Black Womanhood in Music Videos," *Gender & Society* 16, no. 1 (2002).

16. Shayne Lee, *Erotic Revolutionaries: Black Women, Sexuality, and Popular Culture* (Lanham, MD: Hamilton Books, 2010); Dionne Stephens and April Few, "The Effects of Images of African American Women in Hip Hop on Early Adolescents' Attitudes toward Physical Attractiveness and Interpersonal Relationships," *Sex Roles* 56, no. 3/4 (2007); Stephens and Phillips, "Freaks, Gold Diggers, Divas, and Dykes."; Carla E. Stokes, "Representin' in Cyberspace: Sexual Scripts, Self-Definition, and Hip Hop Culture in Black American Adolescent Girls' Home Pages," *Culture, Health & Sexuality* 9, no. 2 (2007).

17. William Simon and John H. Gagnon, "Sexual Scripts," *Society* 22, no. 1 (1984).

18. Ibid.

19. Ibid., 53–54.

20. Stephens and Phillips, "Freaks, Gold Diggers, Divas, and Dykes."

21. Julia S. Jordan-Zachery, *Black Women, Cultural Images, and Social Policy* (New York: Routledge, 2009). Also see Ange-Marie Hancock, *The Politics of Disgust: The Public Identity of the Welfare Queen* (New York: New York University Press, 2004).

22. Collins, *Black Sexual Politics*, 350.

23. A detailed discussion of interpretive interactionism is provided in the introduction.

24. Collins, *Black Sexual Politics*, 120–121; Lisa Jones, *Bulletproof Diva: Tales of Race, Sex, and Hair*, 1st ed. (New York: Doubleday, 1994), 78–82; Stephens and Phillips, "Freaks, Gold Diggers, Divas, and Dykes," 20; Stokes, "Representin' in Cyberspace," 176. Stephens and Phillips argue "freaks are essentially viewed as having no sexual inhibitions or hang-ups. Sex in any place, any position, and with any person (or number of people) characterize the Freak" (20).

25. Jones, *Bulletproof Diva*, 79–80.

26. Stokes, "Representin' in Cyberspace," 176. Stokes does not use the term *assumed* to describe her fourth variation of the freak. She does, however, suggest that visitors to the Web page assume the girl is "freaky." In one case, pornographic images are posted and sexually explicit songs, such as Ludacris's "P-Poppin' " (i.e., pussy popping) play in the background (176).

27. See "Latina's Refrain" in Chapter 6.

28. Collins, *Black Sexual Politics*, 25–52.

29. Deborah Willis, ed. *Black Venus 2010: They Called Her "Hottentot"* (Philadelphia: Temple University Press, 2010), 4.

30. Ibid.

31. William Jelani Cobb, "The Hoodrat Theory," in *Black Venus 2010: They Called Her "Hottentot,"* ed. Deborah Willis (Philadelphia: Temple University Press, 2010); Durham, " 'Check on It': Beyoncé, Southern Booty, and Black Femininities in Music Video"; Fatimah N. Muhammad, "How to Not Be 21st Century Venus Hottentots," in *Home Girls Make Some Noise: Hip Hop Feminism Anthology*, ed. Gwendolyn D. Pough, et al. (Mira Loma, CA: Parker Publishing, 2007); Elaine Richardson, "Lil' Kim, Hip-Hop Womanhood, and the Naked Truuf," in *Home Girls Make Some Noise*.

32. Durham and Báez, "A Tail of Two Women," 134–135.

33. *Booty* refers to the buttocks in African American vernacular and hip hop culture. Similar terms from the African diaspora include *batty* within Jamaican dancehall and *culo* within Puerto Rican reggaetón. There are a variety of African dance practices that emphasize hip movement. *Booty dancing* is an umbrella term deployed to categorize one group of dance practices.

34. Janis Faye Hutchinson, "The Hip Hop Generation: African American Male-Female Relationships in a Nightclub Setting," *Journal of Black Studies* 30, no. 1 (1999).

35. Beauty Bragg and Pancho McFarland, "The Erotic and the Pornographic in Chicana Rap: JV vs. Ms. Sancha," *Meridians: Feminism, Race, Transnationalism* 7, no. 2 (2007); Lorde, *Sister Outsider*. Audre Lorde argues pornography is a denial of erotic power and "emphasizes sensation without feeling" (54).

36. Miguel Muñoz-Laboy, Hannah Weinstein, and Richard Parker, "The Hip-Hop Club Scene: Gender, Grinding and Sex," *Culture, Health & Sexuality* 9, no. 6 (2007): 622, 624. In another article describing sexual dancing by African Americans on a Houston dance floor, Janis Hutchinson writes: "The dancing is very sexual at Club X and, to some degree, mimics the physical act of sex. . . . For example, one night a woman was dancing with her back to her boyfriend. She put her 'butt' in his crotch and proceeded to move in a circular motion against his genital area. He was not dancing, just standing. . . . Then she continued dancing, which was really a grinding of his crotch area." Hutchinson, "The Hip Hop Generation," 67.

37. Muñoz-Laboy, Weinstein, and Parker, "The Hip-Hop Club Scene." Also see Hutchinson, "The Hip Hop Generation," 67–68.

38. Muñoz-Laboy, Weinstein, and Parker, "The Hip-Hop Club Scene," 622, 626.

39. Lee, *Erotic Revolutionaries*.

40. Kyra D. Gaunt, "African American Women between Hopscotch and Hip-Hop: 'Must Be the Music (That's Turnin' Me On),' " in *Feminism, Multiculturalism, and the Media: Global Diversities*, ed. Angharad N. Valdivia (Thousand Oaks, CA: Sage, 1995).

41. Ibid., 280.

42. Brown, *Black Girlhood Celebration*.

43. Beretta E. Smith-Shomade, *Shaded Lives: African-American Women and Television* (New Brunswick, N.J.: Rutgers University Press, 2002), 83.

44. Kyra Gaunt cites Leslie "Big Lez" Segar as an example. Segar choreographed and appeared in several hip hop and R&B music videos, such as Mary J. Blige's "Real Love" and LL Cool J's "Around the Way Girl." She does a solo performance for the opening to Queen Latifah's television show *Living Single*.

45. See Collins, *Black Sexual Politics*; Lisa B. Thompson, *Beyond the Black Lady: Sexuality and the New African American Middle Class* (Urbana: University of Illinois Press, 2009).

46. Ludacris addresses the public and private performance of the desirable lady who is freaky in bed and financially independent in Usher's "Yeah" (2004). In his song "Nasty Girl" (2009), Ludacris and rapper Plies offer a more detailed account of the script. Plies adds that ladies are also college and church girls, referencing the black middle class.

47. Hutchinson, "The Hip Hop Generation," 74.

48. Thompson, *Beyond the Black Lady*; Deborah Gray White, "The Cost of Club Work, the Price of Black Feminism," in *Visible Women: New Essays on American Activism*, eds. Nancy A. Hewitt and Suzanne Lebsock (Urbana: University of Illinois Press, 1993).

49. White, "The Cost of Club Work, the Price of Black Feminism," 259.

50. Christina Simmons, "African Americans and Sexual Victorianism in the Social Hygiene Movement, 1910–40," *Journal of the History of Sexuality* 4, no. 1 (1993): 53. Simmons and Deborah White suggest black female reformers also used Victorian sexual ideology to define white as "other." Black women had to protect themselves from the "unbridled lust" from white men. White, "The Cost of Club Work, the Price of Black Feminism," 258.

51. Carby, "Policing Black Women's Body in an Urban Context."

52. Simmons, "African Americans and Sexual Victorianism in the Social Hygiene Movement, 1910–40."; White, "The Cost of Club Work, the Price of Black Feminism," 258–261.

53. Shanara R. Reid-Brinkley, "The Essence of Res(ex)pectability: Black Women's Negotiation of Black Femininity in Rap Music and Music Video," *Meridians: Feminism, Race, Transnationalism* 8, no. 1 (2008).

54. White, "The Cost of Club Work, the Price of Black Feminism," 260.

55. Bernard Zuel, "Diva Declares Her Intentions with Desultory Double Act," *The*

Sydney (Australia) Morning Herald, November 22, 2008, 14.

56. Robin James,. " 'Robo-Diva R&B': Aesthetics, Politics, and Black Female Robots in Contemporary Popular Music," *Journal of Popular Music Studies* 20, no. 4 (2008): 404.

57. Steven Shaviro, "Supa Dupa Fly: Black Women as Cyborgs in Hiphop Videos," *Quarterly Review of Film and Video* 22, no. 2 (2005).

58. Kobena Mercer, "Monster Metaphors: Notes on Michael Jackson's 'Thriller'" *Screen* 27, no. 1 (1986); Shaviro, "Supa Dupa Fly."

59. Diane Negra, *What a Girl Wants? Fantasizing the Reclamation of Self in Postfeminism* (Hoboken, N.J.: Taylor & Francis, 2008), 61.

60. Mrs. Carter, her married name taken from Sean "Jay Z" Carter, is the name of Beyoncé's 2013 tour.

61. Ronald E. Hall, "Dark Skin and the Cultural Ideal of Masculinity," *Journal of African American Men* 1, no. 3 (1995); Michael B. Lewis, "Who Is the Fairest of Them All? Race, Attractiveness and Skin Color Sexual Dimorphism," *Personality & Individual Differences* 50, no. 2 (2011).

62. Michael Lewis explains that skin complexion helps to construct sexual dimorphism in which dark skin men and light skin women are most attractive. Lewis, "Who Is the Fairest of Them All?"

63. Gina Masullo Chen et al., "Male Mammies: A Social-Comparison Perspective on How Exaggeratedly Overweight Media Portrayals of Madea, Rasputia, and Big Momma Affect How Black Women Feel About Themselves," *Mass Communication & Society* 15, no. 1 (2012).

64. Monica Eng, "Is One of the Ladies in Beyonce's *Single Ladies* Actually a Man?," *Chicago Tribune*, January 8, 2009.

65. "Joe Jonas Dances to Single Ladies," June 3, 2009, video clip, accessed March 8, 2014, YouTube, http://youtu.be/rP-KFnYg6Hw

66. "Single Man Dances to Single Ladies," October 18, 2008, video clip, accessed March 8, 2014, YouTube, http://youtu.be/SGemjUvafBw

67. Thompson, *Beyond the Black Lady*, 182–183.

68. Vicky Mabrey. "Why Can't a Successful Black Woman Find a Man?" *Nightline*, anchor Terry Moran, ABC, April 21, 2010.

69. Steve Harvey and Denene Millner, *Act Like a Lady, Think Like a Man: What Men Really Think About Love, Relationships, Intimacy, and Commitment*, 1st ed. (New York: Amistad, 2009).

70. Ibid., 182–183.

PART 3: POETIC TRANSCRIPTION AS PERFORMANCE ETHNOGRAPHY

1. Brown, *Black Girlhood Celebration*.

2. Corrine Glesne, "That Rare Feeling: Re-Presenting Research through Poetic Transcription," *Qualitative Inquiry* 3, no. 2 (1997): 206; Lorde, *Sister Outsider*, 37.

3. Denzin, *Performance Ethnography*, 133.

4. Ibid.

5. Glesne, "That Rare Feeling," 206.

6. Madison, "That Was My Occupation," 330.

CONCLUSION

1. Wallace, "The Politics of Location," 49.

2. Patricia Bell-Scott and Juanita Johnson-Bailey, *Flat-Footed Truths: Telling Black Women's Lives*, 1st ed. (New York: Henry Holt, 1998).

3. Susan E. Eaton and Christina Meldrum, "Broken Promises: Resegregation in Norfolk, Virginia," in *Dismantling Desegregation: The Quiet Reversal of* Brown v. Board of Education, ed. Gary Orfield, Susan E. Eaton, and Harvard Project on School Desegregation (New York: New Press, 1996).

4. Ellis, *The Ethnographic I*.

5. Denzin, *Interpretive Interactionism*, 7.

6. Ibid., 18.

7. Richardson, "Writing: A Method of Inquiry," 187.

8. Lorde, *Sister Outsider*, 37.

Bibliography

"20 Arrested in Norfolk in Police Drug Stings." *The Virginian-Pilot*, April 2, 1991, D4.

Alexander, M. Jacqui, Lisa Albrecht, Sharon Day, and Mab Segrest, eds. *Sing, Whisper, Shout, Pray!: Feminist Visions for a Just World*. Fort Bragg, CA: Edgework Books, 2003.

Alridge, Derrick P. "From Civil Rights to Hip Hop: Toward a Nexus of Ideas." *The Journal of African American History* 90, no. 3 (Summer 2005): 226–252.

Amber, Jeanine. "She's the Boss." *Essence*, October 2006, 180–183.

Arney, June. "Streets Crush Teen's Potential: He Had Street Smarts in His Corner, but Now He's Back in the Norfolk Jail." *The Virginian-Pilot*, December 12, 1994, B1.

"Arrest in Fatal Shooting." *The Virginian-Pilot*, September 3, 1994, B3.

Barker, Chris. *Cultural Studies: Theory and Practice*. 2nd ed. Thousand Oaks, CA: Sage, 2003.

Baumgardner, Jennifer, and Amy Richards. *Manifesta: Young Women, Feminism, and the Future*. 1st ed. New York: Farrar, Straus and Giroux, 2000.

Beatty, Angie C. "What Is This Gangstressism in Popular Culture? Reading Rap Music as a Legitimate Hustle & Analyzing the Role of Agency in Female Rappers." Dissertation, University of Michigan, 2005.

Bell-Scott, Patricia, and Juanita Johnson-Bailey. *Flat-Footed Truths: Telling Black Women's Lives*. 1st ed. New York: Henry Holt, 1998.

Berlant, Lauren Gail. *The Queen of America Goes to Washington City: Essays on Sex and Citizenship*. Durham, NC: Duke University Press, 1997.

"Blacks in South Africa Protest Whites-Only Beach." *The Virginian-Pilot and the Ledger Star*, September 4, 1989, A5.

Blay, Yaba. *(1)ne Drop: Shifting the Lens on Race*. BLACKprint Press, 2013.

Bobo, Jacqueline. *Black Feminist Cultural Criticism*. Malden, MA: Blackwell, 2001.

Bogle, Donald. *Toms, Coons, Mulattoes, Mammies and Bucks: An Interpretive History of Blacks in American Films.* 4th ed. New York: Continuum, 2001.

Boyd, Todd. *The New H.N.I.C. (Head Niggas in Charge): The Death of Civil Rights and the Reign of Hip Hop.* New York: New York University Press, 2002.

Bragg, Beauty, and Pancho McFarland. "The Erotic and the Pornographic in Chicana Rap: JV vs. Ms. Sancha." *Meridians: Feminism, Race, Transnationalism* 7, no. 2 (April 2007): 1–21.

"Bringing Down the House." Box Office Mojo, http://www.boxofficemojo.com/movies/?id=bringingdownthehouse.htm.

Brooks, Ryan. "The Narrative Production of 'Real Police.'" In *The Wire: Urban Decay and American Television,* edited by Tiffany Potter and C. W. Marshall, 64–77. New York: Continuum, 2009.

Brown, Larry W. "Food-Stamp Plan May Hurt Small Stores: Federal Officials Say the Proposal Would Help Reduce Fraud." *The Virginian-Pilot,* January 8, 1995, B1.

———. "Police to Patrol Public Housing: Officer Richard James Is One of Eight Norfolk Police Officers and Two Supervisors Who Volunteered to Patrol the City's Public Housing Communities on Foot and Bicycle." *The Virginian-Pilot,* March 18, 1995, D3.

Brown, Ruth Nicole. *Black Girlhood Celebration: Toward a Hip-Hop Feminist Pedagogy.* New York: Peter Lang, 2009.

Bynoe, Yvonne. *Stand and Deliver: Political Activism, Leadership, and Hip Hop Culture.* Brooklyn, NY: Soft Skull Press, 2004.

Carby, Hazel. *Cultures in Babylon: Black Britain and African America.* New York: Verso, 1999.

———. "Policing Black Women's Body in an Urban Context." *Critical Inquiry* 18, no. 4 (1992): 738–755.

Carter, Vednita. "Prostitution=Slavery." In *Sisterhood Is Forever: The Women's Anthology for a New Millennium,* edited by Robin Morgan, 315–320. New York: Washington Square Press, 2003.

Carty, Ciaran. "Moma Knows Best: Queen Latifah Proved She Could Act Playing Sassy Prison Warder Moma in *Chicago.*" *The Sunday Tribune,* June 8, 2003, 3.

Cash, Thomas F., Jennifer A. Morrow, Joshua I. Hrabosky, and April A. Perry. "How Has Body Image Changed? A Cross-Sectional Investigation of College Women and Men from 1983 to 2001." *Journal of Consulting and Clinical Psychology* 72, no. 6 (March 2004): 1081–1089.

Chang, Jeff. *Can't Stop Won't Stop: A History of the Hip-Hop Culture.* New York: St. Martin's Press, 2005.

Chawla, Devika. "Performance or Theory? Ethnographic Re/Solutions and Dilemmas." Paper presented at the Third Congress of Qualitative Inquiry & Couch-Stone Symposium, Urbana, IL, May 5, 2007.

Chen, Gina Masullo, Sherri Williams, Nicole Hendrickson, and Li Chen. "Male Mammies: A Social-Comparison Perspective on How Exaggeratedly Overweight

Media Portrayals of Madea, Rasputia, and Big Momma Affect How Black Women Feel About Themselves." *Mass Communication & Society* 15, no. 1 (2012): 115–135.

"Chicago." Box Office Mojo, http://www.boxofficemojo.com/movies/?id=chicago.htm.

Chung, Connie. "Interview with Queen Latifah." *CNN Connie Chung Tonight*, anchor Connie Chung, January 10, 2003.

Cobb, William Jelani. "The Hoodrat Theory." In *Black Venus 2010: They Called Her "Hottentot,"* edited by Deborah Willis, 210–212. Philadelphia: Temple University Press, 2010.

Cole, Johnnetta B., and Beverly Guy-Sheftall. *Gender Talk: The Struggle for Women's Equality in African American Communities.* New York: Ballantine Books, 2003.

Collins, Patricia Hill. *Black Feminist Thought: Knowledge, Consciousness, and the Politics of Empowerment.* Rev. 10th anniversary ed. New York: Routledge, 2000.

———. *Black Sexual Politics: African Americans, Gender, and the New Racism.* New York: Routledge, 2004.

———. "Distinguishing Features of Black Feminist Thought." In *Black Feminist Thought: Knowledge, Consciousness, and the Politics of Empowerment*, edited by Patricia Hill Collins, 21–44. New York: Routledge, 2000.

———. *From Black Power to Hip Hop: Racism, Nationalism, and Feminism.* Philadelphia: Temple University Press, 2006.

———. "The Tie That Binds: Race, Gender and U.S. Violence." *Ethnic and Racial Studies* 21, no. 5 (1998): 917–938.

Cooper, Brittney. "The Beyoncé Wars: Should She Get to Be a Feminist?" *Salon*, January 29, 2014. http://www.salon.com/2013/12/17/a_deeply_personal_beyonce_debate_should_she_get_to_be_a_feminist/.

———. "Excavating the Love Below: The State as Patron of the Baby Mama and Other Ghetto Hustles." In *Home Girls Make Some Noise: Hip Hop Feminism Anthology*, edited by Gwendolyn Pough, Elaine Richardson, Aisha Durham and Rachel Raimist, 320–344. Mira Loma, CA: Parker Publishing, 2007.

Cosco, Joe. "Defense Attorney Depicts Murderer as an Abused Child: Jean Claude Oscar Is the Most Likely of the Three Defendants to Be Sentenced to Death." *The Virginian-Pilot*, March 18, 1994, D3.

Crenshaw, Kimberlé. "Traffic at the Crossroads: Multiple Oppression." In *Sisterhood Is Forever: The Women's Anthology for a New Millennium*, edited by Robin Morgan, 43–57. New York: Washington Square Press, 2003.

Cross, Brian. *It's Not About a Salary: Rap, Race, and Resistance in Los Angeles.* New York: Verso, 1993.

Davis, Angela Y. *Blues Legacies and Black Feminism: Gertrude 'Ma' Rainey, Bessie Smith, and Billie Holiday.* New York: Pantheon Books, 1998.

Davis, Marc. "Mayor Raised for Beach Riot Control: Oberndorf Radio Show Draws Supportive Callers." *The Virginian-Pilot and the Ledger Star*, September 7, 1989, A4.

Decker, Jeffrey Louis. "The State of Rap: Time and Place in Hip Hop Nationalism." In *Microphone Fiends: Youth Music, Youth Culture*, edited by Andrew Ross and Tricia Rose, 99–121. New York: Routledge, 1994.

Denzin, Norman K. *Interpretive Biography*. Newbury Park, CA: Sage, 1989.

———. *Interpretive Interactionism*. 2nd ed. Thousand Oaks, CA: Sage, 2001.

———. *Performance Ethnography: Critical Pedagogy and the Politics of Culture*. Thousand Oaks, CA: Sage, 2003.

———. *Reading Race: Hollywood and the Cinema of Racial Violence*. Thousand Oaks, CA: Sage, 2002.

Denzin, Norman K., and Yvonna S. Lincoln. *The Qualitative Inquiry Reader*. Thousand Oaks, CA: Sage, 2002.

Dicker, Rory, and Alison Piepmeier. "Introduction." In *Catching a Wave: Reclaiming Feminism for the 21st Century*, edited by Rory Cooke Dicker and Alison Piepmeier, 3–28. Boston: Northeastern University Press, 2003.

Dow, Bonnie J. *Prime Time Feminism: Television, Media Culture, and the Women's Movement since 1970*. Philadelphia: University of Pennsylvania Press, 1996.

duCille, Ann. "The Occult of True Black Womanhood: Critical Demeanor and Black Feminist Studies." *Signs* 19, no. 3 (Spring 1994): 591–629.

Durham, Aisha. "'Check on It': Beyoncé, Southern Booty, and Black Femininities in Music Video." *Feminist Media Studies* 12, no. 1 (2012): 35–49.

———. "Hip Hop Feminist Media Studies." *International Journal of Africana Studies* 16, no. 1 (Summer 2010): 117–140.

———. "Recalling, Re-membering, and (Re)Visiting Hip-Hop/Home/Bodies." In *Globalizing Cultural Studies: Ethnographic Interventions in Theory, Method, and Policy*, edited by Cameron McCarthy, Aisha Durham, Laura Engel, Alice Filmer, Michael Giardina and Miguel Malagreca, 153–166. New York: Peter Lang, 2007.

———. "Using [Living Hip-Hop] Feminism: Redefining an Anwer (to) Rap." In *Home Girls, Make Some Noise: A Hip-Hop Feminism Anthology*, edited by Gwendolyn Pough, Elaine Richardson, Aisha Durham and Rachel Raimist, 304–312. Mira Loma, CA: Parker Publishing, 2007.

Durham, Aisha, and Jillian Báez. "A Tail of Two Women: Exploring the Contours of Difference in Popular Culture." In *Curriculum and the Cultural Body*, edited by Stephanie Springgay and Debra Freedman, 130–145. New York: Peter Lang, 2007.

Durham, Aisha, Brittney C. Cooper, and Susana M. Morris. "The Stage Hip-Hop Feminism Built: A New Directions Essay." *Signs* 38, no. 3 (Spring 2013): 721–737.

Dyck, Noel. "Home Field Advantage? Exploring the Social Construction of Children's Sports." In *Constructing the Field: Ethnographic Fieldwork in the Contemporary World*, edited by Vered Amit, 32–53. New York: Routledge, 2000.

Eaton, Susan E., and Christina Meldrum. "Broken Promises: Resegregation in Norfolk, Virginia." In *Dismantling Desegregation: The Quiet Reversal of* Brown v. Board of

Education, edited by Gary Orfield, Susan E. Eaton and Harvard Project on School Desegregation, 115–141. New York: New Press, 1996.

Eisenstein, Zillah R. *Hatreds: Racialized and Sexualized Conflicts in the 21st Century.* New York: Routledge, 1996.

Ellis, Carolyn. "Creating Criteria: An Ethnographic Short Story." *Qualitative Inquiry* 6, no. 2 (2000): 272–277.

———. *The Ethnographic I: A Methodological Novel About Autoethnography.* Walnut Creek, CA: AltaMira Press, 2004.

Ellis, Carolyn, and Arthur Bochner. "Autoethnography, Personal Narrative, Reflexivity: Researcher as Subject." In *Handbook of Qualitative Research,* edited by Norman K. Denzin and Yvonna S. Lincoln, 733–768. Thousand Oaks, CA: Sage, 2000.

Emerson, Rana. "'Where My Girls At?': Negotiating Black Womanhood in Music Videos." *Gender & Society* 16, no. 1 (2002): 115–135.

Eng, Monica. "Is One of the Ladies in Beyonce's *Single Ladies* Actually a Man?" *Chicago Tribune,* January 8, 2009.

Eure, Joseph D., and James G. Spady. *Nation Conscious Rap.* New York: PC International Press, 1991.

FEMA. "Report of the Joint Fire / Police Task Force on Civil Unrest: Recommendations for Organization and Operation During Civil Disturbance." 1994.

Fernando, S.H., Jr. *The New Beats: Exploring the Music, Culture and Attitudes of Hip-Hop.* New York: Doubleday, 1994.

Filmer, Alice. "The Acoustics of Identity: Bilingual Belonging and Discourses of Trespassing." In *Globalizing Cultural Studies: Ethnographic Interventions in Theory, Method, and Policy,* edited by Cameron McCarthy, Aisha Durham, Laura Engel, Alice Filmer, Michael Giardina and Miguel Malagreca, 167–188. New York: Peter Lang, 2007.

Findlen, Barbara. *Listen Up: Voices from the Next Feminist Generation.* Seattle, WA: Seal Press, 1995.

Fleming, Michael. "Rogue Dishes 'Welfare.'" *Daily Variety,* April 12, 2006, 1.

Forman, Murray. "'Movin' Closer to an Independent Funk': Black Feminist Theory, Standpoint, and Women in Rap." *Women's Studies* 94, no. 1 (January 1994): 35–56.

———. "'Represent': Race, Space, and Place in Rap Music." In *That's the Joint: The Hip-Hop Studies Reader,* edited by Mark Anthony Neal and Murray Forman, 201–222. New York: Routledge, 2004.

Frank, Jon. "Diggs Town, Portsmouth: A Porch Here, a Road There Helped Clean Up One Project." *The Virginian-Pilot,* October 5, 1995, A10.

Fregoso, Rosa Linda. *MeXicana Encounters: The Making of Social Identities on the Borderlands.* Berkeley: University of California Press, 2003.

Gallagher, Charles A. "Color-Blind Privilege: The Social and Political Functions of Erasing the Color Line in Post Race America." *Race, Gender & Class* 10, no. 4 (October 2003): 22–37.

Gaunt, Kyra D. "African American Women between Hopscotch and Hip-Hop: 'Must

Be the Music (That's Turnin' Me On).'" In *Feminism, Multiculturalism, and the Media: Global Diversities*, edited by Angharad N. Valdivia, 277–308. Thousand Oaks, CA: Sage, 1995.

Gentles, Kamille, and Kristen Harrison. "Television and Perceived Peer Expectations of Body Size among African American Adolescent Girls." *Howard Journal of Communications* 17, no. 1 (January–March 2006): 39–55.

Giddings, Paula. *When and Where I Enter: The Impact of Black Women on Race and Sex in America*. 1st ed. New York: W. Morrow, 1984.

Gifford, Kathie Lee, and Hoda Kotb. "Today's Talk: Current Events Discussed." *Today Show*, NBC, May 20, 2011.

Gilliam, Angela M. "A Black Feminist Perspective on the Sexual Commodification of Women in the New Global Culture." In *Black Feminist Anthropology: Theory, Politics, Praxis and Poetics*, edited by Irma McClaurin. New Brunswick, NJ: Rutgers University Press, 2001.

Gillis, Stacy, Gillian Howie, and Rebecca Munford. "Introduction." In *Third Wave Feminism: A Critical Exploration*, edited by Stacy Gillis, Gillian Howie and Rebecca Munford, 1–6. New York: Palgrave Macmillan, 2004.

Ginwright, Shawn A. "Classed Out: The Challenges of Social Class in Black Community Change." *Social Problems* 49, no. 4 (November 2002): 544–562.

Glass, Jon. "The Earlier, the Better: A Preschool Program Serving the Berkley and Campostella Areas of Norfolk Is Helping to Raise the Expectations—and Hopes—of Parents and Students." *The Virginian-Pilot*, November 5, 1995, B1.

Glesne, Corrine. "That Rare Feeling: Re-Presenting Research through Poetic Transcription." *Qualitative Inquiry* 3, no. 2 (1997): 202–221.

Goddard, Jacqui, and Nicola Davidson. "British Women Cast Aside the Skinny Look in Quest for a Superior Posterior." *The (London) Telegraph*, August 29, 2005.

Gordon, Maya K. "Media Contributions to African American Girls' Focus on Beauty and Appearance: Exploring the Consequences of Sexual Objectification." *Psychology of Women Quarterly* 32, no. 3 (2008): 245–256.

Griffin, Farah Jasmine. "Black Feminists and DuBois: Respectability, Protection, and Beyond." *Annals of the American Academy of Political and Social Science* 568 (2000): 28–40.

Grossberg, Lawrence. "The Formations of Cultural Studies: An American in Birmingham." In *Relocating Cultural Studies: Developments in Theory and Research*, edited by Valda Blundell, John Shepherd and Ian Taylor, 21–66. New York: Routledge, 1993.

Halberstam, Judith. *Female Masculinity*. Durham, NC: Duke University Press, 1998.

Hall, Ronald E. "Dark Skin and the Cultural Ideal of Masculinity." *Journal of African American Men* 1, no. 3 (1995): 37–62.

Hall, Stuart. "Introduction." In *Paper Voices: The Popular Press and Social Change, 1935–*

1965, edited by A. Smith, E. Immirzi and T. Blackwell, 11–24. Totowa: Rowman & Littlefield, 1975.

———. "What Is This 'Black' in Black Popular Culture?" In *Black Popular Culture: A Project by Michele Wallace*, edited by Gina Dent, 21–33. New York: The New Press, 1998.

Hancock, Ange-Marie. *The Politics of Disgust: The Public Identity of the Welfare Queen*. New York: New York University Press, 2004.

Harrison, Kristen. "Television Viewers' Ideal Body Proportions: The Case of the Curvaceously Thin Woman." *Sex Roles* 48, no. 5/6 (March 2003): 255–264.

Harvey, Steve, and Denene Millner. *Act Like a Lady, Think Like a Man: What Men Really Think About Love, Relationships, Intimacy, and Commitment*. 1st ed. New York: Amistad, 2009.

Helmore, Edwards. "Oprah's Worst Enemies: Rappers Clipse Take Their Inspiration from Their Previous Career as Drug Dealers." *The Guardian*, April 27, 2007, 6.

Henry, Astrid. *Not My Mother's Sister: Generational Conflict and Third-Wave Feminism*. Bloomington: Indiana University Press, 2004.

Hernández, Daisy, and Bushra Rehman, eds. *Colonize This!: Young Women of Color on Today's Feminism*. New York: Seal Press, 2002.

Heywood, Leslie, and Jennifer Drake. "Introduction." In *Third Wave Agenda: Being Feminist, Doing Feminism*, edited by Jennifer Drake and Leslie Heywood, 1–20. Minneapolis: University of Minnesota Press, 1997.

Ho, Rodney. "His Job: Helping Kids in a 'War Zone.'" *The Virginian-Pilot*, January 17, 1993, 1.

Holman Jones, Stacy. "Autoethnography: Making the Personal Political." In *The Sage Handbook of Qualitative Research*, edited by Norman K. Denzin and Yvonna S. Lincoln, 763–792. Thousand Oaks, CA: Sage, 2005.

hooks, bell. *Ain't I a Woman: Black Women and Feminism*. Boston: South End Press, 1981.

———. *Black Looks: Race and Representation*. Boston: South End Press, 1992.

———. *Feminist Theory: From Margin to Center*. 2nd ed. Cambridge, MA: South End Press, 2000.

———. "Writing Autobiography." In *Flat-Footed Truths: Telling Black Women's Lives*, edited by Patricia Bell-Scott and Juanita Johnson-Bailey, 7–14. New York: Henry Holt, 1998.

———. *Writing Beyond Race: Living Theory and Practice*. New York: Routledge, 2013.

———. *Yearning: Race, Gender, and Cultural Politics*. Boston: South End Press, 1990.

"Hostility Greets N.Y. Protestors: Residents Jeer Parade Prompted by Racial Killing." *The Virginian-Pilot and the Ledger Star*, September 5, 1989, A3.

Hughey, Matthew W. "Cinethetic Racism: White Redemption and Black Stereotypes in 'Magical Negro' Films." *Social Problems* 56, no. 3 (2009): 543–577.

Hurston, Zora Neale. *Their Eyes Were Watching God: A Novel*. 1st Perennial Library ed. New York: Perennial Library, 1990.

Hutchinson, Janis Faye. "The Hip Hop Generation: African American Male-Female

Relationships in a Nightclub Setting." *Journal of Black Studies* 30, no. 1 (September 1999): 62–84.

Jackson, Joe. "Abuse Alleged During Anti-Drug Sweep." *The Virginian-Pilot*, April 20, 1991, D3.

———. " 'Gun Central': Norfolk Street Sales Linked to Murder Rate, Drug Trade." *The Virginian-Pilot*, November 17, 1991.

———. "Gunfire Rips School Crowd 3 Teens Wounded." *The Virginian-Pilot*, January 24, 1992.

———. "Norfolk Thieves Target Costly Athletic Clothes." *The Virginian-Pilot*, October 23, 1991.

———. "Tensions High in Diggs Town Drug Fight Police Harassment Is Alleged." *The Virginian-Pilot*, May 10, 1991, D1.

Jacobs, Harriet A. *Incidents in the Life of a Slave Girl*. New York: AMS Press, 1973.

James, Joy. *Shadowboxing: Representations of Black Feminist Politics*. 1st ed. New York: St. Martin's Press, 1999.

James, Robin. " 'Robo-Diva R&B': Aesthetics, Politics, and Black Female Robots in Contemporary Popular Music." *Journal of Popular Music Studies* 20, no. 4 (2008): 402–423.

Jamila, Shani. "Can I Get a Witness?: Testimony from a Hip Hop Feminist." In *Colonize This!: Young Women of Color on Today's Feminism*, edited by Daisy Hernández and Bushra Rehman, 382–394. New York: Seal Press, 2002.

Jenkins, Maureen. "Model Figure: Mannequins' Tushes Are Getting a Little Rounder." *Chicago Sun-Times*, July 5, 2005, 48.

Jones, Lisa. *Bulletproof Diva: Tales of Race, Sex, and Hair*. 1st ed. New York: Doubleday, 1994.

Jordan, Glenn, and Chris Weedon. *Cultural Politics: Class, Gender, Race, and the Postmodern World*. Cambridge, MA: B. Blackwell, 1995.

Jordan, P. "Some of 100 Detainees Allege Random Arrest, Mistreatment." *The Virginian-Pilot and the Ledger Star*, September 5, 1989, A3.

Jordan-Zachery, Julia S. *Black Women, Cultural Images, and Social Policy*. New York: Routledge, 2009.

Keeling, Kara. " 'Ghetto Heaven': *Set It Off* and the Valorization of Black Lesbian Butch-Femme." *Black Scholar* 33, no. 1 (2003): 33–47.

Kelley, Robin D.G. "Looking for the 'Real' Nigga: Social Scientists Construct the Ghetto." In *That's the Joint!: The Hip-Hop Studies Reader*, edited by Mark Anthony Neal and Murray Forman, 119–136. New York: Routledge, 2004.

———. *Yo' Mama's Disfunktional!: Fighting the Culture Wars in Urban America*. Boston: Beacon Press, 1997.

Keyes, Cheryl. "Empowering Self, Making Choices, Creating Spaces: Black Female Identity Via Rap Music Performances." In *That's the Joint!: The Hip-Hop Studies Reader*,

edited by Mark Anthony Neal and Murray Forman, 265–281. New York: Routledge, 2004.

Kitwana, Bakari. *The Hip Hop Generation: Young Blacks and the Crisis in African American Culture*. 1st ed. New York: Basic Civitas Books, 2002.

Knepler, Mike. "Allen Visit Puts a Face on Welfare: Diggs Town Residents Put Safety High on Their Property List for Reforms." *The Virginian-Pilot*, June 30, 1994, B1.

———. "Councilman Takes Aim at Public Housing." *The Virginian-Pilot*, September 21, 1994, B1.

———. "Councilman Won't Retract Slam on Tenants." *The Virginian-Pilot*, September 27, 1994, B1.

———. "Norfolk Plan Designed to Tighten Security." *The Virginian-Pilot*, March 19, 1991, D3.

———. "With Help from Club, Youth Begins Turning Life Around." *The Virginian-Pilot*, February 23, 1992, A11.

———. "Woman Lost Son, but Works to Help Others: A Diggs Town Activist Carries on for the Neighborhood after Her Son Is Slain." *The Virginian-Pilot*, June 15, 1996, B3.

Lacy, Karyn R. "Black Spaces, Black Places: Strategic Assimilation and Identity Construction in Middle-Class Suburbia." *Ethnic and Racial Studies* 27, no. 6 (November 2004): 908–930.

Lee, Shayne. *Erotic Revolutionaries: Black Women, Sexuality, and Popular Culture*. Lanham, MD: Hamilton Books, 2010.

Leonard, David J. *Screens Fade to Black: Contemporary African American Cinema*. Westport, CT: Praeger Publishers, 2006.

Lewis, Michael B. "Who Is the Fairest of Them All? Race, Attractiveness and Skin Color Sexual Dimorphism." *Personality & Individual Differences* 50, no. 2 (2011): 159–162.

Lorde, Audre. *Sister Outsider: Essays and Speeches*. Trumansburg, NY: Crossing Press, 1984.

Mabrey, Vicky. "Why Can't a Successful Black Woman Find a Man?" *Nightline*, ABC, anchor Terry Moran, April 21, 2010.

Madison, D. Soyini. "That Was My Occupation: Oral Narrative, Performance, and Black Feminist Thought." In *Exceptional Spaces: Essays in Performance and History*, edited by Della Pollock, 319–342. Chapel Hill: University of North Carolina Press, 1998.

Marshall, Alex. "Public Housing on the Block; HUD Official's Visit Brings Budget Debate to Diggs Town." *The Virginian-Pilot*, August 22, 1995, B1.

Marshall, C. W., and Tiffany Potter. "'I Am the American Dream': Modern Urban Tragedy and the Borders of Fiction." In *The Wire: Urban Decay and American Television*, edited by Tiffany Potter and C. W. Marshall, 1–14. New York: Continuum, 2009.

Martinez, Theresa A. "Popular Culture as Oppositional Culture: Rap as Resistance." *Sociological Perspectives* 40 (1997): 265–287.

Massey, Douglas S., and Nancy A. Denton. *American Apartheid: Segregation and the Making of the Underclass*. Cambridge, MA: Harvard University Press, 1993.

Mayo, Kierna. "The Last Good Witch." In *Hip-Hop Divas*, edited by Vibe Magazine, 51–61. New York: Three Rivers Press, 2001.

McCarthy, Cameron, Aisha S. Durham, Laura C. Engel, Alice A. Filmer, Michael D. Giardina, and Miguel A. Malagreca. *Globalizing Cultural Studies: Ethnographic Interventions in Theory, Method, and Policy.* New York: Peter Lang, 2007.

McCaskey, Scott. "Parade a Celebration of Southside Pride; a Current of Enthusiasm Is Flowing through the Citizenry of the Neighboorhoods." *The Virginian-Pilot*, December 7, 1995, 5.

McClaurin, Irma. "Salvaging Lives in the African Diaspora: Anthropology, Ethnography and Women's Narratives." In *Transnational Blackness: Navigating the Global Color Line*, edited by Manning Marable and Vanessa Agard-Jones, 229–244. New York: Palgrave Macmillan, 2008.

———. "Theorizing a Black Feminist Self in Anthropology: Toward an Autoethnographic Approach." In *Black Feminist Anthropology: Theory, Politics, Praxis, and Poetics*, edited by Irma McClaurin, 49–75. New Brunswick, NJ: Rutgers University Press, 2001.

Means Coleman, Robin R. *African American Viewers and the Black Situation Comedy: Situating Racial Humor.* New York: Garland Publishers, 2000.

Menzies, Alisha L. "Opening the Doors: HIV Discourse in the Black Church." Paper presented at the National Communication Association, New Orleans, LA, November 2011.

Mercer, Kobena. "Monster Metaphors: Notes on Michael Jackson's 'Thriller.'" *Screen* 27, no. 1 (1986): 26–43.

Merskin, Debra. "Reviving Lolita? A Media Literacy Examination of Sexual Portrayals of Girls in Fashion Advertising." *American Behavioral Scientist* 48, no. 1 (September 2004): 119–129.

Mohanty, Chandra Talpade. *Feminism without Borders: Decolonizing Theory, Practicing Solidarity.* Durham, NC: Duke University Press, 2003.

Moorti, Sujata. "Desperately Seeking an Identity: Diasporic Cinema and the Articulation of Transnational Kinship." *International Journal of Cultural Studies* 6 (2003): 355–375.

Moraga, Cherríe, and Gloria Anzaldúa. *This Bridge Called My Back: Writings by Radical Women of Color.* 1st ed. Watertown, MA: Persephone Press, 1981.

Morgan, Joan. "Afterword." In *Home Girls, Make Some Noise: A Hip-Hop Feminism Anthology*, edited by Gwendolyn Pough, Elaine Richardson, Aisha Durham and Rachel Raimist, 475–479. Mira Loma, CA: Parker Publishing, 2007.

———. *When Chickenheads Come Home to Roost: My Life as a Hip-Hop Feminist.* New York: Simon & Schuster, 1999.

Muhammad, Fatimah N. "How to Not Be 21st Century Venus Hottentots." In *Home Girls Make Some Noise: Hip Hop Feminism Anthology*, edited by Gwendolyn D. Pough, Elaine Richardson, Aisha S. Durham and Rachel Raimist, 115–140. Mira Loma, CA: Parker Publishing, 2007.

Mukherjee, Roopali. "The Ghetto Fabulous Aesthetics in Contemporary Black Culture:

Class and Consumption in the *Barbershop* Films." *Cultural Studies* 20, no. 6 (November 2006): 599–629.

Muñoz-Laboy, Miguel, Hannah Weinstein, and Richard Parker. "The Hip-Hop Club Scene: Gender, Grinding and Sex." *Culture, Health & Sexuality* 9, no. 6 (November–December 2007): 615–628.

Musolf, Richard Gil. "The Chicago School." In *Handbook of Symbolic Interactionism*, edited by Larry T. Reynolds and Nancy J. Herman-Kinney, 91–118. Walnut Creek, CA: Altamira Press, 2004.

Neal, Mark Anthony. *Soul Babies: Black Popular Culture and the Post-Soul Aesthetic*. New York: Routledge, 2002.

———. *What the Music Said: Black Popular Music and Black Public Culture*. New York: Routledge, 1999.

Negra, Diane. *What a Girl Wants? Fantasizing the Reclamation of Self in Postfeminism*. Hoboken, N.J.: Taylor & Francis, 2008.

The Negro Family: The Case for National Action Office of Policy Planning and Research, U.S. Department of Labor, 1965.

"Norfolk's Drug Fights: Working Together [Commentary]." *The Virginian-Pilot*, May 19, 1991, 518.

Ogunnaike, Lola. "Clipse Get Their Day in the Sun." *Daily News*, August 29, 2002, 52.

Patillo, Mary. "Black Middle-Class Neighborhoods." *Annual Review of Sociology* 31 (August 2005): 305–329.

Patton, Tracey Owens. "Hey Girl, Am I More Than My Hair?: African American Women and Their Struggles with Beauty, Body Image, and Hair." *NWSA Journal* 18, no. 2 (Summer 2006): 24–51.

Pelias, Ronald J. *Writing Performance: Poeticizing the Researcher's Body*. Carbondale: Southern Illinois University Press, 1999.

Peoples, Whitney A. "'Under Construction': Identifying Foundations of Hip-Hop Feminism and Exploring Bridges between Black Second-Wave and Hip-Hop Feminisms." *Meridians: Feminism, Race, Transnationalism* 8, no. 1 (April 2008): 19–52.

Perry, Imani. *Prophets of the Hood: Politics and Poetics in Hip Hop*. Durham, NC: Duke University Press, 2004.

Peterson, Carla L. "Foreword: Eccentric Bodies." In *Recovering the Black Female Body*, edited by Michael Bennett and Vanessa D. Dickerson, ix–xvi. New Brunswick, NJ: Rutgers University Press, 2001.

Phillips, Layli, K. Reddick-Morgan, and Dionne Stephens. "Oppositional Consciousness within an Oppositional Realm: The Case of Feminism and Womanism in Rap and Hip Hop, 1976–2004." *Journal of African American History* 90, no. 3 (Summer 2005): 253–277.

Potter, Russell A. "History, Spectacle and Resistance." In *Spectacular Vernaculars: Hip-Hop and the Politics of Postmodernism*, 107–130. New York: State University of New York Press, 1995.

Pough, Gwendolyn D. *Check It While I Wreck It: Black Womanhood, Hip Hop Culture, and the Public Sphere*. Boston: Northeastern University Press, 2004.

———. "Love Feminism but Where's My Hip Hop?: Shaping a Black Feminist Identity." In *Colonize This!: Young Women of Color on Today's Feminism*, edited by Daisy Hernández and Bushra Rehman, 85–98. New York: Seal Press, 2002.

Pough, Gwendolyn D., Elaine Richardson, Aisha S. Durham, and Rachel Raimist. *Home Girls Make Some Noise: Hip Hop Feminism Anthology*. Mira Loma, CA: Parker Publishing, 2007.

"Queen Latifah." IMDb: The Internet Movie Database, http://www.imdb.com/name/nm0001451/.

Queen Latifah. *Ladies First: Revelations of a Strong Woman*. New York: William Morrow, 1999.

———. *Put on Your Crown: Life-Changing Moments on the Path to Queendom*. New York: Grand Central, 2010.

Randolph, Carolyn. "Discursive Ruptures as Productive Failures: A Critical Multicultural Paradigm in Communications Studies." Paper presented at the International Communication Association, San Francisco, CA, May 27, 2007.

Reed-Denahay, Deborah. *Autoethnography: Rewriting the Self and the Social*. New York: Berg Publishers, 1997.

Reeves, Jimmie. "Re-Covering Racism: Crack Mothers, Reaganism, and the Network News." In *Living Color: Race and Television in the United States*, edited by Sasha Torres, 97–117. Durham, NC: Duke University Press, 1998.

Reeves, Jimmie L., and Richard Campbell. *Cracked Coverage: Television News, the Anti-Cocaine Crusade, and the Reagan Legacy*. Durham, NC: Duke University Press, 1994.

Reid-Brinkley, Shanara R. "The Essence of Res(ex)pectability: Black Women's Negotiation of Black Femininity in Rap Music and Music Video." *Meridians: Feminism, Race, Transnationalism* 8, no. 1 (April 2008): 236–260.

Rhett, Starrene. "Slim Thug: 'Black Women Need to Stand by Their Man More.'" *Vibe Magazine*, http://www.vibe.com/article/slim-thug-black-women-need-stand-their-man-more.

Richardson, Elaine. "Lil' Kim, Hip-Hop Womanhood, and the Naked Truuf." In *Home Girls Make Some Noise: Hip Hop Feminism Anthology*, edited by Gwendolyn D. Pough, Elaine Richardson, Aisha S. Durham and Rachel Raimist, 187–201. Mira Loma, CA: Parker Publishing, 2007.

Richardson, Laurel. "Writing: A Method of Inquiry." In *Handbook of Qualitative Research*, edited by Norman K. Denzin and Yvonna S. Lincoln, 923–949. Thousand Oaks, CA: Sage, 2000.

———. "Writing: A Method of Inquiry." In *Turning Points in Qualitative Research: Tying Knots in a Handkerchief*, edited by Yvonna S. Lincoln and Norman K. Denzin, 379–396. Walnut Creek, CA: AltaMira Press, 2003.

Richardson, Laurel, and Elizabeth Adams St. Pierre. "Writing: A Method of Inquiry." In

The Sage Handbook of Qualitative Research, edited by Norman K. Denzin and Yvonna S. Lincoln, 957–978. Thousand Oaks, CA: Sage, 2005.

Roberts, Dorothy E. *Shattered Bonds: The Color of Child Welfare*. New York: Basic Books, 2002.

Roberts, Robin. "'Ladies First': Queen Latifah's Afrocentric Feminist Music Video." *African American Review* 28, no. 2 (Summer 1994 1994): 245–258.

Rodriguez, Dalia. "A Homegirl Goes Home: Black Feminism and the Lure of Native Anthropology." In *Black Feminist Anthropology: Theory, Politics, Praxis, and Poetics*, edited by Irma McClaurin, 233–258. New Brunswick, NJ: Rutgers University Press, 2001.

Rose, Tricia. *Black Noise: Rap Music and Black Culture in Contemporary America*. Hanover, NH: University Press of New England, 1994.

———. "'Two Inches or a Yard': Silencing Black Women's Sexual Expression." In *Talking Visions: Multicultural Feminism in a Transnational Age*, edited by Ella Shohat, 315–324. New York: MIT Press, 1998.

———. *Longing to Tell: Black Women Talk About Sexuality and Intimacy*. 1st ed. New York: Farrar, Straus and Giroux, 2003.

"S. Africa Blacks Strike to Protest Today's Election." *The Virginian-Pilot and the Ledger Star*, September 6, 1989, A7.

Salaam, Mtume. "The Aesthetics of Rap." *African American Review* 29 (1995): 303–316.

Samuels, Allison. "Minstrels in Baggy Jeans?" *Newsweek*, May 5 2003, 62.

Sandoval, Chela. *Methodology of the Oppressed*. Minneapolis: University of Minnesota Press, 2000.

Seeman, Bruce T. "Merchants Pick up Pieces in Aftermath of Looting." *The Virginian-Pilot and the Ledger Star*, September 4, 1989, A1–A3.

Seeman, Bruce, Lynn Waltz, and Tracie Finley. "Students Voice Their Concerns as Tension Lingers." *The Virginian-Pilot and the Ledger Star*, September 5, 1989, A1–A3a.

Sharpley-Whiting, T. Denean. *Pimps Up, Ho's Down: Hip Hop's Hold on Young Black Women*. New York: New York University Press, 2007.

Shaviro, Steven. "Supa Dupa Fly: Black Women as Cyborgs in Hiphop Videos." *Quarterly Review of Film and Video* 22, no. 2 (2005): 169–179.

Shepard, Beverly, and Davis, Marc. "Revelry Turns to Mayhem: Police Use Force on 2nd Night of Clash." *The Virginian-Pilot and the Ledger Star*, September 4, 1989, A1–A3a.

Shohat, Ella. "Area Studies, Gender Studies, and the Cartographies of Knowledge." *Social Text* 20, no. 3 (Fall 2002): 67–78.

———. "Introduction." In *Talking Visions: Multicultural Feminism in a Transnational Age*, edited by Ella Shohat, 1–62. New York: MIT Press, 1998.

Shomari, Hashim A. *From the Underground: Hip Hop Culture as an Agent of Social Change*. New Jersey: X-Factor Publications, 1995.

Siegel, Deborah L. "The Legacy of the Personal: Generating Theory in Feminism's Third Wave." *Hypatia* 12, no. 3 (August 1997): 46–75.

Simmons, Christina. "African Americans and Sexual Victorianism in the Social Hygiene Movement, 1910–40." *Journal of the History of Sexuality* 4, no. 1 (July 1993): 51–75.

Simon, William, and John H. Gagnon. "Sexual Scripts." *Society* 22, no. 1 (November/December 1984): 53–60.

Skog, Jason. "Beach Tries to Get Black Guests Back: 15 Years after Greekfest Riots, City's Ban Still Leaves a Bad Taste." *The Virginian-Pilot and the Ledger Star*, September 6, 2004, B1.

Smith, Andrea. "Heteropatriarchy and the Three Pillars of White Supremacy: Rethinking Women of Color Organizing." In *Color of Violence: The Incite! Anthology*, edited by Incite! Women of Color Against Violence., 66–73. Cambridge, MA: South End Press, 2006.

Smith, Anna Deavere. *Twilight–Los Angeles, 1992.* 1st ed. New York: Anchor Books, 1994.

Smith, Barbara. *Home Girls: A Black Feminist Anthology.* 1st ed. New York: Kitchen Table—Women of Color Press, 1983.

Smith, Danyel. "Ooh, La, La: Heads Ain't Ready for Queen Latifah's Next Move." *Vibe*, December 1996/January 1997, 98–102.

Smith, Linda T. *Decolonizing Methodologies: Research and Indigenous Peoples.* London: Zed Books, 1999.

Smith-Shomade, Beretta E. *Shaded Lives: African-American Women and Television.* New Brunswick, N.J.: Rutgers University Press, 2002.

Smith Cooper, Tia. "Can a Good Mother Love Hip-Hop?: Confessions of a Crazysexycool Baby Mama." In *Home Girls Make Some Noise: Hip Hop Feminism Anthology*, edited by Gwendolyn Pough, Elaine Richardson, Aisha Durham and Rachel Raimist, 368–382. Mira Loma, CA: Parker Publishing, 2007.

Springer, Kimberly. "Third Wave Black Feminism?" *Signs: Journal of Women in Culture and Society* 27, no. 4 (Summer 2002): 1059–1082.

Spry, Tami. "Performing Autoethnography: An Embodied Methodological Praxis." *Qualitative Inquiry* 7, no. 6 (2001): 706–732.

Stephens, Dionne, and April Few. "The Effects of Images of African American Women in Hip Hop on Early Adolescents' Attitudes toward Physical Attractiveness and Interpersonal Relationships." *Sex Roles* 56, no. 3/4 (2007): 251–264.

Stephens, Dionne, and Layli Phillips. "Freaks, Gold Diggers, Divas, and Dykes: The Sociohistorical Development of Adolscent African American's Sexual Scripts." *Sexuality & Culture* 7, no. 1 (2003): 3–50.

Stokes, Carla E. "Representin' in Cyberspace: Sexual Scripts, Self-Definition, and Hip Hop Culture in Black American Adolescent Girls' Home Pages." *Culture, Health & Sexuality* 9, no. 2 (March/April 2007): 169–184.

Sturken, Marita, and Lisa Cartwright. *Practices of Looking: An Introduction to Visual Culture.* Oxford, UK: Oxford University Press, 2001.

Suo, Steve. "She'll Be the First in Her Family to Graduate: Scott's Reversal Done for Mom." *The Virginian-Pilot*, June 23, 1991, 3.

Tate, Claudia. "Audre Lorde." In *Black Women Writers at Work*, edited by Claudia Tate, 100–116. New York: Continuum, 1983.

Tate, Sonsyrea. "Does Pace Work?: It Depends Whom You Ask." *The Virginian-Pilot*, May 24, 1992, B3.

"Teen Shot in Berkley Area." *The Virginian-Pilot*, June 5, 1991, D4.

Thompson, Lisa B. *Beyond the Black Lady: Sexuality and the New African American Middle Class*. Urbana: University of Illinois Press, 2009.

Torres, Sasha. "Introduction." In *Living Color: Race and Television in the United States*, edited by Sasha Torres, 1–11. Durham, NC: Duke University Press, 1998.

Tucker, Cynthia. "Who Are the Hos Here?" *Time*, April 12 2007, 38.

Vibe Magazine, ed. *Hip Hop Divas*. New York: Three Rivers Press, 2001.

Walker, Rebecca. *To Be Real: Telling the Truth and Changing the Face of Feminism*. New York: Anchor Books, 1995.

Wallace, Michele. *Black Macho and the Myth of the Superwoman*. New York: Dial Press, 1979.

———. *Invisibility Blues: From Pop to Theory*. New York: Verso, 1990.

———. "The Politics of Location: Cinema / Theory / Literature / Ethnicity / Sexuality / Me." *Framework* 36 (1989): 42–55.

White, Deborah Gray. "The Cost of Club Work, the Price of Black Feminism." In *Visible Women: New Essays on American Activism*, edited by Nancy A. Hewitt and Suzanne Lebsock, 247–269. Urbana: University of Illinois Press, 1993.

Williams, Claudine R. "Hard Work Pays Off in Scholarship Aid for Student." *The Virginian-Pilot*, July 6, 1995, 3.

Willis, Deborah, ed. *Black Venus 2010: They Called Her "Hottentot."* Philadelphia: Temple University Press, 2010.

Yeoman, Fran, Carolyn Asome, and Graham Keeley. "Skinniest Models Are Banned from Catwalk." *The (London) Times*, September 9, 2006, 3.

Zhang, Yuanyuan, Travis L. Dixon, and Kate Conrad. "Rap Music Videos and African American Women's Body Image: The Moderating Role of Ethnic Identity." *Journal of Communication* 59, no. 2 (June 2009): 262–278.

Zook, Kristal Brent. "'Living Single' and the 'Fight for Mr. Right': Latifah Don't Play." In *Gender, Race, and Class in Media: A Text Reader*, edited by Jean McMahon and Gail Dines Humez, 129–135. Thousand Oaks, CA: Sage, 2002.

Zuel, Bernard. "Diva Declares Her Intentions with Desultory Double Act." *The Sydney (Australia) Morning Herald*, November 22, 2008, 14.

MOTION PICTURES

Basic Instinct. Directed by Paul Verhoeven. TriStar Pictures, 1992.

Bringing Down the House. Directed by Adam Shankman. Touchstone Pictures, 2003.

Brown Sugar. Directed by Rick Famuyiwa. 20th Century Fox, 2002.

Chicago. Directed by Rob Marshall. Miramax Films, 2002.
Do the Right Thing. Directed by Spike Lee. 40 Acres & A Mule Filmworks, 1989.
Easy Rider. Directed by Dennis Hopper. Columbia Pictures, 1969.
Ghost. Directed by Jerry Zucker. Paramount Pictures, 1990.
Gone with the Wind. Directed by Victor Fleming. MGM, 1939.
The Help. Directed by Tate Taylor. DreamWorks Studios, 2011.
Hip Hop: Beyond Beats & Rhymes. Directed by Byron Hurt. Media Education Foundation, 2006.
Hoodlum. Directed by Bill Duke. United Artists Pictures, 1997.
Jungle Fever. Directed by Spike Lee. 40 Acres & A Mule Filmworks, 1991.
Losing Isaiah. Directed by Stephen Gyllenhaal. Paramount Pictures, 1995.
Mama Flora's Family. Directed by Peter Werner. Hallmark Entertainment, 1998.
Monster's Ball. Directed by Marc Forster. Lions Gate Films, 2001.
Set It Off. Directed by F. Gary Gray. New Line Cinema, 1996.
Sex and the City 2. Directed by Michael Patrick King. New Line Cinema, 2010.
The Wild One. Directed by Laslo Benedek. Columbia Pictures, 1953.

SONGS

Allen, Lily, "Hard Out Here," in *Sheezus*, Parlophone, 2013.
Blige, Mary J., "Real Love," in *What's the 411?*, Uptown Records, 1992.
Jon, Lil, and The East Side Boyz, "Get Low," in *Kings of Crunk*, TVT Records, 2003.
Knowles, Beyoncé, "Check on It," in *B'Day*, Columbia Records, 2005.
———, "Get Me Bodied," in *B'Day*, Columbia Records, 2005.
———, "Flawless," in *Beyoncé*, Parkwood/Columbia Records, 2013.
———, *I Am . . . Sasha Fierce*, Columbia Records, 2008.
———, "If I Were a Boy," in *I Am . . . Sasha Fierce*, Columbia Records, 2008.
———, "Single Ladies (Put a Ring on It)," in *I Am . . . Sasha Fierce*, Columbia Records, 2008.
LL Cool J, "Around the Way Girl," in *Mama Said Knock You Out*, Def Jam, 1990.
Ludacris, "Nasty Girl," in *Theater of the Mind*, Def Jam, 2009.
Nelly, "E.I. (Tip Drill Remix)," in *Da Derrty Versions: The Reinvention*, Universal Records, 2003.
N.W.A., "Fuck tha Police," in *Straight Outta Compton*, Ruthless Records, 1988.
Public Enemy, "Fight the Power," in *Fear of a Black Planet*, Def Jam/Columbia Records, 1990.
———, "Welcome to the Terrordome," in *Fear of a Black Planet*, Def Jam/Columbia Records, 1990.
Queen Latifah, *All Hail the Queen*, Tommy Boy/Warner Bros. Records, 1989.
———, "U.N.I.T.Y.," in *Black Reign*, Motown/PolyGram Records, 1993.

———, "When You're Good to Mama," *Chicago: Music from the Miramax Motion Picture*, Epic Records, 2002.

The Time, "Jungle Love," in *Ice Cream Castle*, Warner Bros., 1984.

Usher, "Yeah!" in *Confessions*, Arista Records, 2004.

TELEVISION SHOWS

Black in America. Directed by Cable News Network, Dave Timko, and Soledad O'Brien. CNN, 2008.

The Cosby Show, created by Ed Weinberger, Michael Leeson, and Bill Cosby, NBC, 1984–1992.

Drawn Together, created by Dave Jeser and Matthew Silverstein, Comedy Central, 2004–2008.

Living Single, created by Yvette Lee Bowser, Fox, 1993–1998.

Six Feet Under, created by Alan Ball, HBO, 2001–2005.

The Sopranos, created by David Chase, HBO, 1999–2007.

The Wire, created by David Simon, HBO, 2002–2008.

Index

Intersections in Communications and Culture

Global Approaches and Transdisciplinary Perspectives

General Editors: Cameron McCarthy & Angharad N. Valdivia

An Institute of Communications Research, University of Illinois Commemorative Series

This series aims to publish a range of new critical scholarship that seeks to engage and transcend the disciplinary isolationism and genre confinement that now characterizes so much of contemporary research in communication studies and related fields. The editors are particularly interested in manuscripts that address the broad intersections, movement, and hybrid trajectories that currently define the encounters between human groups in modern institutions and societies and the way these dynamic intersections are coded and represented in contemporary popular cultural forms and in the organization of knowledge. Works that emphasize methodological nuance, texture and dialogue across traditions and disciplines (communications, feminist studies, area and ethnic studies, arts, humanities, sciences, education, philosophy, etc.) and that engage the dynamics of variation, diversity and discontinuity in the local and international settings are strongly encouraged.

LIST OF TOPICS

- Multidisciplinary Media Studies
- Cultural Studies
- Gender, Race, & Class
- Postcolonialism
- Globalization
- Diaspora Studies
- Border Studies
- Popular Culture
- Art & Representation
- Body Politics
- Governing Practices

- Histories of the Present
- Health (Policy) Studies
- Space and Identity
- (Im)migration
- Global Ethnographies
- Public Intellectuals
- World Music
- Virtual Identity Studies
- Queer Theory
- Critical Multiculturalism

Manuscripts should be sent to:

Cameron McCarthy OR **Angharad N. Valdivia**
Institute of Communications Research
University of Illinois at Urbana-Champaign
222B Armory Bldg., 555 E. Armory Avenue
Champaign, IL 61820

To order other books in this series, please contact our Customer Service Department:
(800) 770-LANG (within the U.S.)
(212) 647-7706 (outside the U.S.)
(212) 647-7707 FAX

Or browse online by series:
w w w . p e t e r l a n g . c o m

/